KT-499-644

ART
FUNDAMENTALS

ART
FUNDAMENTALS

BASICS OF DRAWING, PAINTING, SCULPTURE AND PRINTMAKING

By
Morton Garchik

STRAVON EDUCATIONAL PRESS
New York, N.Y.

To
Gerda

Copyright ©MCMLXXIX
By Morton Garchik

Library of Congress Cataloging in Publication Data

Garchik, Morton, 1929-
 Art fundamentals.

 Includes index.
 1. Art Technique. I. Title .

N7430.G28 70 2'.8 78—10336

ISBN 0-87396-082-03

Printed in the United States of America

CONTENTS

List of Illustrations and Color Plates

INTRODUCTION

BEGINNERS WITH A DESIRE TO EXPRESS THEMSELVES through art seldom seek or receive unified instruction in all major art techniques. The technical skills they study are often taught in a vacuum rather than against a background of art history and a definition of art.

This is a self-study book which will teach the basic art techniques — drawing, painting, sculpture, and printmaking — based upon a definition of art that is principled and disciplined, but flexible enough for application to the best art of the past and to the art a talented student may create. The analyses and exercises in Chapter I, for example, will provide the student with a sound foundation for personal creative expression.

It is of critical importance that the student explore all four techniques. The evidence of great artists producing important bodies of work in at least three of these forms is overwhelming. Among the old masters, the following are but a few examples: Michelangelo (drawing, sculpture, painting), Dürer (drawing, painting, woodcut), Rembrandt (drawing, etching, painting), and Goya (drawing, etching, painting). Among the late-nineteenth-century artists, Toulouse-Lautrec, Degas, Gauguin, Van Gogh, and Renoir are a few who might be named. Since 1900, such moderns as Munch, Klee, Beckmann, Picasso, Matisse, and Rouault and such contemporaries as Baskin, Peterdi, Warhol, and Rauschenberg have worked freely in a variety of techniques.

The quality and quantity of pictures these artists created may in part have been due to their ability to shift from one technique to another when creative "blocks" occurred. Such blocks, which are experienced by most artists, can lead to extreme discouragement for the beginner. They may indicate that the technique in which he/she is working may be ill suited to the individual's talents and expressive needs. Familiarity with a variety of techniques is then very helpful in maintaining a creative flow.

The book may also be used by those students who wish to proceed directly to painting, sculpture, or printmaking. The chapters on these techniques are complete units. However, Chapter I, "The Visual Language," and Chapter II, "Fundamentals of Drawing," are essential to the other studies, and it is urged that the student begin with them.

At least one month should be devoted to the exercises in Chapter I. The chapter on drawing will require a longer period, depending upon individual aptitude and the amount of time available for study.

Students should save all their work. Comparisons between first attempts and later efforts will make it possible to judge the progress made. As students advance to the later chapters, the studies of the visual language and drawing fundamentals should continue as adjuncts to the new study of painting, sculpture, or printmaking. When proceeding to one of these, students will naturally select a favorite, but they should try the others too.

Many new insights about drawing, for instance, will be discovered in painting. Making prints will induce an understanding of painting or sculpture that could not be obtained in any other way.

The student seeking to understand her/his position as an artist in society will be helped by Chapter VI, "The Function of Art and the Evolution of Style." The perspective introduced in this chapter is important for an intelligent approach to one's work after techniques have been mastered. In addition, this chapter examines the development of styles that are available to the student as a broad artistic vocabulary for personal expression.

While the main portion of this book is concerned with fine art, people with artistic skills who find their emotional and practical needs not suited to the pursuit of fine art will find other opportunities discussed in Chapter VII, "Careers in Art."

This text offers basic, step-by-step procedures for learning several techniques. With their aid, the novice can gain enough skill to explore her/his creative talent in full range. The ultimate goal is to instill in the student a dedication to the mastery of those skills for the creation of images worthy to be called art.

THE
VISUAL LANGUAGE

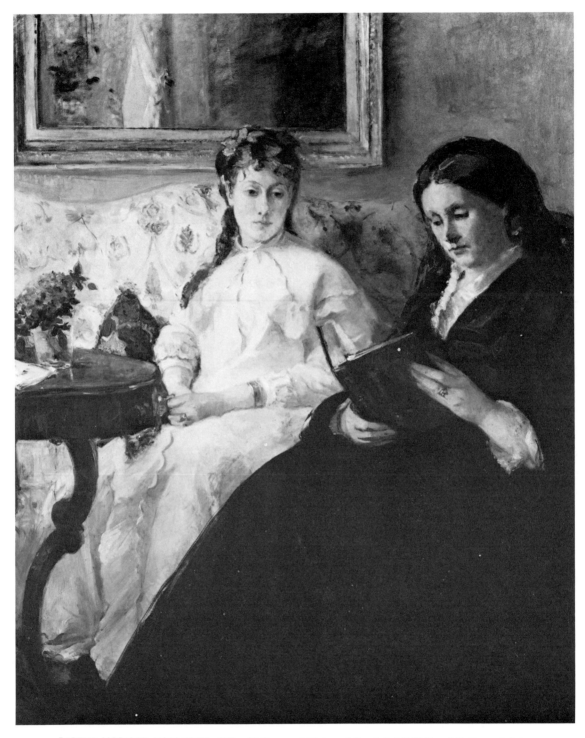

BERTHE MORISOT (1841-1895). "The Mother and Sister of the Artist." National Gallery of Art, Washington, D.C. (Chester Dale Collection)

Chapter I

THE VISUAL LANGUAGE

MANY PEOPLE THINK THAT THEY DO NOT KNOW HOW TO RESPOND TO ART. Actually, the language of art is one that most of us respond to easily and naturally, but we have not learned to understand our response, and therefore we mistrust it.

Visual art is an illusion; artists use devices, which symbolize objects, to describe the world. Those devices—lines, shapes, forms, values (light and dark), colors, and textures—have an expressive language of their own.

The line in Figure 1A can symbolize a face, but it also has the potential for other expressive qualities, which artists can manipulate.

A Fig. 1 B

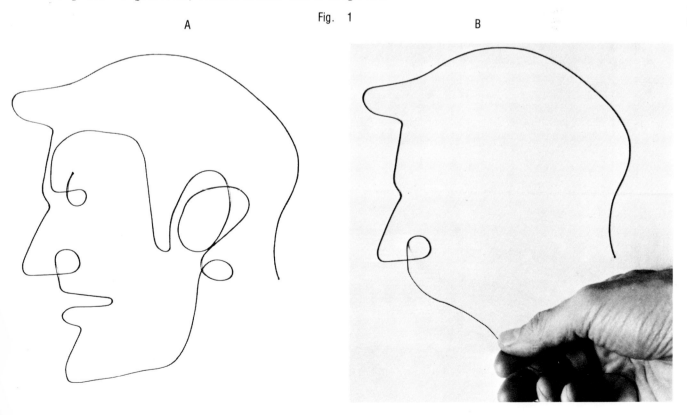

15

Try this experiment: Figure 2 has six sets of abstract "pictures"; look at them. Do not try to analyze them, do not try to associate them with other things ("this reminds me of broken glass" or "this makes me think of mountains" or "this looks like such and such"). Just relax and try to let the answer come from your first emotional or intuitive response. Write your answers on a piece of paper, then check them with the answers on page 20.

Fig. 2

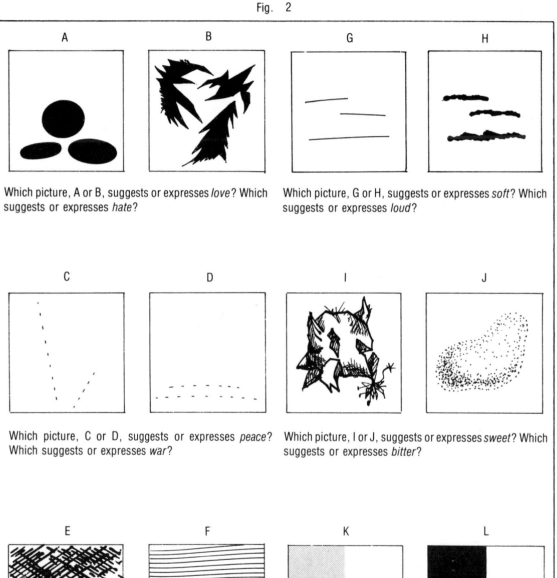

Which picture, A or B, suggests or expresses *love*? Which suggests or expresses *hate*?

Which picture, G or H, suggests or expresses *soft*? Which suggests or expresses *loud*?

Which picture, C or D, suggests or expresses *peace*? Which suggests or expresses *war*?

Which picture, I or J, suggests or expresses *sweet*? Which suggests or expresses *bitter*?

Which picture, E or F, suggests or expresses *calm*? Which suggests or expresses *hectic*?

Which picture, K or L, suggests or expresses *timidity*? Which expresses or suggests *aggressiveness*?

You might think that your answers are personal and subjective, but in fact most people answer in the same way. Try it, and ask some of your friends or relatives to do the experiment.

The universality of the responses is of great significance to artists. It proves that the devices of art—lines, shapes, forms, values, colors and textures—are a *visual language* that we all understand.

This language, in a sense, is the real *subject* of art. The illusions it creates—likenesses of people, objects, or landscapes—are the *subject matter*. Subject matter and the styles of portraying it have changed throughout history. In the twentieth century many artists (Abstractionists) have abandoned subject matter completely. They assert that visual art should be as pure as music and should achieve its expression solely through the visual language (see Chapter VI). In either case, whether artists choose to work abstractly or realistically, they must understand and control the elements of the visual language.

Look at the pictures in Figure 2 again. This time try to analyze the responses. Picture A is composed of three harmonious shapes; they are variations of curves. Curves themselves suggest a feeling of gentleness. The positioning of the shapes is symmetrical. This evokes a feeling of stability. In contrast, B has shapes which are agitated and disjointed. They move to and from each other "aggressively." Their violent, diagonal thrusts create tensions with the stable horizontal and vertical borders of the picture. It is evident that our interpretation of what these pictures "say" was *felt* as a reaction only to the way in which *shapes* were designed and placed.

The differences between C and D are more subtle, but nonetheless they are specific. D expresses peacefulness by its horizontal character. Horizontals associated with the position of sleep, suggest rest. The dots form two linear movements that repeat a similar restful curve. In C our eyes connect the dots into lines that pull away from each other and that also create tensions with the borders of the picture. The inequality of size between the two lines in C also contributes to tension. All of these factors are more likely to suggest "war" than the gentle "peaceful" design of D.

By now you should begin to understand, in rather specific terms, what caused your responses. E and F communicate through differences in *texture*. G and H express feelings by the qualities of their *line*. In I and J *forms* are used to evoke sensations. K and L speak solely through contrasts of light and dark, or *values*. (A value scale showing gradations of light and dark is shown in Figure 3.)

The Necessity for Structure

Art is said to imitate nature. This does not mean copying the outward appearances but rather composing, as nature does, on structural principles.

Much can be learned about structure by studying natural forms. Notice the elements of line, shape, and form in Figure 4. They are diverse in size and direction, but are unified by rhythmic patterns that control the sizes and movements. This is organic structure; the lines, shapes, and forms evolve from functional growth. Good art must have a similar structure if it is to be alive and powerful.

Fig. 3

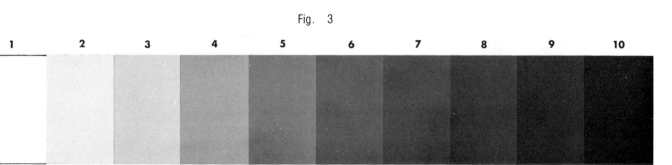

1 2 3 4 5 6 7 8 9 10

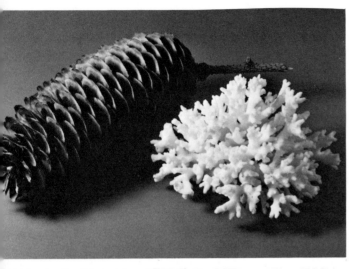

Fig. 4

Structure, or *composition*, means arranging things so that they have well-ordered relationships. The need for order and pattern is deeply rooted in human nature and influences our response to art. A lack of order in art results in works that are confused, boring, and powerless to attract attention or communicate. These concepts are summarized in Figure 5.

Content

So far we have examined only some aspects of technique. Before studying them in detail, let us think about content.

You may be confused by the variety of images exhibited today in museums and galleries, many of which seem to make no sense. Art styles and theories have changed throughout history (see Chapter VI). But good art, regardless of style, has expressive content in addition to structure. However, art that lacks these qualities may still have some historical or political significance. For instance, it may be the first, though not necessarily the best, example of an important new trend. It may be an example of an image that was more successful as social or political propaganda than as a work of art. Some art may in fact be just plain bad, but may be popular because it exemplifies a temporary fad.

To achieve expressive content, you must have a definition of art to work towards. Art

has been defined and redefined over the centuries. A group of artists, calling themselves Dadaists (ca. 1915), rejected definitions of art that included content and structure, as a protest against a civilization that had produced the first World War. But such beliefs cannot endure. Art based upon content and structure has always manifested itself despite wars and upheavals.

The current Webster (Third New International) defines art as "the conscious use of skill, taste, and creative imagination in the practical definition or production of beauty." This limits art to the production of *beautiful* objects, in which case artists would only have to learn to copy things generally agreed upon as beautiful: a particular flower, sunset, or person.

While art can of course utilize beautiful forms, and art itself, when it is good, takes on attributes of being beautiful, a modification of the preceding definition is desirable:

Art is the conscious use of skill, taste, and creative imagination in the production of objects that *exalt the mind or spirit.*

We can go even further and ask that art demonstrate some profound, if not divine, motivation or inspiration. Such a definition can explain how some art has affected people and endured for thousands of years. The artistic experience, the exalting of the mind

The elements of the visual language are:
 point form color
 line value texture
 shape
They have attributes of:
 size
 movement
They can be controlled by rhythmic devices:
 graduated progressions
 alternating patterns
 repeated patterns
 contrasts
 dominant features
Control results in:
 unified artistic expression

Fig. 5

and spirit, is what enables us to return to great drama, poetry, music, dance, or visual art over and over again. It fills a deep human spiritual need. Giovanni Bellini's "St. Francis in Ecstasy" (Fig. 6) is an excellent example.

Expressive content can range from evo-cations of sophisticated humor and fantasy to the most violent tragedies. To be effective, expressive content must be presented in a structured form that grips the viewer's attention so that the content can act upon him/her. The mastery of that form is what we will study in the remainder of this chapter.

GIOVANNI BELLINI (c.1430-1516). "St. Francis in Ecstasy." Copyright the Frick Collection, New York

This painting is a magnificent example of expressive content presented in a highly structured manner. A multitude of lines, shapes, forms, tones, and textures have been composed to communicate the Saint's reverence for the complex harmony of creation.

Fig. 6

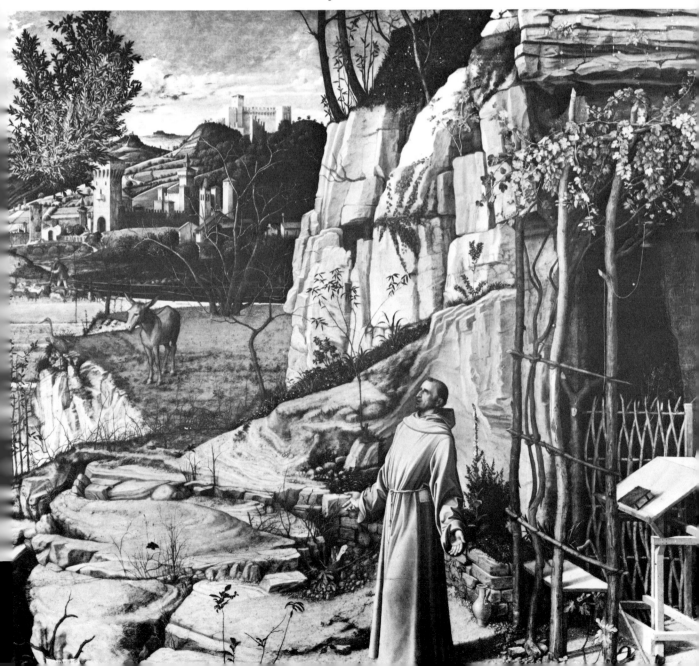

The Properties of Line

The point is the smallest unit in visual art (Fig. 7). Though static, it has the power to call attention to itself; the eye is drawn to and held by it.

Fig. 7

A point may be used in any size, tone, color, or texture (Fig. 8). These will intensify its power of attraction.

Fig. 8

Points in group or series (Fig. 9) lose their individual power and combine (the eye connects them) to take on the attributes of *line*.

Fig. 9

Line, then, is an extension of the point. It can appear to move two-dimensionally across space (Fig. 10); it can also appear to move into space, three-dimensionally (Fig. 11).

Fig. 10

Fig. 11

Answers to the experiment: Love—A, Hate—B; Peace—D, War—C; Calm—F, Hectic—E; Soft—G, Loud—H; Sweet—J, Bitter—I; Timidity—K, Aggressiveness—L.

Line is one of the truly abstract elements of visual art, in that it does not exist in nature. With the few exceptions of things that look like lines—twigs, string, etc.—what we perceive in nature or art as lines are either the edges of forms (Fig. 12) or the edges that result when two contrasting tones, colors (Fig. 13), or textures (Fig. 14) adjoin.

Line also has emotional qualities. In Figure 15, the line is neutral; it describes a form but does not call undue attention to itself. The line in Figure 16 takes on a life and expression of its own, independent of the form it describes; the thicker parts of the line even begin to take on attributes of *shape*.

To control the effect of lines, attention must be given to their character, size, and movement in relation to each other; to the spaces between them (in the terminology of artists, *negative spaces*); and their relationships to the borders of the picture.

Fig. 12

Fig. 13

Fig. 14

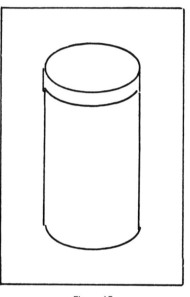

Fig. 15

Fig. 16

Exercise 1

Using only thin, straight lines of varying lengths, create an image that suggests speed and motion. A student's solution is shown in Figure 17.

Fig. 17

Notice the long thrusting diagonal across the center of the picture: it is reinforced with smaller lines. As the eye jumps from one line to another and follows the thrusts, a sense of motion is created. The lines are in contrast to the stable horizontal and vertical borders of the picture; this creates tension, adding to the feeling of motion.

Exercise 2

Using only thick, curved lines of varying lengths, create an image that suggests growth. Figure 18 shows one student's approach to the problem.

Fig. 18

Growth has been suggested by lines that seem to evolve out of each other like the branches or leaves of a plant form (compare Fig. 4).

Exercise 3

Using thin and thick, straight and curved lines of varying lengths, create an image that suggests conflict. Figure 19 illustrates one student's effort.

Fig. 19

In this example, the student created two opposing forces (thin against thick). This solution is more complex, because it uses several elements (thin, thick, straight, curved). An attempt was made to create a basic pattern: The thick lines are vertical and at a similar angle, the thin lines are generally horizontal. All the lines have a jagged quality, which suggests a sensation of irritability.

As you work on these exercises, you will become sensitive to the problems involved in controlling the elements of the visual language. You will learn to compose by creating a structure that organizes sizes, patterns, and movements.

Shapes and Forms

When a line encloses an area (Fig. 20), it creates a shape.

Fig. 20

A shape can be given the attribute of a form, that is, it can be made to look as if it has weight and three dimensions. Artists refer to this technique as modeling. One method of modeling is to use lights and darks (Fig. 21)

Fig. 21

which we associate with the feeling of weight and dimension in nature. This technique can be reinforced by the use of color, and it will be taken up in the chapter on painting.

Still another way to create an illusion of form is to draw lines on the shape that can be "read" as moving *around* the shape in space. In this example (Fig. 22), which might be a

Fig. 22

drawing of a beachball, the lines are of course on the flat surface of the paper, but they create an illusion of moving from the front of the ball (the thicker parts of the line) around to the furthest edges. The Rembrandt etching in Figure 23 utilizes both modeling and line technique to create form.

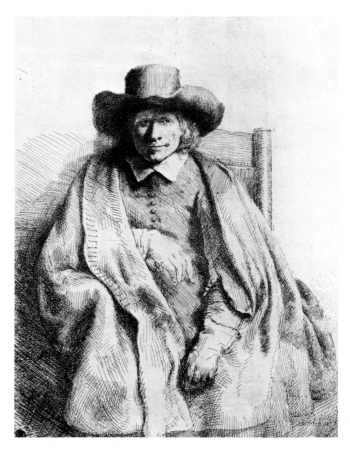

Fig. 23

REMBRANDT VAN RIJN (1606-1669). "Clement de Jonghe." Copyright the Frick Collection, New York

This Rembrandt etching is an excellent example of line used to create lights and darks, which build three-dimensional form and weight. In addition, notice how form is suggested in the sitter's upper hand, with almost no light and dark modeling, but purely by the articulation of the line itself as it carefully describes the edges of the form (see Outline Drawing, page 49). The picture is also instructive in the control of light and dark. The tones of the figure, chair, and background are closely related by low contrasts (close intervals on the value scale, see page 17), while the strongest contrasts of tone are focused in the drama of the face.

It is interesting to observe that these artistic devices are very sophisticated illusions. Young children and animals do not respond to the "realism" of drawings or photographs, because they have not learned to let the devices—lines, shapes, lights and darks—symbolize the three-dimensional forms of reality.

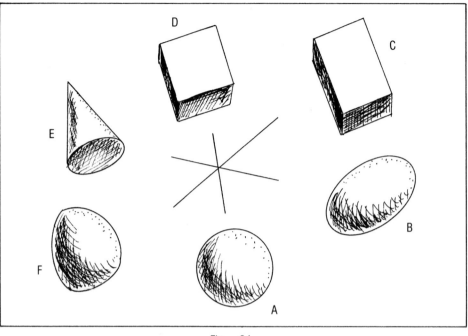

Fig. 24

Fig. 25

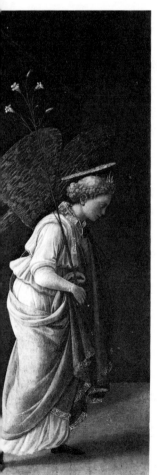

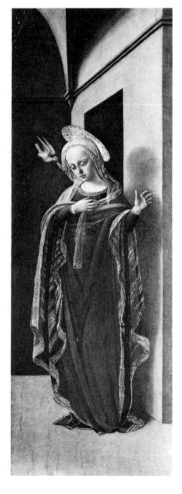

Shapes and forms, like lines, have expressive characteristics and relationships which you must be aware of and compose selectively.

When beginning a picture, decide the general mood or statement you wish to communicate—happy, brooding, exciting, peaceful, etc. Then select and compose the pictorial elements that will reinforce the mood you have decided upon.

FRA FILIPPO LIPPI (1406-1469). "Annunciation." Copyright the Frick Collection, New York

The poignant theme requires a harmonious structure and thus appropriately uses symmetrical balance. This is done by placing figures of comparable weight and size in equal portions of a room. However, to avoid monotony, Lippi creates subtle contrasts that add vitality while maintaining the harmony. The Angel is painted in light tones against a dark background, while the Virgin is rendered in dark tones in the lighter portion of the picture. Both figures are silent contrasting tableaus. The Angel has completed an action or is poised for one; the artist stresses this by designing the figure with diagonal lines and movements. The Virgin is absorbed in thought; the artist reinforces that mood by composing her on a stable vertical axis, which is echoed by, and harmonized with, the verticals of the wall and door.

For example, look at the forms in Figure 24. If you want a harmonious feeling to pervade your picture, select forms that have similarities: D and C, or A and B, or F and A, or E and D. Each of these pairs have similar characteristics.

If, on the other hand, you wish your picture to have excitement and agitation, select *contrasting* forms: E-F-C, F-A-C, A-B-E, or D-C-F. Notice that in these instances the selections include *three* forms, of which two are similar while the third is contrasting. If you use only *two* contrasting forms, they would cancel each other out and the composition would seem indecisive.

However, this is not an absolute rule. Equal elements used symmetrically can be effective for certain types of expression; many religious pictures are based upon symmetrical arrangements, but they employ subtle contrasts, to avoid monotony. Fra Filippo Lippi's "Annunciation" (Fig. 25) demonstrates the point.

Symmetry, illustrated in Figure 26A, is

a simple compositional device for achieving balance and harmony. But, if the content of your picture demands tension and excitement, use asymmetrical balance (Fig. 26B).

Austere and dignified subject matter does not always have to be portrayed symmetrically. "The Descent from the Cross" (Fig. 27) is a profound religious theme, but

REMBRANDT VAN RIJN (1606-1669). "The Descent from the Cross." National Gallery of Art, Washington, D.C. (Widener Collection)

Rembrandt treats this tragic theme dramatically by using asymmetrical balance. He places the most active figures and forms far to the side of the picture. Tensions and movements are created by the diagonal thrusts of arms, legs, and heads. Balance is achieved by a counterweight of one highlighted figure (on the lower right), which is contrasted against a large dark area.

Fig. 27

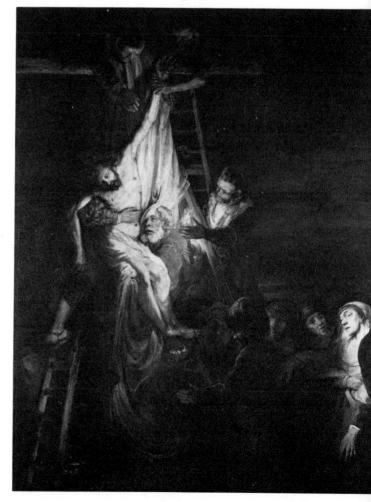

Fig. 26

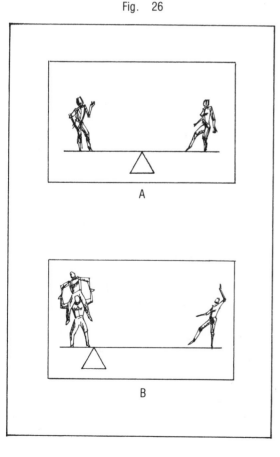

Rembrandt, unlike Lippi, chose to dramatize it by using an asymmetrical composition.

Another characteristic of shapes and forms is that they are self-contained; like points, they attract and hold the eye. The eye and mind link similar forms and shapes; this linking creates movements in the picture that must be controlled.

For example, in Figure 28 the eye makes connections between A-B-C-D in several ways: clockwise or counterclockwise; verti-

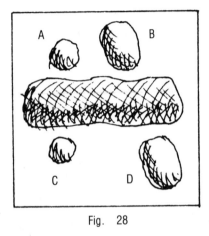

Fig. 28

cally (A-C, C-A, B-D, D-B); or diagonally (A-D, D-A, B-C, C-B).

The eye also follows the movements of forms as they appear to thrust into space. These movements, too, must be carefully considered, then organized and arranged (Fig. 29).

Fig. 29

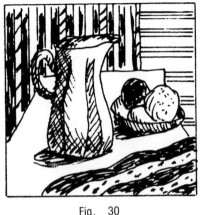

Fig. 30

It is also possible for shapes and forms to have tones, textures, and colors. If so, these elements must be considered in the organization of your picture (Fig. 30).

In addition to all the specific elements discussed above, works of visual art have a unique quality that you must attend to—a total presence that projects a complete impression at first sight. One can, of course, move close to a picture or sculpture and examine it detail by detail. But there is always a total impact that acts upon us every time we look at it. Therefore, it is imperative that the elements of the visual language (shapes, lines, forms, values, textures, and colors) are designed so as to take that dynamic first and ever-present total impression into account, before attention is given to the solving and rendering of details. Georges Braque's "Le Jour" (Fig. 31), is a masterful example of how these elements can be controlled.

Methods of Composition

As you have learned in the exercises with line, composition means ordering relationships—the sizes and movements of the visual elements—by organizing them into rhythmic patterns.

Order and rhythm are essential parts of nature and human physiology. The bodies in outer space move in regular patterns as do the tides of the sea. We experience rhythmic pattern in our breathing, heartbeat, and cycles of sleeping and waking. Any disruption of those rhythmic patterns leads to disorder. It is in this sense that art is said to imitate

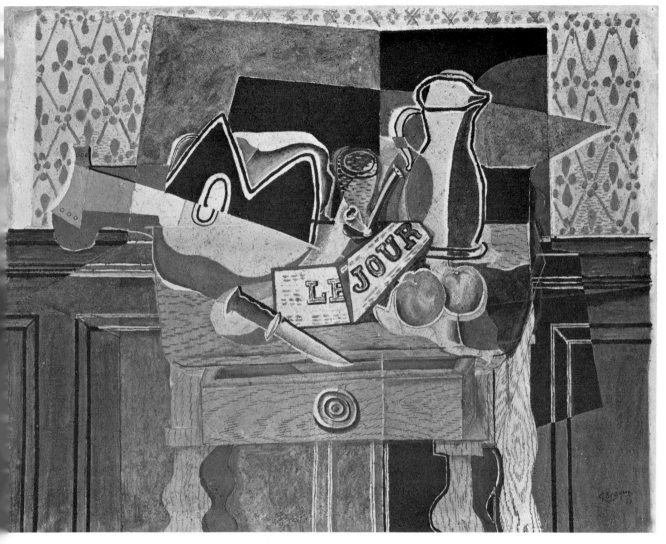

Fig. 31

GEORGES BRAQUE. (1882-1963). "Still Life: Le Jour." National Gallery of Art, Washington, D. C. (Chester Dale Collection)

Georges Braque's "Le Jour" illustrates the unique ability of visual art to communicate a total impression instantly. (Other art forms—music, dance, drama, and literature—build their effects over a span of time.) In this still life, the lines, shapes, forms, lights and darks, and textures, which describe the items on the table (a guitar, knife, fruit, pitcher, etc.), have been fused into a new large entity. Each time we look at the picture, that dynamic form—greater than its parts—acts upon us before we inspect and react to the subtleties of the details.

nature. Even when art creates a world with its own laws, it must conform to natural laws of structure to be effective.

The principle of ordering relationships by organizing rhythmic patterns applies not only to line, but to all the devices artists use. In creating patterns, however, you must not lose sight of the need for contrast. Too much pattern and regularity results in monotony.

Briefly then, good composition requires sufficient organization of patterns to establish stability, and sufficient contrast and variety to sustain interest. Let us look at some specifics:

Fig. 32

Fig. 33

Fig. 35

The forms in Figure 32 are of equal sizes and they are equally spaced. The result is a well ordered rhythmic pattern. But because there are no contrasts, the image is monotonous.

In Figure 33 several new elements (texture, tones, different shapes) have been introduced, making the composition more interesting than the previous one, but there is still some monotony because the sizes and spacing are the same.

There is greater interest in the forms in Figure 34. They vary in size, but notice that

Fig. 34

harmony is maintained because they are all based upon curves. Yet there is still too much regularity in their spacing and placement. In addition, the three units—the large circle, the two small circles, and the oval—all have similar "weight," and this tends to balance them somewhat monotonously.

Figure 35 has a more successful arrangement, with interesting variation and sequence of sizes and shapes. Unlike the previous example, here the weights of the units have a proportioned progression, from large to small. The placement of the forms is more dynamic, allowing the negative shapes (the space around the forms) to become more active in the composition.

Proportion and Progression

Our appreciation and need for proportion and progression also have their roots in nature, and account for our response to "beautiful" people or objects, or a graceful series of movements by a dancer or athlete. It motivates people's constant desire to transform (make a composition of) their environments.

The Golden Section is a ratio that can be used to divide a line or a rectangle into the most interesting proportions. The ratio, 1:1.618, is traceable to the ancient Greeks, who used it extensively in their architecture. Since that time artists have applied the proportion to various aspects of their work: the shape of a canvas or mural, space divisions within the canvas, the divisions of lines, and even the divisions of values and colors.

The study of the Golden Section is too broad to be covered here in full, but it will be

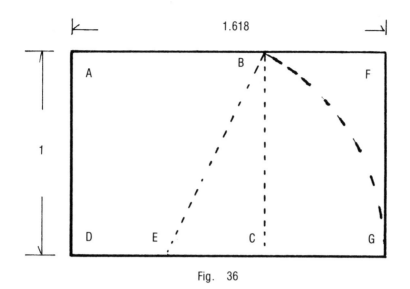

Fig. 36

instructive for you to draw and analyze a Golden Section rectangle. Tests have proven that, given several rectangles to choose from, most people will select this as the one with most pleasing proportions (Fig. 36).

Exercise 4

1. Draw square ABCD.

2. Plot E at the midpoint of DC. Using E as the center and EB as a radius, draw arc BG.

3. Complete the rectangle DGFA.

Notice how the proportions create variety and interest with subtle repetitions: the 1:1.618 ratio exists between lines AD and AF and is repeated in the relationship of BF to AB. Rectangle BFGC repeats the proportion of AFGD.

Study these points carefully. They will give you insights into the principles of unity with variety, which are discussed throughout this chapter.

While it is always beneficial to study and consider the possibilities of any art theory, bear in mind that formulas alone will not produce art. What should always guide your work is what will best express the idea or content. If you find it necessary to depart from "rules" to accomplish your end, do so. Breaking rules and creating sound, compelling alternatives to them can result in highly original work. For example, compare "The Deposition" by Gerard David (Fig. 37) to

GERARD DAVID (c. 1460-1523). "The Deposition." Copyright the Frick Collection, New York

Fig. 37

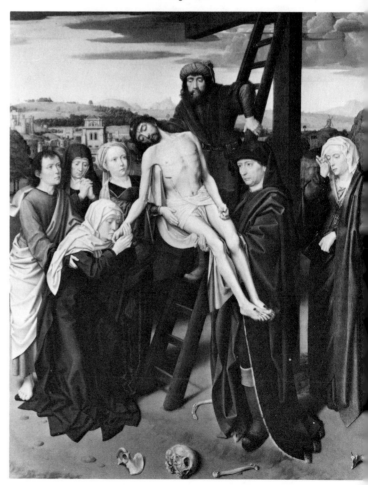

Rembrandt's treatment of the same theme (Fig. 27). Both artists approached it differently and both have found successful solutions.

David's composition is symmetrical; Rembrandt's is asymmetrical. David renders every form in complete detail, regardless of its importance; Rembrandt merges forms into each other or into the background and subdues details. In David's conception, light illuminates everything evenly; Rembrandt uses light theatrically, he places it selectively.

The same subject can be approached quite differently, as these artists have demonstrated. A talented artist can break "rules" so long as the image he/she creates has structure and consistency.

Returning to Figure 35, notice a new element that was introduced: The circular form is behind the large oval form. Thus, while they can be felt as two separate forms, the two combine into a new shape/form creating new effects which must be considered.

These examples illustrate many compositional problems which must be solved; the addition of color would complicate them even more. In order not to be overwhelmed by them in your studies, limit yourself to just a few devices; they go a long way. Consider the portrait by Gentile Bellini; it is based almost entirely on one design element, the curve (Fig. 38).

Fig. 38

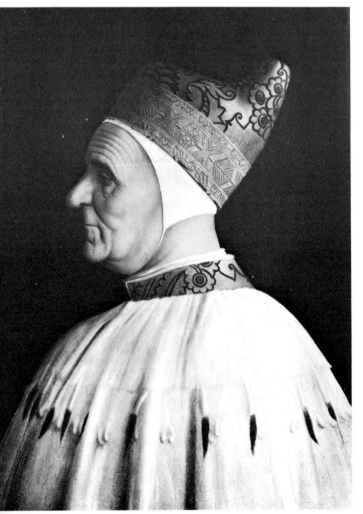

GENTILE BELLINI (1429-1507). "Doge Giovanni Mocenigo." Copyright the Frick Collection, New York

Gentile Bellini's portrait provides a superb example of the way in which a few simple elements can be organized to reinforce the expressive content. What must have struck Bellini about the sitter's face was the way its severe and dignified character was revealed by lines, which expressed a lifetime of care and thought.

The artist seizes upon those lines and makes them the basic motif of the painting, particularly the group of curved lines of the forehead. Bellini must have decided that curves alone were sufficient to achieve the expressive content, for there are almost no straight lines in the picture. Notice how your eye even connects the dark spots (points) of fur on the cape, to make a long horizontal curve, which acts as a subtle counterpoint to the vertical sloping curves of the cape itself.

All the curves are dominated by the long curving outline that silhouettes the figure against the background. Bellini also bases the shapes and forms on curves; they grow and radiate out of each other like the forms of a plant (compare Fig. 4). These organic relationships unify the curves despite their various sizes and movements.

Notice, too, how the artist limits his use of light and dark. He uses a strong light and a strong dark, with just a few intermediate tones. The strongest contrast is that of the figure against the background; the contrasts within the figure are subtle and simple.

Study of this painting will show it to be a carefully thought-out work in which the artist organizes the elements of the visual language (the subject) into pictorial "music" to express his feelings about the sitter (the subject matter).

Exercise 5.

Take three sheets of dime-store construction paper: a light, medium, and dark tone. Cut each sheet into shapes as shown in Figure 39.

Select a general theme or idea and arrange the cutouts into a composition that expresses the theme. First try it with only one tone; then try it with all three tones. Pay attention, too, to the *negative shapes*, the spaces between the cutouts; design them so that they too reinforce the mood of your theme. Figures 40, 41, 42, and 43 show some students' solutions to Exercise 5.

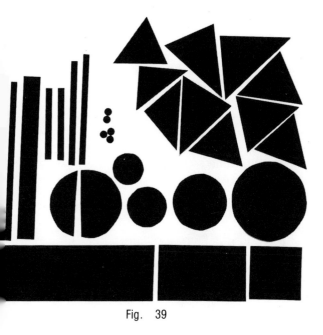

Fig. 39

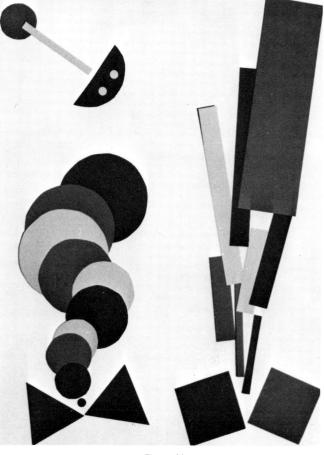

Fig. 41

Here a student tried to express the feeling of "Racing." There is a great rushing movement to the right, created by the arrow-like shapes at the top and reiterated by the round shapes at the bottom, which feel like they are rolling across the space. All the lines behind the arrows and circles are diagonals which emphasize the movement (notice how the points behind the lowest triangle function as a line). Stability is established by the long horizontal at the bottom and the contrast of the lone rectangle which tilts towards the left creating a tension that keeps all the other shapes from "racing" out of the picture.

Fig. 40

This student chose "Springtime" as a theme:

Notice the selection of a vertical format, the direction we generally associate with growing things. The group of circles seems to have germinated from the smallest point. The circles overlap, creating a sense of movement into space.

It is interesting to see how we tend to make associations out of these abstract shapes. The circles suggest an undulating caterpillar-like form; the configuration at the top left might be some flying creature, but it actually functions as a device that combines elements of the circles on the left with the growthlike rectangles on the right. All the elements express a burgeoning process we can associate with springtime.

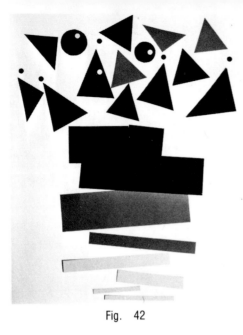

Fig. 42

In this work a student expressed the musical term "Crescendo."

It was accomplished by the student's devising an organic pattern that begins with "quiet," thin, light-toned grays (note that the close values make a "soft" contrast), which gradually progress into thicker, darker rectangles. Finally there is an eruption of "loud" triangles, circles, and points. Note how the white of the paper acts as a background for the rectangles, but at the top the white spaces become active negative shapes, which contribute to the "noisy" crescendo.

"Nightmare" was the concept a student tried to express in this design.

Terror is expressed by rhythmic diagonal patterns of jagged, sharp shapes, which "surround" and "menace" the solitary point.

Fig. 43

Practice these exercises carefully. What you learn from them will form the basics of the visual language which you can apply to drawing, painting, sculpture, and printmaking.

Summary

All artists have different approaches to making visual images. Some begin work with no preconceived idea at all; as the work evolves it seems to take on a life of its own. At some point during that process, the artist discovers or feels a "statement" emerge. From that point on, the artist must compose the visual language to reinforce the statement if the picture is to be effective.

Artists throughout history have given much preliminary thought to content and devoted a great deal of time to studying methods by which their ideas communicate powerfully. That is the procedure recommended in this book.

Review this chapter from time to time. Its lessons are difficult to absorb all at once. Many of them will make more sense and become more important as you proceed with the practical work in the following chapters. Keep what you learn in this chapter in mind as you draw or paint. Have a positive idea of what you want to express, even if it is a very simple one — for example, the gracefulness or angularity of a model; the dramatic contrast of forms in a still life; the rolling sweep of the landscape. Try to make every line, shape, form, texture, value, and color echo that feeling.

Save all your early efforts, even the most humble ones. They will be a basis for measuring progress as your study continues. It is also often beneficial to return to an old idea and try it again, armed with more knowledge and skill.

The fact that you are reading this book indicates that you realize art can enrich your spiritual and visual life. Creative work is one of life's most satisfying activities; it is also hard work. Do not be discouraged by your initial failures. The skills of art can be learned by study, patience, and practice.

FUNDAMENTALS OF DRAWING

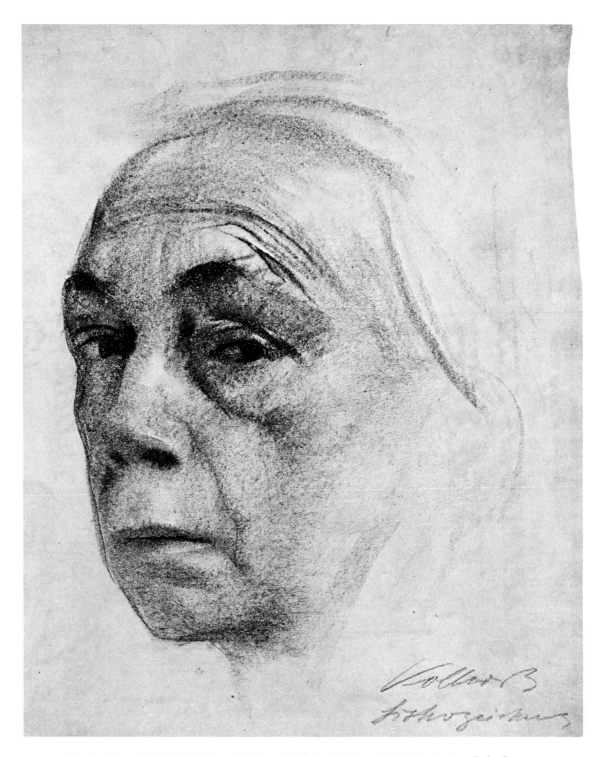

KAETHE KOLLWITZ (1867-1945). ''Self-Portrait.'' National Gallery of Art, Washington, D.C. (Rosenwald Collection)

Chapter II

FUNDAMENTALS OF DRAWING

DRAWING IS FUNDAMENTAL TO PAINTING, sculpture, or printmaking. The mastery of drawing enables you to look at an object and understand in visual terms the relationships of its parts and its relationships to the things around it.

Drawing is a skill that can be learned. The time required to learn it will obviously vary with individual aptitude and the time devoted to practice. Some students can make considerable progress in six months, others may take a year. In a profound sense it will take a lifetime. The great Japanese artist, Katsushika Hokusai exemplified that attitude (Fig.44). But, that is one of the great joys of art: no matter how much you learn, there are always more challenges ahead.

Fig. 44

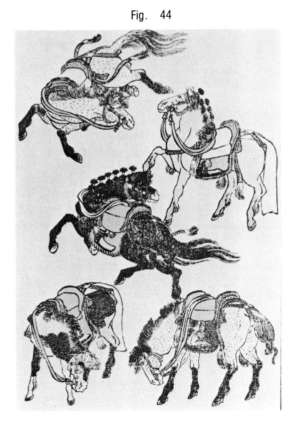

KATSUSHIKA HOKUSAI (1760-1849). Woodcut drawings from his sketchbooks

One of the greatest draftsmen* who ever lived, Hokusai delighted in the visual world and drew everything that he saw—people, landscapes, animals, birds, machines—and even things he did not see, phantasies from his imagination. All of these he translated into the elements of the visual language—lines, shapes and tones—which he imbued with life and energy. His devotion to the study of drawing was expressed in these lines, which he wrote at age seventy-five:

"From the age of six I had a mania for drawing the forms of things. By the time I was fifty I had published an infinity of designs; but all I produced before the age of seventy is not worth taking into account. At seventy-three I learned a little about the real structure of nature, of animals, plants, trees, birds, fishes and insects. In consequence, when I am eighty I shall have made still more progress; at ninety I shall penetrate the mystery of things; at a hundred I shall certainly have reached a marvelous stage; and when I am a hundred and ten everything I do, be it a dot or a line, will be alive....**

*A draftsman is defined as a person skilled in drawing.
**From *The Hokusai Sketchbooks*, James A Michener, published by Charles E. Tuttle Co., Rutland, Vermont, and Tokyo, Japan

Fig. 45

A page from the author's sketchbook

MICHELANGELO (1475-1564). Studies for the "Libyan Sibyl." The Metropolitan Museum of Art, New York (Joseph Pulitzer Bequest)

Fig. 46

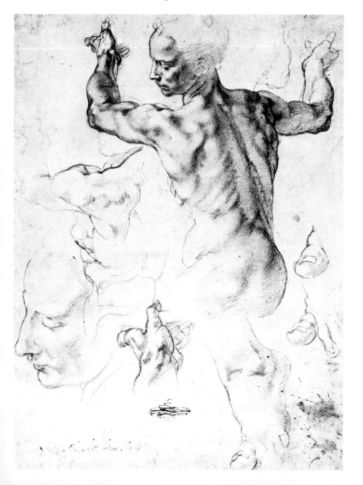

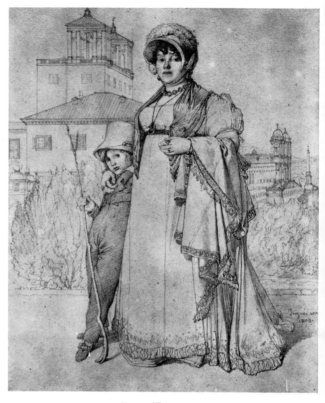

Fig. 47

JEAN AUGUSTE DOMINIQUE INGRES (1780-1867). "Mme. Guillaume Guillon Lethière, With Her Son Lucien." The Metropolitan Museum of Art, New York (The H.O. Havemeyer Collection).

A sketch is a quick graphic impression of something seen or imagined. It may be detailed, but more often is sparse and suggestive (Fig. 45).

A study is a preliminary graphic, in which an artist works out problems for another more comprehensive work. The page of studies by Michelangelo (Fig. 46), demonstrates the thoroughness with which he approached the figures for his Sistine Chapel mural.

A drawing makes a unified artistic statement and is an end in itself (Fig. 47). Ingres's extraordinary pencil drawing exhibits many of the techniques to be analyzed in this chapter: the delineation of form with sensitive line and/or tonal modeling; the rhythmic control of values, textures, shapes, and forms; the use of eye levels for psychological purposes as well as for perspective. Notice that, though the portrait is full of details, the artist has subdued them so that they harmonize with the total effect rather than becoming distractions.

Though drawings are generally thought of as having the *finish* of an Ingres, it is not always the case. Compare the Daumier (Fig. 54), which has few details and looks *sketchy* but is a powerful, complete, unified drawing.

What all the categories have in common is the ability to produce illusions by the mere manipulation of lines and tones, causing us to respond emotionally. That magic is the heart of the art experience.

The exercises that follow have been designed to progress from simple to more complex elements of drawing. You may wish to read the entire chapter to get an overview of the procedure. Then go back to the beginning and work your way through, step by step.

Learning to draw is not unlike learning a musical instrument. The need for practice cannot be overstated. No one can practice for you, and without practice you cannot learn.

Most of us drew joyfully as children, until we reached a competitive age, when "good" drawing began to be defined as the ability to copy accurately. Those of us who could not copy were intimidated by others with a natural facility for it, and we withdrew behind "I can't draw a straight line with a ruler."

Copying, in itself, does not produce art; nor does it necessarily produce good drawings. But copying—understood as the ability to look at an object, understand it, and delineate it with a drawing tool—is a basic skill the artist must master, just as the musician masters complex finger exercises before proceeding to advanced interpretation.

What Is a Drawing?

In fine art, a graphic is generally thought of as an image drawn with pencil, pen and ink, brush and ink, charcoal, crayons, and images made with printmaking techniques, usually in black and white tonalities. The graphic can be either a sketch, a study, or a drawing.

A *sketch* is a quick graphic impression of something seen or imagined. A *study* is a preliminary graphic with which an artist works out problems for another more comprehensive work. A *drawing* is a graphic that is a complete artistic statement in itself.

A study is easily recognized: It is a preparatory image for a painting, print, sculpture, or even a drawing (Fig. 46). The distinction between a sketch and drawing is more subtle. While some drawings may be highly finished, some have the spontaneous and "unfinished" look of sketches. The difference is the artist's intention; the sketch can be thought of as a shorthand technique used to record any visual idea (Fig. 45), while a drawing makes a unified artistic statement (Fig. 47).

Materials

A ream of inexpensive white typing paper
A drawing pad suitable for crayon, charcoal, and watercolor paint, approximately 12 x 18
Pencils: HB, B, and 3B
Penholders and a few thin and thick points
A small bottle of India ink
A box of Conté crayon sticks
Small jars of black and white poster paints
A drawing board or a clipboard
Black felt-tip pens with thin and wide tips
A tracing pad or some onionskin paper (9 x 12)
A sketchbook, about 4 x 6
A No. 3 watercolor brush

Drawing Position

Form the habit of drawing in this position (Fig. 48). Keep your drawing board or

Fig. 48

Fig. 49

clipboard at about a 45° angle. If you do not, and your drawing surface is flat on the table, the figure or object you draw will tend to elongate; the lower parts will become larger and out of proportion (Fig. 49).

Exercise 1
Basic Characteristics

The purpose of this exercise is to teach you to observe and analyze the main features of any object you want to draw.

1. Examine some of the *basic characteristics* of the objects in Figure 50. They are made of different substances: glass, which is shiny; and wood, which is dull. These, however, are surface details—the mug might be made of a dull material and the instrument could be manufactured out of a shiny plastic.

The basic characteristics are independent of such surface details.

2. Squint at the pictures. This will eliminate the details and permit you to see the basic characteristics: the *shape* and *form*. The mug is stable; it is not a dainty cup that is likely to be tipped over easily. Its stability is expressed by a shape that is almost square and a form that is almost cubelike. The stability is reinforced by the fact that its horizontal and vertical axes are parallel to the horizonal and vertical borders of the picture (Fig. 51).

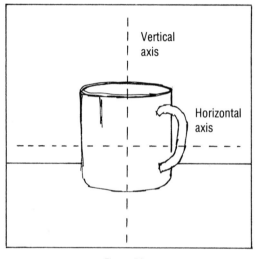

Fig. 51

3. Break a piece of Conte crayon into a 1 inch length; use the flat side to sketch with.

Observe the mug; notice that it is slightly taller than it is wide. Using broad

Fig. 50

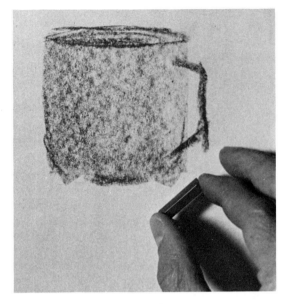

Fig. 52

simple strokes, sketch the basic proportions and shape of the mug (Fig. 52).

4. Now look at the photograph of the recorder (Fig. 50). Its proportions are very slender; its relationship to the picture border is highly active; it creates a strong diagonal thrust into space.

5. Again, use the flat side of the Conté crayon and with a few simple strokes, indicate the slender shape and the diagonal movement (Fig. 53).

Practice Assignment

Study Figure 54 and notice how freely Honoré Daumier captured the *basic characteristics* of his subject. Strive to emulate that freedom.

Go all around your house or apartment and make *basic characteristic* sketches of objects such as a bookcase, a telephone, a couch, a chair, a piano (or any other musical

Fig. 53

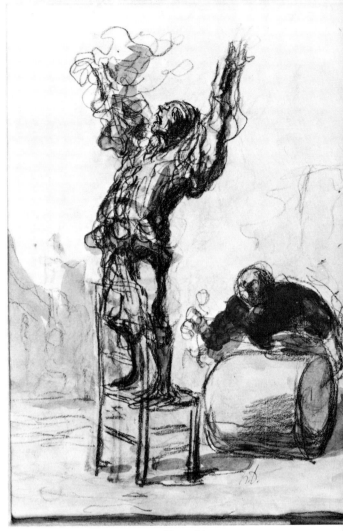

Fig. 54

HONORE DAUMIER (1808-1879). "A Clown." The Metropolitan Museum of Art, New York (Rogers Fund)

In this vibrant drawing, Daumier demonstrates the essence of putting down the *basic characteristics* of forms. He probes the primary rhythms and movements of the performers and props, with lines and tones (visual abstract elements) which subtly express the action.

instrument), a lamp, a hi-fi set, a TV set, a vase and flowers, a coffee pot, a tea pot, a salad bowl, a fork, a spoon, a salt shaker, a table, a toothbrush, a towel hanging on a rack.

Draw quickly. Spend only about three minutes on each item. Squint at it, then indicate the basic shape and movement with a

few simple broad strokes. Sketch freely, as if you were actually stroking the crayon over the object itself (Fig. 55).

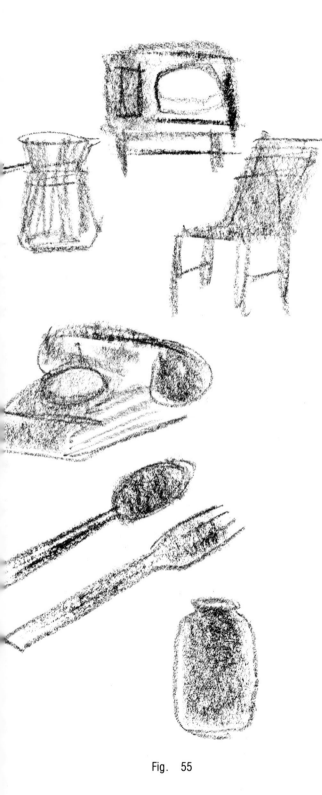

Fig. 55

Sketchbook Assignment

One of the most valuable study aids is a sketchbook. Carry one at all times and sketch at every opportunity: while waiting for a bus or train, and while riding them; on line at the supermarket; even while watching TV.

Sketch everything, including things which do not interest you. For the purposes of study, what you sketch is not as important as how you observe and interpret.

Exercise 2
Basic Characteristics
Continued

In this exercise you will draw the human figure. It is a complex of shapes and forms, capable of an infinite variety of movements and configurations. Yet every pose has one or two dominant characteristics, which you can find by squinting at the figure and disregarding its details.

Refer to the photographs of models in Figure 56. Squint at the figure you are going to draw. Then quickly, with the flat side of a Conté crayon, put down the one or two basic movements of the pose. Keep the crayon moving on the paper as you search out the movement; imagine that the crayon is actually probing all over the figure itself. For the moment, ignore such details as fingers, features, hair, or clothing (Fig. 57).

Practice Assignment

Make at least 25 basic characteristic sketches of figures in action poses.

Sketchbook Assignment

With a wide-point felt-tip pen, make basic characteristic sketches of real people.

Exercise 3
Basic Characteristic Sketches
With More Detail

Having completed Exercises 1 and 2, you will find that your ability to see basic characteristics is improving. Now you can proceed to more detailed aspects of drawing.

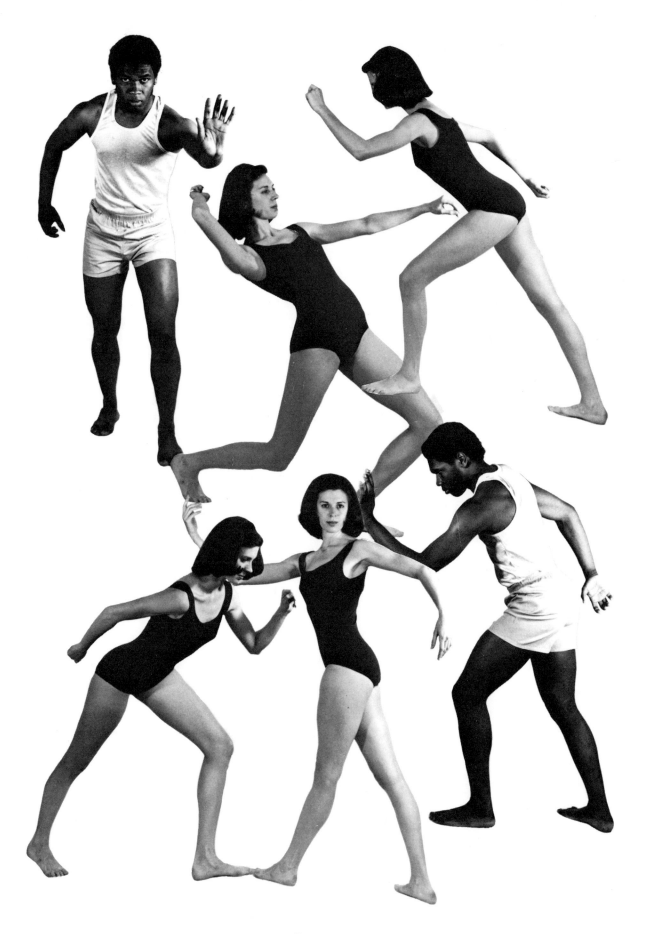

Fig. 56

Fig. 57

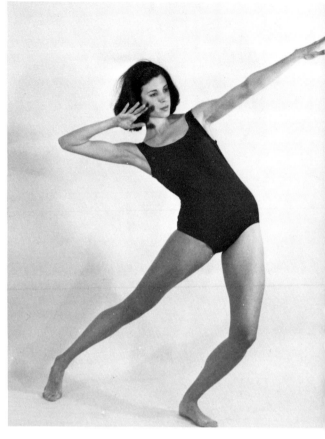

Fig. 58

Fig. 59

Use Figure 58 as a "model."

1. Notice that the basic characteristic of this pose is a dynamic rhythm expressed in curves and diagonal movements. The surface details might be different (the model might be heavier or thinner, her hair might be a lighter shade, she could be wearing another costume), but the *basic characteristic* of this pose—its strong rhythic movement—remains the same.

2. As before, put down the basic movements with a few broad strokes of the flat side of a Conté crayon: the large curve that extends from the head, along the body, all the way to the foot; the curve on the other side of the body, which extends from the bent elbow, along the side of the body to the model's right foot (Fig. 59).

3. Now look at the straight, diagonal movements. One extends from the left armpit to the left hand. It is echoed by a similar diagonal starting at the right elbow and going to the right hand. A third straight-line diagonal movement is created by the right leg.

4. Sketch these movements very simply in broad strokes (Fig. 60).

Fig. 60

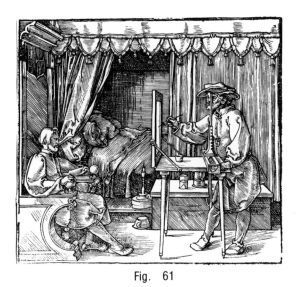

Fig. 61

ALBRECHT DURER (1471-1528). "Artist Drawing a Portrait of a Man." The Metropolitan Museum of Art, New York (Gift of Henry Walters)

Throughout history, artists have experimented with a variety of methods to aid them in drawing. In this woodcut, Dürer depicts an artist using a mechanical device that functions not unlike the grid technique described in this chapter. While such machines and methods can be useful for studying the relationships of objects to one another, artists strive ultimately to develop an "eye," a mental grid, through which they look at things they wish to draw.

Exercise 4
The Use of Grids

A grid is a device which can help you study an object in detail and see its relationships with greater ease. (There are even examples of mechanical grids, as illustrated in Figure 61.)

Ultimately you will develop an "eye," a mental grid through which you look at objects. This exercise will teach you to develop your "eye," so that you will not have to rely upon mechanical aids.

1. Look at Figure 62. The outer borders of the grid, ABCD, are established by drawing horizontal and vertical lines at points that touch the extremities of the model; her left hand and feet.

This has the immediate effect of bringing the negative shapes (the blank spaces around the form) to attention (Fig. 63). Negative shapes will require careful consideration when we take up the study of composition, but for the moment, they will help you to see the figure itself, more clearly.

2. Grid lines within the borders can be drawn arbitrarily as needed. In this example, most were projected from extended points or edges of the body: line I was extended vertically from the right elbow; F was extended vertically from the left toe; etc.

Fig. 62

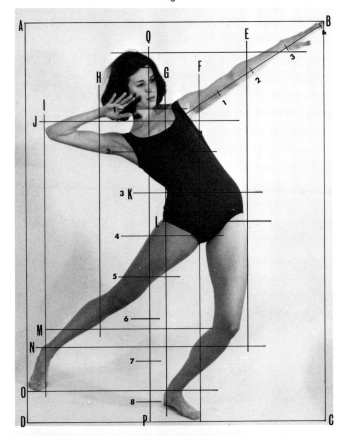

Fig. 63

Go back to the *basic characteristic* sketch you made of this figure and refine it by studying the grid.

Notice where the head, elbows, hands, knees, and feet are, in relation to the large curved and straight rhythms you indicated

on your sketch, and rough them in (Fig. 64).

To carry the study further and establish correct proportions, it is necessary to measure.

Exercise 5
Measurement

This exercise, too, employs a mechanical technique utilized by artists. Like the grid, it can be dispensed with after you develop your "eye."

1. Prop the book up vertically on a table, open to Figure 58.

2. Use your pencil as a measuring device as follows: Hold the pencil vertically, *at arm's length.* It is essential that the pencil be at arm's length each time you measure; inconsistency will cause inaccuracy. It is also important to keep your head (your eye) in the same place each time you measure. If you move it up and down or from side to side as you measure, you will be combining different viewpoints and distances, which will result in inaccuracies.

3. Now "sight" the model's head alongside the pencil so that the tip of the pencil aligns with the top of the model's forehead; then slide the tip of your thumb to a place on the pencil that aligns with the model's chin (Fig. 65).

That unit on your pencil—from the tip of

Fig. 64

Fig. 65

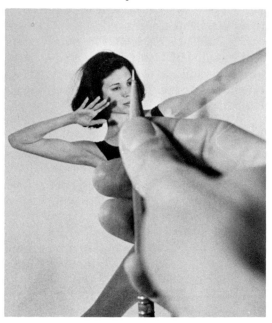

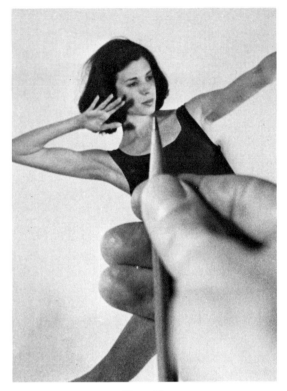

Fig. 66

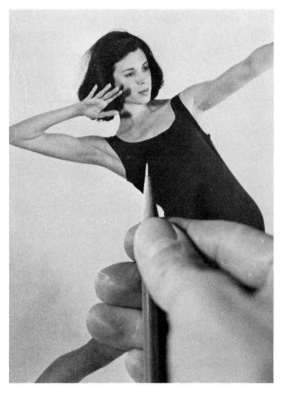

Fig. 67

the pencil to the tip of your thumb—is referred to as one "head-unit." It can be used to measure other parts of the model.

4. Now keep the pencil at arm's length and your thumb tip in the same position on the pencil; place the tip of the pencil point at the chin (the bottom of the first head-unit) and note where your thumb tip aligns. In our example, it is a point which, if extended horizontally, would pass through the model's right armpit, her right breast, and across the mid-point of her left side. This point marks off 2 head-units (Fig. 66).

5. Continue by placing the pencil tip at the bottom of the second head-unit and note where your thumb tip aligns. In this case, it is across the hips (Fig. 67).

6. By continuing down the figure in this manner, you will find that, in this pose, the figure is 8½ head-units in length.

7. Now go back to your Conté crayon sketch of this figure, and with a black, fine-point marking pen establish a vertical line Q-P (Fig. 68) on your drawing and indicate 1 head-unit on it.

The size of the unit you use on the paper is arbitrary—¼ inch, ½ inch, etc. It has no

relationship to the actual size of the model's head or the size of the space between the tip of the pencil and the tip of your thumb. The arbitrary unit you use on the paper is like the system used on maps (1 inch equals 1 mile,

Fig. 68

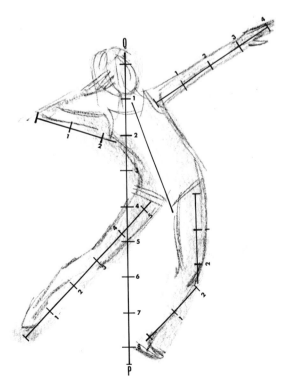

for example); in this drawing system, 1 arbitrary unit on the paper "equals" 1 head-unit measured on the model (Fig. 69).

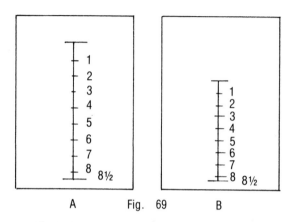

A Fig. 69 B

The size of the head-unit you use on the paper depends upon how large you wish the drawing of the model to be in relation to the picture. In Figure 69, an identical picture area is established within which alternative dimensions may be occupied by the drawing of the model. The larger units in A will create a drawing that is almost the total height of the picture area; in B, the smaller units will create a smaller drawing in relation to the picture area. However, both drawings will be in the exact relationship to the proportions of the model—8½ head-units.

8. Mark off 8½ head-units on line Q-P on your drawing. You can now locate and measure any other form on the figure.

9. Plotting the left arm, the armpit, just where it leaves the costume, is 1 head-unit to the right of the chin and slightly below it; mark it on your drawing. The tips of the fingers of the left hand fall on a horizontal line which is 1 head-unit above the forehead and 4 head-units from the armpit; mark that spot on your drawing.

10. Plot the major forms of the remainder of the body in the manner described (Fig. 68).

Exercise 6
Mental Grid Lines and
Measurements Continued

The previous exercises are very important. Though they produce studies that look somewhat diagrammatic, they will teach you to *observe* and *think*, instead of just sketching aimlessly.

When your work shows that you are learning to sketch basic characteristics and to measure accurately, you can apply those skills in a more direct way, which will make your work look more like a drawing than a diagram.

1. Look at a large object in your room—a chair, table, or some other piece of furniture.

2. Use your pencil as both a measuring instrument and as a grid line, in this manner: Hold the pencil vertically in front of you, making sure that it is at arm's length. Move it vertically from left to right, slowly. Stop whenever the "vertical" touches or intersects significant points of the chair (Fig. 70).

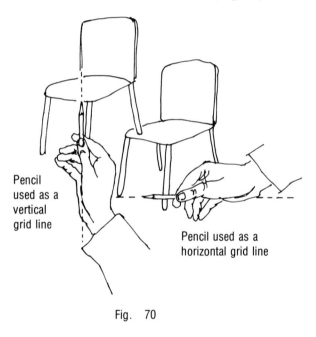

Pencil used as a vertical grid line

Pencil used as a horizontal grid line

Fig. 70

3. Make mental notes, such as: A vertical line from the top left corner of the chair passes near the center of the seat and falls a little to the left of the right front leg.

Begin sketching the chair roughly, without actually putting grid lines on your paper. But keep in mind as you draw, the relationships you discover, by *using the pencil as a grid line*.

4. Use the same method for horizontal relationships. Hold the pencil (at arm's length) horizontally and move it up and down. Make mental notes of points on the chair that line up horizontally.

5. Next, refine the drawing by using the pencil as a measuring tool. Select a small unit on the object (in this case, the rear leg) and measure it by holding the pencil out at arms length, aligning its tip with the top of the chair leg, and moving your thumb so that it aligns with the bottom of the chair leg. Now you have a "leg-unit" for measuring anything else on the chair (Fig. 71).

6. Continue measuring until you have accurately established the proportions of the main features of the object.

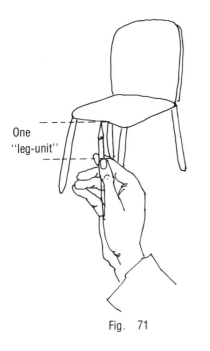

One "leg-unit"

Fig. 71

Exercise 7
Practicing the Use of Grid Lines and Measurement

When experienced artists are copying, they are either consciously or unconsciously using a grid and measuring system. To gain that facility, in addition to the above exercises, practice the following:

1. Take five magazine pictures of complicated objects, figures, or scenes that look as if they would be difficult to copy.

2. Tape a piece of tracing paper or onionskin paper over each, and draw grid lines on the paper. Study each carefully.

Make mental notes; actually say to yourself, "This vertical line passes through X, touches the edge of Y, and falls a little to the right of Z." Do the same with horizontals.

3. Then select some part of the object or scene that would serve as a convenient measuring unit, and use it to measure all the main features of the object or scene.

Keep practicing until seeing relationships and measuring becomes a habit. It is even possible to practice this during spare moments, without pencil and paper. Look at any object or person and *visualize* verticals and horizontals. Then actually articulate information to yourself: "A horizontal line beginning at that woman's left elbow would pass through her hip and touch her right hand."

Select some unit of measurement on an object and *mentally* use it as a measuring device: "That car is 3 door-width-units long."

Sketchbook Assignment

Make some quick *basic characteristic* sketches, then draw two or three vertical and horizontal grids, which will aid you to accurately place the parts of the object. Select a small part of the object, which can be used as a unit of measurement.

Exercise 8
Light and Shade

If you practiced the preceding exercises sufficiently, you should have improved your ability to sketch the *basic characteristics* of any object and to measure its parts accurately. In this section, you will learn how to look still closer at an object in order to study and render its *form*, its feeling of three-dimensionality.

Despite some modern trends towards flatness in art, form is a traditional element, which gives power and life to images. Pictures that do not have form may be very beautiful, as are some fabric designs and wallpaper, but like paper and cloth designs they may not go beyond being handsome decoration. Thus, whatever mode you eventually choose to work in, you should develop

a sensitivity to form and learn how to render it.

1. Place a simple geometric form—a ball or box—on a table, so that it is illuminated from one source, a lamp or window (Fig. 72).

Fig. 72

2. Look at the object. Our presumptions about its three-dimensionality come as much from our knowledge about it, as from our perception of it. That is, our previous experience with objects—that their tops, sides, and bottoms indicate weight and volume—causes us to experience a sense of weight and volume when we look at pictures of objects. This sense of weight and volume is emphasized when the object is illuminated in such a way that its top or bottom and sides are clearly differentiated.

Our ability to interpret images in this way is what permits us to comprehend drawings and paintings, photographs, movies, and TV pictures.

Exercise 9
Creating the Illusion of Form

A traditional way to create the illusion of form in a drawing is to simulate the tones you see on the object.

1. Outline a rectangle on your paper 1 inch high and 6 inches long. With a 3B pencil, start on the left side of the rectangle and fill it in with tones. Begin with very dark tones (made by pressing hard on the pencil).

As you move across to the right, put less pressure on the pencil so the tones get lighter (Fig. 73).

Fig. 73

2. On a water color pad outline a rectangle 2 inches high and 10 inches long. Begin filling in the rectangle on the left side with black poster paint. As you move across to the right, add white paint (mix the tones of black and white paint in an old jar lid, thin the mixture with water if necessary), so that the tones get grayer and lighter. By the time you reach the right side of the rectangle, the tones should be completely white (Fig. 74).

Fig. 74

In both of the above procedures, using pencil and paints, you have created actual tones, that is, tones which really are black or gray. With the next technique, you will learn to simulate tones, using only black.

3. Outline a rectangle on your watercolor pad, ½ x 6 inches. This time, using a thin penpoint and black India ink, begin filling in the rectangle with widely spaced lines (Fig. 75A).

Next, starting at the left, draw another set of lines at a different angle than the first, but do not go all the way across to the right (Fig. 75B).

Go back to the left side again; add still more lines at another angle placing them closer together. This time, stop when you are about three-quarters across the rectangle.

Again, go back to the left side and add more lines at another angle and closer together, stopping about halfway across. Keep repeating the process. When you are fin-

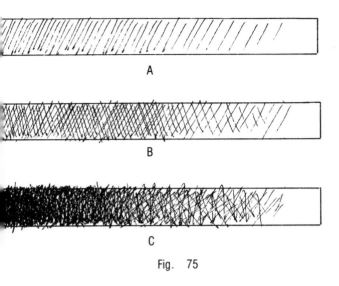

Fig. 75

ished, the rectangle should look like Figure 75C.

It is a very old and fascinating graphic technique, called *cross-hatching*. It makes use of the fact that the eye "mixes" the black lines and the white of the paper to create an impression of grays. There are an infinite number of variations on it—dots and textures—which can be used to build these simulated tones (Fig. 76).

Fig. 76

Exercise 10
Modeling

Now we will return to the illuminated object in Figure 72, and draw its tones using the above techniques. Using tones to give a drawn object a feeling of form and dimension is called *modeling*.

To achieve a strong feeling of form, model objects with at least four tonal values (refer to the value scale on page 17).

In our example, which is lit from the top left, the top of the box is off-white (approximately No. 2 on the value scale); the left side of the box is a light gray (about No. 3 on the scale); the side of the box closest to us is a darker gray (about No. 5 on the scale); and the shadow areas on the table are composed of dark grays and black (Nos. 8 through 10 on

the scale). Notice that the darkest shadow area is right next to the box; the parts of the shadow which are further from the box are more diffused and lighter.

All objects can be rendered in this basic manner to achieve an illusion of form, weight, and space. But it is not always necessary or desirable to use the particular combination of values described above. For example, a soft, *high-key* effect can be obtained by using four light tones on the value scale: Nos. 2,3,4,6 (Fig. 77A).

Or a heavy, *low-key* effect can be obtained by modeling with tones from the dark side of the value scale: Nos. 4,6,8,10 (Fig. 77B).

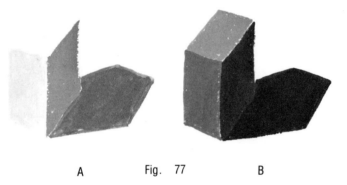

A Fig. 77 B

Practice Assignment

1. Take some household items: a cup, a hairbrush, a rectangular box. Place them on a table and illuminate them from one side.

2. Study the light and shade effects on the object. Then make some value sketches of each, using different techniques. Do the cup in pencil, the brush with white and black paint, and the box with pen-and-ink cross-hatching.

Exercise 11
Outline Drawing

This section will teach you how line alone can describe both shape and form. In these exercises, it is important that you use real objects so that you will learn how to analyze and interpret line (in this instance, working from photographs or reproductions would defeat the learning process).

1. Start with a simple object, a towel on a

table top. Concentrate on the edges only. Pick a spot on the edge, the top right-hand corner, for example. Place your pencil point on your paper, and think of that spot as if it were actually the edge of the towel itself.

2. Keep your pencil on the paper, but *do not* look at it; look only at the edge of the towel. As you begin to draw, try to feel as if you were actually moving the pencil point along the edge of the towel itself.

3. Draw very slowly. Concentrate, and observe the edge of the towel keenly; be aware of the slight changes of direction the line takes. Keep moving the pencil slowly; do not look at the paper, and do not lift the pencil from the paper unless you feel absolutely lost. In that case, take a quick look at the drawing, orient the pencil, and continue.

This exercise should take *at least 20 minutes*—the longer the better. The purpose is to train your concentration and observation, and to coordinate your hand and eye (Fig. 78).

Now examine the finished drawing. Distortion and mistakes in proportion are usually caused by moving the pencil faster or slower than you are moving your eye around the form. Practice will improve your coordination and result in more accurate drawings.

4. Next, make an outline drawing of a more complicated form, perhaps a living-room lamp.

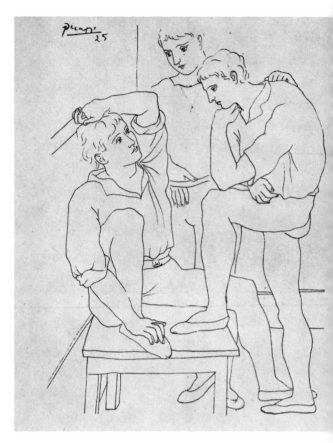

Fig. 79

PABLO PICASSO (1881-1973). "Three Dancers Resting." (Collection Mr. Paul Rosenberg)

Despite some "flaws" in its details—the awkward placement of the central figure's feet and the clumsy delineation of his hands; the anatomical distortion of the arm of the dancer on the right—this drawing is a superb example of what can be accomplished with outline. The consistent rhythm and weight of the line gives the image a basic unity. It is simple, yet it suggests the softness of the shirts and the firmness of the muscular limbs; it articulates shapes, space, and forms as if they were fully modeled with light and shade, allowing us to feel the weight of the figures and the three-dimensional field they occupy. Its gracefulness even evokes the dance itself.

5. Now find something even more complex to draw in outline—a statuette of a human figure or an animal, or some elaborate piece of furniture.

Remember, as you practice drawing outlines, keep your eye on the edge of the form, draw very slowly, and try to imagine that the pencil is on the edge of the form and not on

Fig. 78

the paper. Try to move your eye and pencil at the same rate of speed.

As you improve, draw faster and look at the paper. Strive to develop a rhythmic line as in Figure 79.

Exercise 12
Suggesting Form with Outlines

In Exercise 10, you learned how to model form with different values of light and dark. In this exercise you will learn how to suggest form by using only line.

In Figure 80, A is a tonal drawing of a

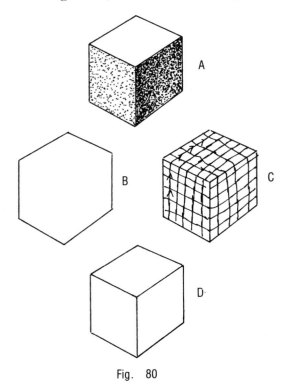

Fig. 80

cube and B is an outline drawing of the same cube. However, notice that merely drawing the outer edges results in a flat, two-dimensional shape. In C lines have been drawn "across" the sides and top of the cube. In D a minimum number of these "inner contour" lines have been drawn—enough to describe the top and sides of the cube; these enable it to be "read" as a three-dimensional form.

Now let us try this with an actual object.

1. Place a banana on the table and illuminate it from one side (Fig. 81).

Fig. 81

2. Draw the outline (Fig. 82).

Generally, just drawing the outline of an object will make it look flat.

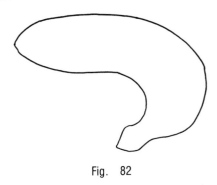

Fig. 82

3. To draw the banana in line successfully, observe how the different values of light on its sides and top planes indicate its form. To get a real sense of the forms, draw lines A-B, C-D, E-F, and G-H on your drawing, as indicated in Figure 83. As you draw

Fig. 83

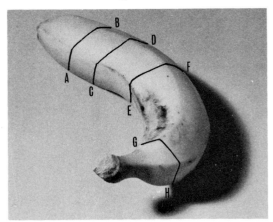

these lines, imagine that the point of the pencil is actually on the banana itself, moving up the side plane from point A, across the top plane, and down the other side to point B.

Doing this will give you a tactile sense of the form, as if you ran your finger over it with your eyes closed. However, the resulting "drawing" is merely diagrammatic—the lines map out the form, but they do not express it pictorially.

4. To achieve pictorial form with line, begin another outline drawing of the banana. But this time, as you slowly draw one edge, look across its form (up the side, across the top plane, and down the other side), and as you sense the form between the outer edges, immediately draw the opposite edge (Fig. 84).

Fig. 84

As you draw the lines and sense the form between them, make parts of the lines a little thicker and darker, where you feel the weight of the form "pushing" against the outline. Complete the drawing in this manner (Fig. 85).

Fig. 85

5. Compare this drawing to the first one and you will find that it is not quite as flat, not as mechanical. The reason for this is that the irregularities of the line—its thicks and thins ("darks" and "lights" in a sense)—stimulate the eye, which stops and starts as it moves around the line, instead of running quickly around it, as it does when the line is too even and mechanical. The thicks and thins, the darks and lights of the line, also create *ten-*

sions, which suggest form. Some of the darker sections of the line even suggest shadows cast by forms within the outlines.

These are subtleties and nuances of drawing to which you will become sensitive through practice, and by studying the drawings of the masters.

6. Returning to your drawing, the illusion of form thus far achieved can be carried further by selecting lines that describe the planes and surfaces within the form: E-F, G-H, and I-J (Fig. 86).

Fig. 86

When drawing these lines, imagine, as you did when drawing the outer edges, that the pencil point is on the line you are drawing; feel the weight of the form that is created at the point where the edges of the planes meet.

Practice Assignment

Look at the outline drawings you made in Exercise 11, and improve their sense of form by reworking the outlines, and by drawing lines that suggest planes and surfaces within the object.

Study the use of line in Figures 87 and 88.

Sketchbook Assignment

Sketch some objects, using only outlines and inner lines that suggest three dimensions. This assignment can also be practiced mentally, when you don't have your sketchbook. Look at an object and draw its outlines *in your mind* (as if you were drawing while not looking at the paper). Then study the planes and surfaces, and find a place to draw inner lines that would describe them.

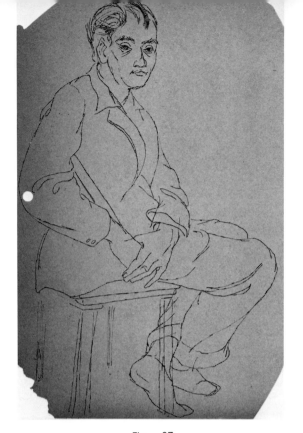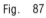

Twenty-minute outline drawing from the author's sketchbooks.

The outline drawing exercises described in the text are intended to train your ability to observe, your concentration, your coordination, and to develop your sensitivity to methods of describing form with line.

 Select a point on the model, the top of the head, for example; place your pencil point on the paper, where you wish the head to be. Then, *without looking at the paper,* study the outline of the form and try to feel as if the pencil were on the model instead of the paper. Begin to move your eye down and around the head—very slowly—and move the pencil at the same rate of speed.

Fig. 87

Student outline drawings

Fig. 88

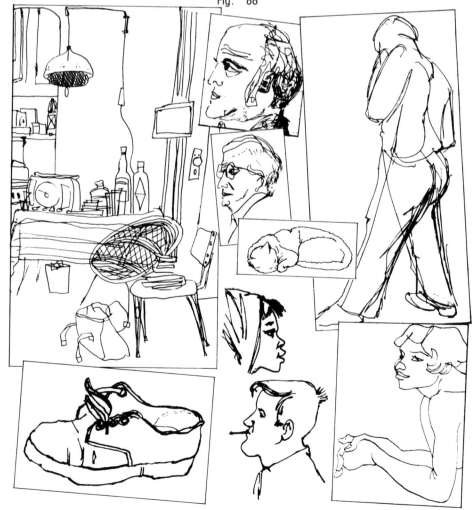

Exercise 13
Line and Tone Combinations

Form can be created with combinations of line and tone. It is a technique favored by many artists.

1. Use a simple object, a box or small statuette, and illuminate it from one side. Make an outline drawing of it, including inner contour lines, which define the surfaces and planes. Draw the lines lightly in pencil on watercolor paper.

2. Mix some India ink and water (you can use the jar lid as a mixing tray) until it is a medium shade of gray, about a No. 3 value (see value scale, page 17). With a large brush, wash the tone across the whole drawing (Fig. 89A).

3. Mix a darker tone, about No. 5 value.

When the first tone is dry, paint the darker tone over the side of the box that is in the shadow (Fig. 89B).

4. Mix a darker tone, No. 7 value, and use it to paint in the shadow cast by the box (Fig. 89C).

5. Now, with a pen and black ink, work back into the outlines. Where the form and shapes are clearly expressed by the tonal values (the close side and the cast shadow), you will not need any lines. But where the tones of the background, table, and the object are similar, use a line to separate and delineate them. If necessary, add some cross-hatching (Fig. 89D).

The drawing is now rather complex; it describes form with line, tone and texture (the cross-hatching).

Fig. 89

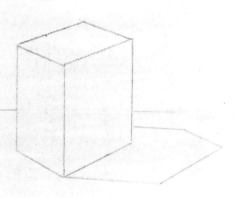

A

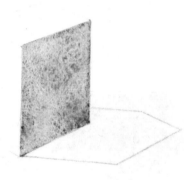

B

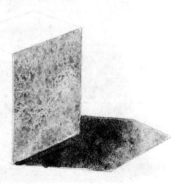

C

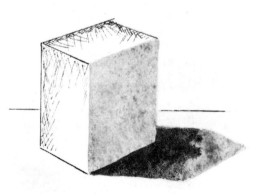

D

Practice Assignment

Study Figures 90, 91, and 92; notice the variety of ways in which different artists describe form and space. Seurat works only with tone; no lines are used at all. The Greek artist relies completely on a sensitive line, which articulates all the nuances of the forms. Rouault uses a combination of tone, line, and texture.

GEORGES SEURAT (1859-1891). "Portrait of Edmond-François Aman-Jean." Metropolitan Museum of Art, New York (Bequest of Stephen C. Clark)

Fig. 90

Fig. 91

UNKNOWN GREEK ARTIST (ca. 490 B.C.). Red-figured Amphora: Lyre Player. Metropolitan Museum of Art, New York (Fletcher Fund)

GEORGES ROUAULT (1871-1958). "Head." Metropolitan Museum of Art, New York (Bequest of Miss Adelaide Milton de Groot)

Fig. 92

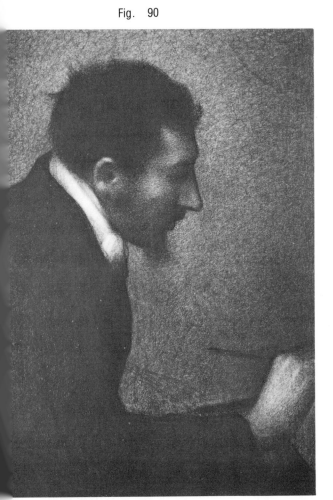

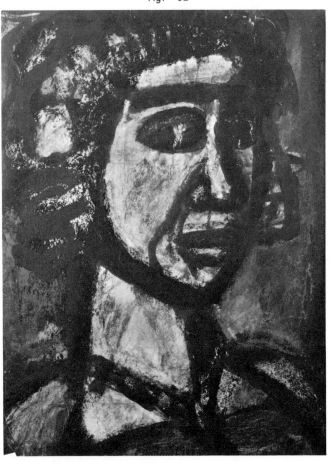

Sketchbook Assignment

Using pencil or pen and ink and wash tones, make several drawings of objects, emphasizing their form.

Exercise 14
Drawing from Memory

This is an excellent exercise for learning to copy accurately. Drawing from memory forces you to study the object you want to draw very carefully. Use an HB pencil in sketching and drawing.

1. Select a simple household object that you have not drawn before. (Drawing something you are familiar with defeats the purpose of this exercise.)

2. Look at the object for five minutes; make mental notes about it, as if you were drawing it in your head.

3. Turn your chair around, so that you cannot see the object (and will not be tempted to peek at it).

4. Sketching very freely, make a *basic characteristic* sketch of the object, from memory. Just work for the main shapes, proportions, and movement; ignore the details.

5. When you have carried the drawing as far as possible, turn back to the object for comparison. Analyze the reasons for inaccuracies and write them down. For example: "The proportions would have been better if I had made a mental note that the height of the object was twice the width"; or "A mental grid would have helped me remember that part X at the top of the object is directly over part Y at the bottom." (This kind of analysis will help you improve your drawing, even when you are working directly from an object.)

6. Select another unfamiliar object and make another memory drawing; concentrate on the points that needed improvement the first time. Again, compare the sketch to the object and make notes about faults that need more attention.

7. Continue making memory drawings. After five or six, you will see a definite improvement.

8. Go back to the first object you tried to draw from memory; study it again. This time, take about eight minutes, and try to remember some details. Turn away from it and make a more detailed memory drawing in line, with tonal modeling.

9. After completing the drawing, repeat the process of comparing it to the object and analyzing any problems.

Practice Exercise

It has been said, we draw what we know, not what we see. To prove this, think of someone's face—a parent, a sibling, a spouse, or even your own! Draw it from memory. You will probably find that, while you have seen the face—perhaps every day—for many years, you cannot recall such details as the slant of the eyebrows; the space between them; the specific curve of the eyes; just how close or far apart they are set; the length and width of the nose; the height of the forehead; the amount of space between the end of the nose and the beginning of the lips; the width of the lips in relationship to the nose and eyes. These images, or most of them, are as dim in your memory as if you had only seen the face once instead of often.

This realization will impress upon you the need to continually sharpen your observation and make it a habit, which will improve your drawing ability.

Sketchbook Assignment

The importance of memory drawing cannot be overstated. It should be practiced as a permanent exercise. Do several such drawings in your sketchbook every week.

Exercise 15
Drawing from Imagination

William Blake's "The Great Red Dragon and the Woman Clothed with the Sun" (Fig. 93) is a fascinating work by an artist who created images primarily from his imagination. Drawing from the "mind's-eye" rather than just copying what the eyes see helps to train your ability to draw from memory and to stimulate creative thinking. Like other drawing skills, working from the imagination is a skill that can be practiced.

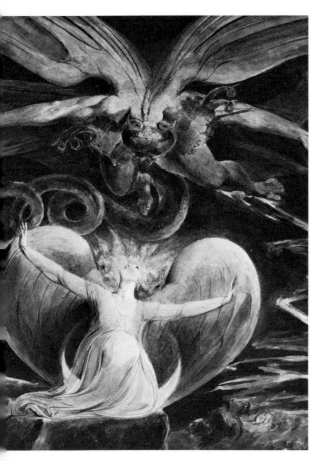

Fig. 93

WILLIAM BLAKE (1757-1827). "The Great Red Dragon and the Woman Clothed with the Sun." National Gallery of Art, Washington, D.C. (Rosenwald Collection)

1. Close your eyes for a moment and think of some familiar object, something you use every day (a cup or your shoe, for example).

2. Visualize it for a few moments, then think about its basic characteristics, as you would if you were going to draw it from memory.

3. Now, do *not* think about copying it; think of some way in which you can change it. For example, you can change its usual context or add something unusual to it.

If it is a cup, instead of thinking of cup and saucer, imagine something totally unrelated to it, perhaps a tree growing out of the cup. If you are thinking about the shoe, think of something unusual that could be in the shoe, such as a flower or animal. Or think of

some unlikely place in which the shoe might be. Let your imagination roam; fantasize about the object.

Make at least one change and sketch it immediately. Do not fuss with details. The important thing is to go through the mental process and the practice of letting your imagination work.

Like memory drawing, drawing from the imagination should be a permanent part of your study plan. Even if you eventually intend to do only realistic pictures from nature, practicing the imagination exercises will help you approach realistic subject matter more creatively.

Sketchbook Assignment

Imagination drawings are another good sketchbook exercise, which can be practiced in spare moments. Here are some approaches: Look at an object and try to draw it, using only straight, parallel lines; look at a cup or mug, and animate it by giving it features (for example, the handle easily suggests an ear). Figure 94 shows some sketches done from imagination.

Student imagination sketches

Fig. 94

Perspective

Perspective is a system for drawing objects in space, as they appear to the eye.

The techniques of perspective, like those of grids and measuring, are mechanical. After you have mastered them and trained your "eye," they can be used somewhat more freely and creatively.

The appearance of an object changes, depending upon how near or far it is; and whether it is below, on, or above the *eye level*. The eye level is the height from which the viewer sees an object or scene; it is sometimes called the horizon line (Fig. 95).

Fig. 95

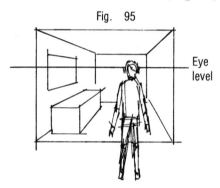

Eye level

For example, when several cubes that we know to be the same size are seen at different distances and heights, their appearances will be affected by several factors (Fig. 96).

If the cubes are on the eye level (A, B, C), we see neither their tops nor their bottoms. We do see the top of the cube that is below the eye level (D); and the bottom of the cube that is above the eye level (E). In addition, as the cubes recede, they appear smaller and less distinct. The application of the fundamentals of perspective helps to make pictures and the objects in them more realistic.

Many students balk at studying perspective. It seems too rigid and mathematical. While perspective does involve mechanical procedures, the principles must be used, consciously or unconsciously, to draw anything convincingly. Therefore, do not be tempted to skip or skim this section. Draw the figures step-by-step; you will learn much more from them, and they will not seem as confusing as they might if you just read the descriptions.

Fig. 96

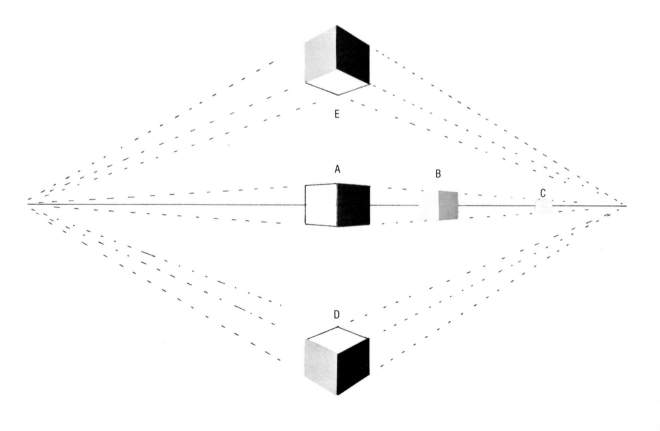

Exercise 16
One-Point Perspective

The controlling elements in correctly drawing objects and pictures in perspective are the eye level and the *vanishing points*. A vanishing point is that point on the eye level (horizon line) towards which lines representing actual parallels seem to converge. For example, you have probably noticed, when looking down a straight stretch of road or railroad tracks, that the sides of the road or the tracks appear to meet in the far distance, even though you know they are parallel.

Let us begin by applying this principle to drawing a room in one-point perspective.

1. Draw the outer borders of the room. The sides will be vertical parallels at right (90°) angles—that is, perpendicular—to the ground. The ceiling and floor will be horizontals, perpendicular to the walls (Fig. 97).

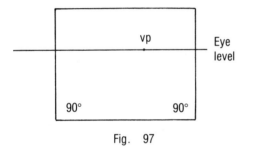

Fig. 97

2. Draw the eye level parallel to the floor and ceiling. The eye level may be drawn at any height in the room; the place you decide to draw it determines the "view." A high eye level, for example, creates a view of the room as you would see it if you stood on a chair or ladder. A slightly above-center eye level offers an average view, as if you were standing in the room. A low eye level shows the room as it would look if you were kneeling or lying on the floor.

3. Place a vanishing point anywhere on the eye level; this too is an arbitrary decision, which indicates the exact spot directly in front of which you (or the viewer) may be standing. It also establishes the point to which the sides and tops of anything within the room, whose front is parallel to the borders of the room, will converge.

To facilitate drawing lines to a vanishing

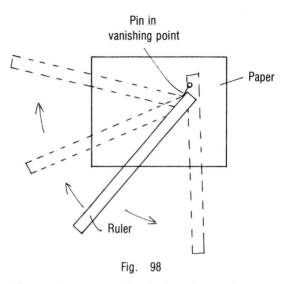

Fig. 98

When making a perspective drawing that requires many projections to a vanishing point, a convenient method is to stick a pin in the vanishing point and pivot your ruler on the pin to any point from which you are projecting.

point, stick a pin at the point as shown in Figure 98.

4. Establish the walls, floor, and ceiling as follows (Fig. 99): Project lines from each corner to the vanishing point (A-vp, B-vp, C-vp, and D-vp).

The right-hand wall can now be established by drawing a vertical line upward from any point along D-vp and parallel to DB, until it intersects line B-vp at E.

5. Project a horizontal line from E until it intersects line A-vp at G and a horizontal line from F until it intersects line C-vp at H.

Line EG represents the meeting of the ceiling and rear wall; FH represents the meeting of the floor and rear wall.

Finally, draw line GH, which represents

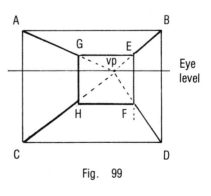

Fig. 99

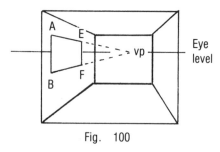

Fig. 100

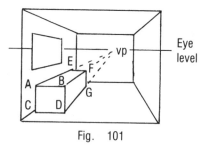

Fig. 101

the meeting of the left and rear walls.

6. To draw a window in the left wall (Fig. 100): Draw the near side, AB, and project lines from its top and bottom to vp. Complete the far side of the window by projecting a vertical from the top to the bottom, EF.

7. To draw a table in the room, first draw the nearest side, (ABCD in Fig. 101) parallel to the plane of the front of the room—the picture plane. Remember, in one-point perspective, the near side of any object is shown frontally (parallel to the picture plane.)

8. Project lines from its top and sides (A,B, and D) to vp and sketch in the far ends of the table's side and top. The edge of the right side, FG, is parallel to the walls; the far edge of the top, EF, is parallel to the floor and ceiling.

Salvador Dali's "The Sacrament of the Last Supper" (Fig. 102) is an interesting contemporary use of one-point perspective.

SALVADOR DALI (1904-)."The Sacrament of the Last Supper." National Gallery of Art, Washington, D.C. (Chester Dale Collection)

One-point perspective tends to produce rigid compositions, because objects must be shown frontally; but it can be effective for expressing austere and reverent subject matter. In this work, Dali reinforces the mystical nature of the painting by placing the vanishing point in Christ's face (itself in the exact center of the picture). Notice how the sides of the table and the folds of the tablecloth project to that point.

Fig. 102

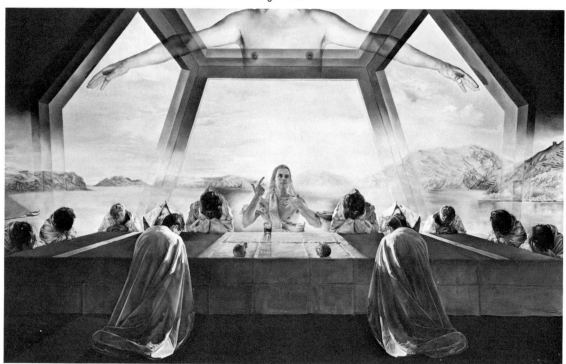

Exercise 17
Using Several Vanishing Points

To draw the table at an angle to the picture plane (Fig. 103):

1. Sketch the table in the approximate position you wish it to occupy in the room.

2. Then refine it according to the rules of perspective: Draw the nearest corner (BD) parallel to the walls. (Despite the fact that we are going to turn the object in space, its verticals are still parallel to the walls.)

3. Place vanishing points 2 and 3 on the eye level. Their placement is somewhat arbitrary. A general rule is: The vanishing point for the short side of the object (vp 2.) should be at least twice the length of the object away from the object, and the vanishing point for the long side of the object (vp 3.) should be at least three object lengths away from the object. (If the points are too close to the object or too far from it, distortion occurs.)

4. Now you can correct your rough sketch by projecting lines from B and D to vp 2 and from B and D to vp 3.

If you were drawing an actual object, you could determine the lengths of the sides by using your pencil as a grid and by establishing a unit of measurement. For the purposes of our constructed drawing, just use your "eye" and find reasonable proportions. Draw line AC parallel to BD and line FE, parallel to BD.

5. Project lines A-vp 3. and F-vp 2. The point at which they intersect will determine the far end of the table.

Tilting an Object
in Space

You must learn about one more possible position for the table—with none of its sides parallel to the room (Fig. 104). (Remember, in the last exercise, even though the table was turned in space, its verticals, BD, AC and FE, were parallel to the sides of the room and picture.)

Suppose someone lifts the table from the back end so that only corner D touches the floor and none of the sides are parallel to the room. The vanishing points will have to be relocated:

1. Make a rough sketch of the table in the approximate position described above.

2. Draw BD (notice, it is *not* parallel to the room).

3. Project a line from B, along your sketch line BF. At a place on that projection (at least three lengths of the table), mark vanishing point X.

4. Project a line from B, along your sketch line BA. At a place on that projection (at least three lengths of the table), mark vanishing point Y.

5. Project line BD below the picture. At a place on that projection (at least four or five lengths of the table) mark vanishing point Z. (Note, if any of the vanishing points is too close to the object, it will look distorted; if any is too far, the object will look too flat.)

6. Now you can complete the sides and top of the table by projecting FE-vpZ; AC-vpZ; DC-vpY, DE-vpX, AG-vpX and FG-vpY.

Fig. 103

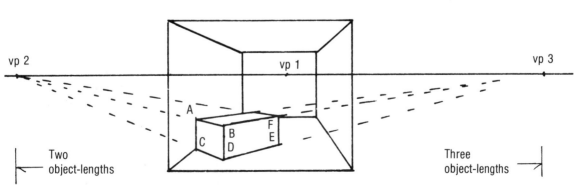

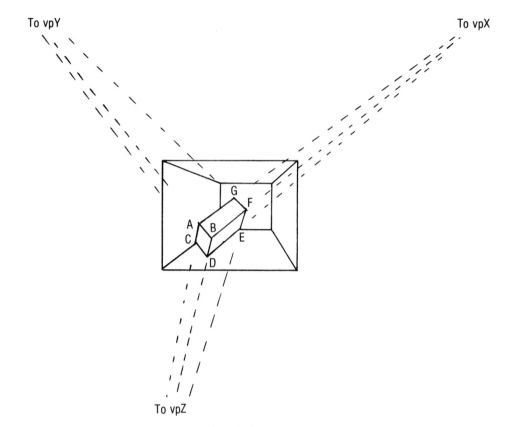

Fig. 104

Exercise 18
Methods of Dividing
Spaces in Perspective

Diagonals drawn from the corners of a rectangle or square intersect at the center. The same is true when a rectangle is drawn in perspective (Fig. 105). The diagonals are useful for determining other divisions—for example, to divide a rectangle, which is

Fig. 105

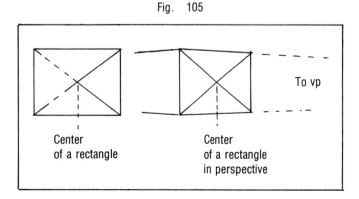

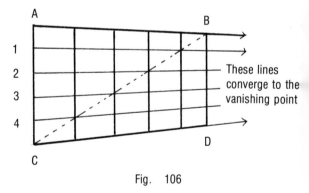

Fig. 106

drawn in perspective, into any given number of equal divisions.

1. ABCD is a rectangle drawn in perspective (Fig. 106) that is to be divided into five equal *vertical* parts in perspective. First divide line AC into five equal parts and project lines from those points to the vanishing point of the rectangle.

2. Draw the diagonal CB.

3. Draw vertical lines parallel to AC

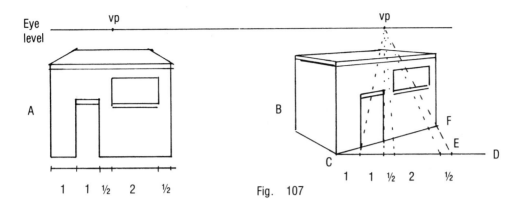

Fig. 107

through the points where diagonal CB intersects projections 1, 2, 3, and 4. The resulting five vertical divisions are in correct perspective proportions.

A similar method can locate *unequal* divisions in perspective. In Figure 107, A shows the front of a building with a door and a window. To draw the building in perspective (B) and locate the correct position of the door and window, follow these steps:

1. Sketch the building in perspective and then draw the horizontal line CD from the base of the near corner of the building, at a right angle to that corner.

2. Measure the door, the window, and the spaces between them, using the door width in A as 1 unit. The space between the door and the left-hand wall is the same width, 1 door-unit; there is ½-unit space between the door and the window; the window is 2 units wide.

3. Transfer these measurements to line CD in B.

4. Project a line from the last measurement (E) through the base of the right corner (F) to the eye level. The point at which they intersect establishes an arbitrary vanishing point (vp).

5. Project lines from all the measurement points on line CD to vp. The points at

which they intersect line CF establish the positions (in perspective) for the door and the window.

Suppose you wish to draw in perspective objects that are set up or located at equal distances from one another such as telephone poles, the rungs of a ladder, the cars of a train, a fence post, or a checkerboard pattern (Fig. 108).

1. Draw the closest vertical item, AB.

2. Project lines from its top and bottom to a vanishing point on the eye level (A-vp, B-vp).

3. Draw a line from the center of AB to the vanishing point (do not confuse it with the eye level, its purpose is to determine the centers of subsequent verticals).

4. Arbitrarily place the second item, CD, parallel to AB. (If you were drawing an actual group of objects—bricks, telephone poles, etc.—you could determine the exact spot for the second item by using your pencil as a grid and measuring tool.)

5. Now the size and positions of the remaining items can be quickly plotted. Extend a line from A through the center of CD to line B-vp. The point E at which it meets line B-vp locates the next vertical.

6. Repeat the process for the remaining verticals.

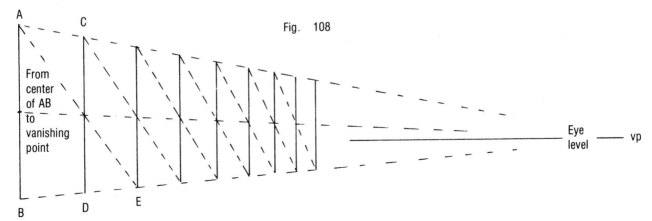

Fig. 108

Circular Objects

To draw plates, clocks, cups, lamps, coins, cylinders, cones, the human eye, or any round object, at an angle, it is necessary to know some principles about circles in perspective.

Actually an *ellipse* (though not a true circle in perspective) "looks right" for most drawing purposes. An ellipse is symmetrical, constructed by dividing a rectangle into four equal parts and connecting the outer center points with arcs. Copy the ellipses in Figure 109.

center feature—the handle on a pail, for example—use an ellipse, but locate the perspective center for the placement of the handle or *it* will not "look right" (Fig. 111).

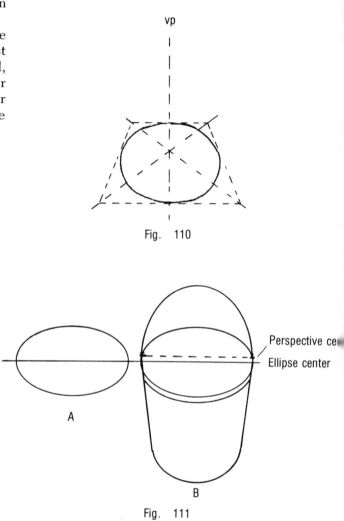

Fig. 110

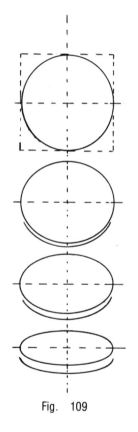

Fig. 109

Fig. 111

A circle drawn in perspective is based upon a square drawn in perspective.

1. Draw a square that has been tilted into space by using one-point perspective (Fig. 110).

2. Locate its center by drawing diagonals from corner to corner.

3. Sketch in the connecting arcs.

Compared to an ellipse, Figure 110 "looks" distorted. However, when drawing in perspective a circular object that has a

Exercise 19
People in Perspective

Figure 112 shows how to determine the sizes of people in space.

1. Draw an eye level.

2. Sketch in the nearest figure.

3. Establish a vanishing point on the eye level. Its placement is arbitrary. (Experiment by trying points closer to the figure than shown in the illustration, and you will see the different effects created by the changes.)

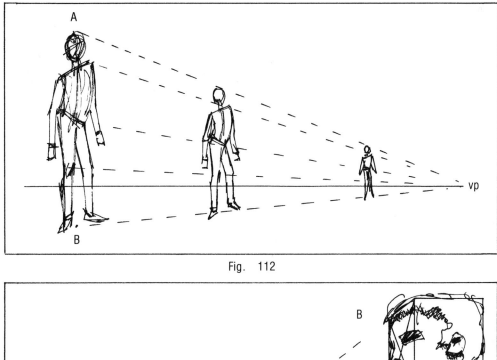

Fig. 112

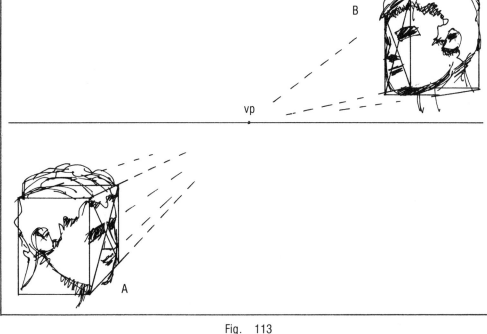

Fig. 113

4. Project lines to the vanishing point from several places on the figure (in our example, from the head, shoulder, waist, knee, and feet).

5. The sizes of people at different locations in space (if they are all about the same height — adjustments must be made for children or extremely tall or short people) can easily be determined by the projection lines. The lines will pass through the same parts of the body of any figure standing within the A-vp and B-vp projections.

General Applications of Perspective

A knowledge of perspective will make you aware of its application when drawing objects that might not seem to be affected by it. A head, for example, is subject to the same laws of perspective as a cube (Fig. 113).

In A, which is below the eye level, we look down and see the *top* planes of the head, nose, lips, and chin. The brow, eyes, lips, and jaw project up towards the vanishing

point. The center of the face can be found by intersecting diagonals.

B is above the eye level. We do not see the top planes; instead, we see *under* the brow, nose, lips, and chin. The projection of the features is down towards the vanishing point.

Practice Assignment

Be sure to copy all the above examples. Then apply the principles in order to develop your eye. Sketch things in your room, the room itself, and buildings and streets that you can see from your window.

First analyze them, using your pencil as a sighting line to follow projections (a rooftop and groups of windows, for example) to actual vanishing points. Sketch roughly, putting the general lines of perspective down. Then tack your sketch to the drawing board, locate the eye level on the paper, insert pins in the vanishing points, and refine all the elements of perspective by drawing them carefully, with a ruler, to the vanishing points.

Sketchbook Assignment

Look through your sketches and see if you can improve some of them by correcting the obvious errors in perspective.

Exercise 20
Composition*

Up to this point, you have concentrated on drawing isolated objects. In this exercise, you will consider them in relationship to their surroundings; you will compose them.

As noted in Chapter I, a good composition is one that arranges all the elements within the borders of the picture in a way that is both interesting and harmonious. The arrangement should also reinforce the mood or idea you wish the picture to express.

1. Consider these student sketches (Fig. 114).

*Additional instruction on composition will be given in Chapter III.

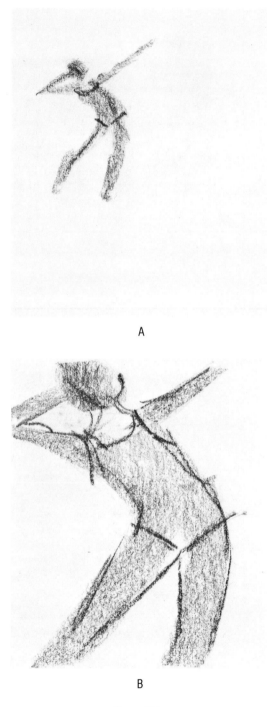

A

B

Fig. 114

Both students were asked to make *basic characteristic* sketches of the same model. Composition A is more successful than B, because in B the arms and legs were cropped off, destroying the long, graceful linear movements that characterized the pose.

2. But suppose the assignment had been

to use the model to create a picture that expresses power and heroism. In that case, composition B would be a better approach, because the figure has been placed in such a way that it dominates the space and asserts itself as the main theme.

3. Suppose, again, the assignment had been to use the model for a composition that expresses loneliness or isolation. A would be better suited, because in that picture the figure appears to be lost or struggling in a vast, desolate environment.

Thus you can see that the space around an object is just as important as the object itself to the mood you wish to express.

4. Try this with one of your own drawings: Cut two strips of gray cardboard to the sizes shown in Figure 115. Place one of your drawings on a table and adjust the cardboard strips to make "frames" of different sizes and shapes around the drawing. Notice that, as you change the space around the figure, the mood changes too.

5. Think of a specific mood or feeling,

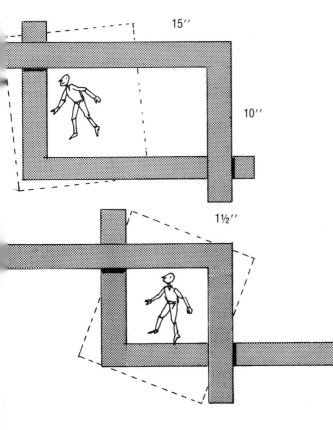

15''

10''

1½''

Fig. 115

and try to find a frame-shape that evokes it. Be very conscious of the fact that you are *designing* the blank space (*negative space*) that surrounds the figure, and that the space contributes as much as the figure to the mood of the picture.

6. Practice the exercise with different drawings.

Composing a Still Life

Still life affords an excellent means of studying composition because all the elements can be controlled by the artist. There are two basic approaches:

One is to select random objects, place them casually on the table, and then alter the composition of those objects as you draw.

The second is to choose the objects with careful attention to their relationships: how their shapes, forms, tones, colors, textures, and individual basic characteristics harmonize or contrast with each other. Attention can also be given to the symbolic associations of each item: for example, if you have a clock in the still life, is it just there because its curves harmonize with the curves of other objects such as plates and cups), or because you also wish to make a philosophical statement about time?

The placement of the objects on the table can be casual or deliberate. If casual, the actual still life serves merely as a starting point. Some artists prefer this approach, because they feel that most of the creative work and struggle should take place during the drawing (or painting) process.

Other artists spend a great deal of time and creative energy in setting up the still life. In a sense they compose a physical entity, which they then "copy."

A middle course is perhaps the best. Merely tossing objects on the table can inspire creative solutions, but it can also be confusing to a beginner. On the other hand, too much deliberation in setting up the still life can result in too mechanical an interpretation.

In either case, you will discover that, at some point, the image you are drawing (or painting) begins to generate a life of its own and to make demands other than those you

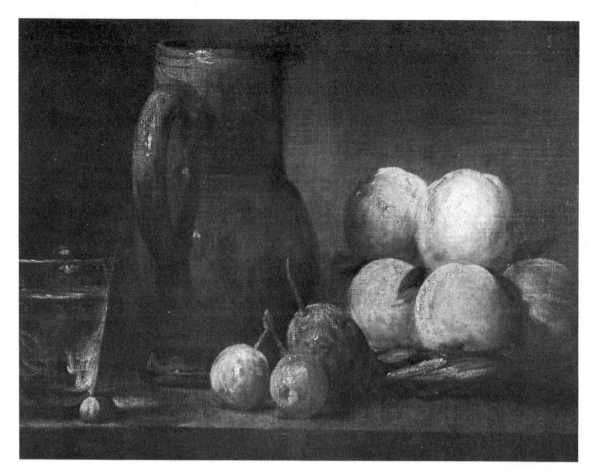

Fig. 116

originally intended. At that point it is wise to turn away from the actual still life objects and just work on the picture.

Study the still life in Figure 116. It is an excellent example of the concepts discussed above.

Exercise 21
Drawing a Still Life

Select a few items related to breakfast: a plate, bowl, cup, and saucer; some food, a coffee pot, and perhaps a bowl of flowers. Use a Conté crayon and typing paper for the initial sketches.

1. Think of the mood you would like to express. It might be "happy anticipation"— breakfast will be delicious and a prelude to an interesting and exciting day you have planned. Or it might be an unpleasant mood, irritation or annoyance—you got up with a

JEAN-BAPTISTE-SIMEON CHARDIN (1699-1779). "Still Life." National Gallery of Art, Washington, D.C. (Gift of Chester Dale)

Chardin is an excellent example of an artist who used still life as a starting point for expressive visual statements. Beginning with a softly lit corner of a table, containing a few humble forms, he composed them—harmonized their curved, straight, and diagonal movements; balanced their patterns of lights and darks—into an organic structure that went beyond mere description of water-glass, pitcher, fruit, table, and water, to become a little visual universe, that speaks with a quiet, delicate eloquence.

headache and hardly feel like eating before going off to perform some boring task.

2. Begin to arrange the still life items, keeping the mood in mind. To express a happy feeling, a neat, orderly arrangement would be appropriate. The unpleasant mood could be shown by a haphazard, uncaring placement.

Fig. 117

3. Decide what format (horizontal or vertical) would most reinforce the mood. Generally, a horizontal format has underlying associations of sleep, inactivity, and passivity, and so it might be more suitable to expressing the downbeat, sad mood. In comparison, a vertical format has connotations of action and mobility, and in this case could be used to enforce the idea of the happy mood.

4. Another of the basic decisions to make is the eye level from which the still life is to be seen: from below, on the eye level, or above it (Figs. 117, 118, 119).

Here, too, each viewpoint evokes an unconscious feeling. The low eye level (Fig. 117, sometimes called a "worm's-eye" view) would probably strengthen the mood of the "sad" picture; the objects tower over the viewer, making him/her feel lowly.

The high ("bird's-eye") view (Fig. 119) expresses a soaring feeling—the viewer gets a feeling of being on top of the world; therefore it would be better suited to the "happy" picture.

5. The next thing to consider is the distance between the viewer and the objects of the still life: close, medium, or far (Figs. 120, 121, 122).

The extreme close-up (Fig. 120) would be most appropriate for expressing a negative, irritated mood, because it focuses entirely on the subject matter and excludes the environment, creating a feeling of brooding introspection.

Fig. 118

Fig. 119

Fig. 120

Fig. 121

Fig. 123

Fig. 122

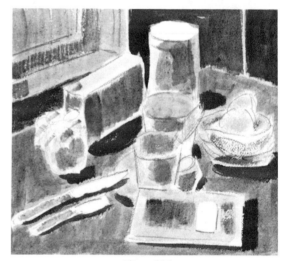

Fig. 124

The far view (Fig. 122) is more suited to express a positive, happy mood, because it relates the still life to the room and the world outside the window, evoking an extroverted, expansive feeling.

6. *Tonality* is another important aspect of composition. The decisions about tonality concern tonal *key* and the amount of contrast within that key.

Bright tones evoke feelings of cheerfulness. Thus the high-key tones of Figure 123 would be preferable for the "happy" picture.

A darker (low-key) tonality (Fig. 124) suggests feelings we associate with somberness and solemnity; it would be a good choice for the "sad" picture.

Notice that a high-key tonality maintains its high-key feeling even while it includes a few small areas of very dark tones (which give the picture contrast and excitement).

Similarly, the few small areas of white in a low-key picture add excitement and contrast but do not detract from the general low-key mood.

Exercise 22
Beginning the Picture

Some artists work loosely and freely without preplanning. They work out all the

details of compositional problems on the picture itself. The philosophy behind this approach is that, if the picture is to become a living thing, its entire growth process should take place on the picture. You may wish to try that method on your own.

However, the following steps will describe the method of making preliminary studies favored by many other artists. This method can save the beginner time and effort.

1. Review the preceding steps on Composition and also the Visual Language (Chapter I). Then actually write down your decisions about the mood you wish your still life to express, and the ways you will reinforce that mood: the format (horizontal or vertical); the eye level (high, medium, or low); the focus (close, middle, or far); the tonality (high or low); and the contrasts within the tonality (strong or subtle).

2. After you have decided upon the format, use a light pencil, and subdivide it into quarters and sixteenths (Fig. 125).

Fig. 125

Subdividing the picture area is an aid to composition. It enables you to evaluate the placement of shapes and forms, as well as the negative space around them. In Figure 126A, the objects are arranged too evenly; the space around them is also even and monotonous. In 126B the subdivision lines help you to see that the arrangement is more interesting and cohesive.

It is also helpful to look at the little rectangles, created by the subdivision lines, as pictures within the picture. If the composition is effective, you will generally find this confirmed by the fact that the space divisions of each small rectangle is varied from the others.

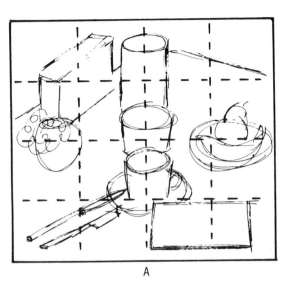

A

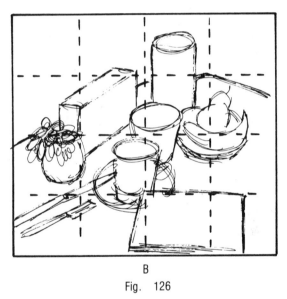

B

Fig. 126

3. Rough in the outlines of the basic composition.

4. Rough in the tonal values. Do this in a simple manner, without details and without modeling the forms. This may call for some creative decisions; for example, you may have decided upon an overall light tonality, without strong dark contrasts.

In Figure 127 the values are too even and lacking in rhythm: The white shapes are equal in size and placed statically; the blacks, too, are equal in size and are placed monotonously. Both the lights and darks are set against a neutral tone that contributes little movement or excitement within the picture.

Figure 128 is better. There is a proportioned sequence of the light and dark patterns, which create interesting movements across and into the picture space.

However, the actual coffee pot or dish in your still life may be dark. Use artistic license, and create a tone for the object that best suits the total composition. Remember what counts is how well the elements of the picture work together. The fact that you copy exactly any tone, shape, size, form, color, or position of an object will prove nothing if it does not function properly.

5. Step back from the picture and squint at it. Do the tonalities make interesting patterns? Do the patterns contribute to the mood you wish to create?

It is also helpful, when analyzing a picture, to turn it upside down and sideways. Doing so gives you a fresh look at the work, eliminating the distraction of its subject matter. Try looking at the picture in a mirror; this too can help you see compositional errors.

6. With a kneaded eraser, make changes and corrections in the tonal pattern.

7. Model the forms with lights and darks. Remember, if you are working in a tonality without strong contrasts, model subtly with tones that are close on the value scale, and use line and texture to bring out shapes or forms. If your tonal scheme is wide, you will be able to model with lights and darks and a minimum of line.

8. Continue to look at the picture upside down or in a mirror from time to time. Systematically look at each shape, line, form, and tone, and ask questions about them. For example, how does it relate to the adjacent one? Would the whole effect be better if it harmonized more or contrasted more? Actually try some changes.

9. Put the picture aside for a few days and work on something else. When you look at it again, it will be easier to see and correct faults.

10. Now some courage is called for. When you think you have carried the picture as far as possible, try to look at it very objectively and rethink the entire concept. Can you improve it by simplifying it—perhaps by taking some element out? Or, would it be better if you added something—some object or shape which had not occurred to you during the initial stages of creation?

11. At this point, the picture will probably have taken on a life and logic of its own. Remove the actual objects of the still life and concentrate solely on the picture.

Practice Assignments

Working on the still life composition undoubtedly made you realize that composition is basic to everything you draw. Even if you draw an individual form, it must be composed in a way that relates all of its parts to itself and to all the surrounding space within the picture borders.

Fig. 127

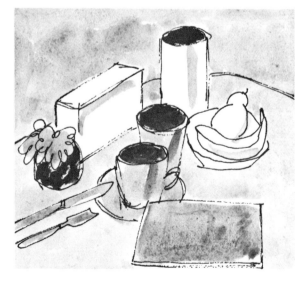

Fig. 128

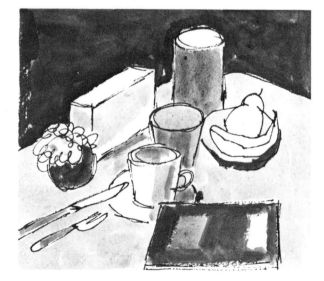

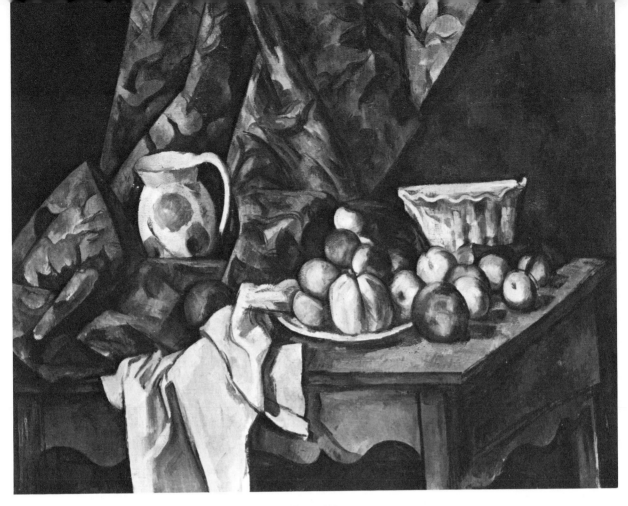

Fig. 129

PAUL CEZANNE (1839-1906). "Still Life with Apples and Peaches." National Gallery of Art, Washington, D.C. (Gift of Eugene and Agnes Meyer).

Cézanne, known for his experiments with color (see Color Plate IV, follows page 96), also had a profound concern with the expressive powers of composition itself. He limited his subject matter to still life and landscape, often painting the same ones over and over. When he did paint people, he treated them primarily as shapes and forms to be composed in pictorial space.

In this picture, painted the year before his death, the artist has composed some common objects into a structure that takes on the dramatic power of a great cathedral, mountain, or symphony.

He has fused all the shapes and forms, so that they become one mighty sculptural entity, which stands out boldly against the background. Within that framework he created rhythmic patterns of all the elements of the visual language. The large shape/form, comprising the outline of the curtain and table, contains a rich variety of smaller shapes and forms—rectangles and cubes, triangles and pyramids, circles and spheres. These resonate like a massive orchestra. The linear elements play their own theme and variations: Notice the way the curves of the fruit are echoed in the bowl, pitcher, and arabesque woodwork of the table. The tonality is low-key, with a few lights and intermediate tones that work contrapuntally against the dominant darks.

Cézanne also utilized tensions as a dramatic force in composition. Notice the way all the verticals and horizontals of the table are tilted; the tilts are repeated by some of the folds of the cloth and curtain, and the pitcher, which leans precariously to the left. These tilts create tensions with the verticals and horizontals of the picture's borders and help to counterbalance the strong diagonal thrust of the curtain.

Still another device that Cézanne often used to create tension was the bending and splitting of the table tops. If you lay a ruler on either of the front edges of the table top, you will find that they do not meet under the cloth.

Because of his concern with the formal problems of picture making, Cézanne is considered the father of modern art. It is interesting, in this respect, to look at the picture upside down and see how well it functions as an abstraction.

1. Rearrange your still life objects on the table and make another drawing following the above procedure. (Avoid the temptation of using new objects; the discipline of working on the same forms will help the learning process.)

2. After completing two or three still lifes using the same objects to create different moods by changing the composition, do some still life studies with new objects.

Even if your primary interest is drawing people, animals, or landscapes, you should continue working periodically on still life. The compositional principles you learn from still life can be applied to any other type of picture making.

The still lifes of Paul Cézanne are most instructive in respect to composition. Figure 129 is a superb example.

Compose a simple landscape or cityscape (perhaps something you can see from your window). Follow the same procedures given for the still life: Decide upon a mood; a suitable format (vertical or horizontal); the eye level (in this case it will be determined by your view from the window); the focus (even though you cannot physically move nearer to or farther from the scene, you still have a choice of how much you will include—everything you can see out the window or just a small section of the view); the tonality, and contrasts within the tonality. Take liberties when necessary; for example, draw a building or tree larger, smaller, lighter, or darker, if it will help the composition.

Sketchbook Assignment

Using very simple forms, which you can draw from memory—a cube, a sphere, and a cone—create several compositions with them. In each case, review the points studied previously: First decide upon a definite mood or idea that you wish to express; then compose all the pictorial elements in a way that contributes to that expression (Fig. 130).

Exercise 23
Creating an Abstraction

When Kandinsky declared (see page 173) that painting should be free to achieve expression through its own elements: line, shape, form, texture, tone, and color—analogous to the way that musical expression is achieved by melody, rhythm, harmony, and timbre—a new branch of visual art was born, in which the elements of a picture became its own subject.

Whether or not you are personally attracted to this style of picture making, it can be a valuable method of study and you should try it.

1. Without thinking of anything in particular, put down a shape or form or some lines on a sheet of paper—even something like an insignificant doodle (Fig. 131A).

2. Study the "doodle." Does it suggest any feeling? The feeling or emotion does not necessarily have to be expressed in words, it can be just an intuitive response to "something" generated by what you have drawn.

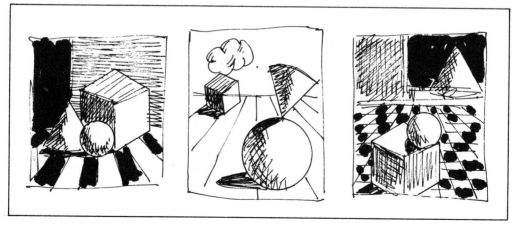

Fig. 130

Fig. 131

Your reaction may be: "The lines are agitated and they seem to want to move to the left, but need some other shape or line to balance them."

3. Decide what other elements can be added to develop the mood; where other shapes, lines, forms, textures, and tones might be placed.

4. As you work on the intellectual and emotional compositional problems, you will find that they are not unlike the problems that you dealt with in organizing the realistic subject matter of a still life. You may also find them to be just as exciting and engaging (Figs. 131B and C).

Practice Assignment

Review Exercises 1, 2, 3, and 5 in the Visual Language chapter. You will now realize, that they were simple abstract composition problems. Try them again. The results will be a good measure of the progress you have made.

Exercise 24
Anatomy

As your drawing and compositional skills progress, you will be anxious to include more detail in your work. Mastering detail convincingly is just an extension of the exercises you have been practicing—observation and measurement—plus an understanding of the anatomy, or the *structure*, of what you are drawing.

Traditionally, artists have used the human figure both as a vehicle for expression and for study. The body has a basic symmetry, which unifies it; at the same time, it has a variety of forms, which are capable of endless and complex configurations. Thus, studying the anatomy of the figure is extremely valuable.

Once having gone through the process of learning the structure of the figure, and incorporating it into your drawings, you can apply the learning principles to the anatomy of anything else you wish to draw.

How much anatomy one should study is debatable. Some artists who draw well have studied little or no anatomy. Doctors, on the other hand, study anatomy in great detail, but they are not necessarily able to draw the figure. However, most great draftsmen have studied some anatomy.

Anytime you are floundering and your drawings betray just a superficial understanding of what you are trying to portray, study the structure below the surface, the anatomy. What you should strive for is sufficient knowledge of the structure of the body to give life to your figures and drawings, while avoiding the look of medical illustrations.

Figures 132, 133, and 134 are diagrams of the skeletal system and some of the muscles. As you draw and study them, do the following:

1. Work in front of a mirror. If, for instance, you are sketching the muscles and bones of the hand and wrist, observe your own hand and visualize the bones and muscles under the skin.

2. Move your fingers and wrist. Notice the changes that occur: How certain bones protrude against the skin (when the hand is

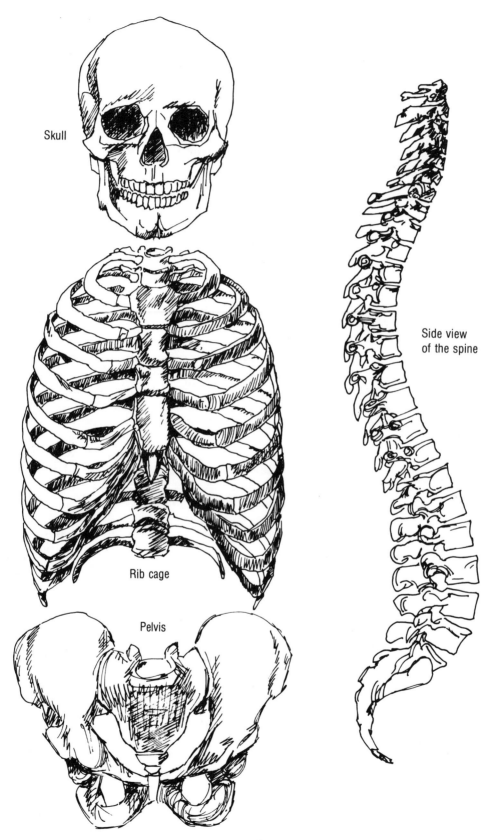

Skull

Rib cage

Pelvis

Side view
of the spine

Fig. 132

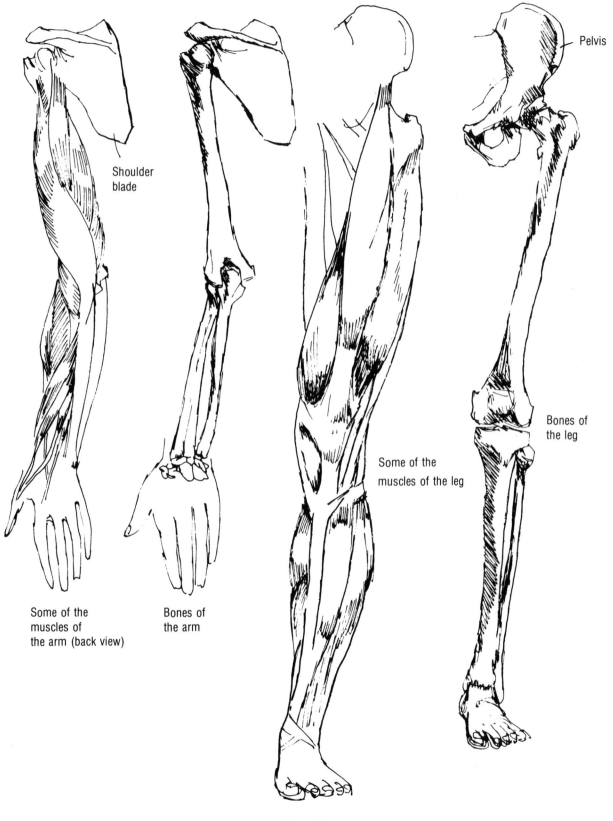

Shoulder
blade

Some of the
muscles of
the arm (back view)

Bones of
the arm

Some of the
muscles of the leg

Pelvis

Bones of
the leg

Fig. 133

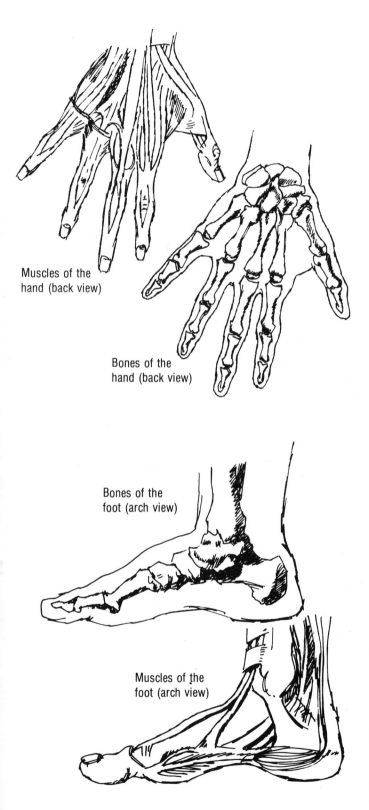

Muscles of the
hand (back view)

Bones of the
hand (back view)

Bones of the
foot (arch view)

Muscles of the
foot (arch view)

Fig. 134

clenched), or how muscles that were flat, bunch up.

3. Do the same thing for other parts of the body.

Museums, Galleries, and Art Books

The works of old and new masters afford excellent instruction in all aspects of picture making: drawing, composition, and anatomy. Study them at every opportunity. Don't merely copy famous drawings, paintings, and sculpture; make sketches and studies of them. As you do so, ask specific questions: Is the composition based on curves, straight lines, verticals, horizontals, or diagonals? Trace all the dark tonalities and study the patterns they make; do the same with the light tonalities. Note the way in which different artists use line and tone to create moods and form.

Compare the different approaches to anatomy. It is fascinating to see how many ways the figure can be drawn and still be convincing.

Summary

There are a few lucky people who seem to have a "natural" ability for drawing, making music, or writing, or who can learn to do these things quickly. The rest of us have to work hard at it.

The exercises in this chapter have been designed to produce results—if you practice. Perhaps "to work hard" is the wrong phrase. Learning to draw *is* hard work but it is also enjoyable and enriching. Practice will bring improvement and that will bring the joy of seeing your talent and skill develop. With that development will come a rich visual life: the increased understanding and experiencing of art, and the ability to perceive the visual world more profoundly. The humblest face, landscape, or object will take on interest and beauty because of your increased knowledge of visual relationships.

In addition, once you develop a sound foundation in drawing, it will be an essential asset to your future studies of painting, sculpture, and printmaking.

FUNDAMENTALS OF PAINTING

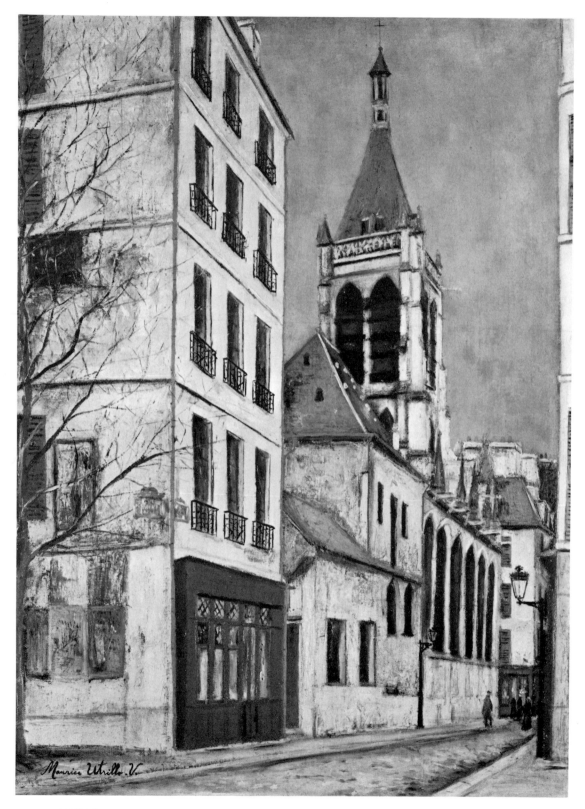

MAURICE UTRILLO (1883-1955). "The Church of Saint-Séverin." National Gallery of Art, Washington, D.C. (Chester Dale Collection)

Chapter III

FUNDAMENTALS OF PAINTING

H ISTORICALLY THERE HAVE BEEN THREE BASIC APPROACHES TO PAINTING—specifically to the use of color.

The first approach *relies upon line* to delineate shapes, forms, and space. Color is added to describe objects, decorate them, or to create a mood. Forms are modeled with lights and darks of a color, rather than with changes of chroma or temperature.* Pablo Picasso's "The Lovers" is an example of this method (Color Plate II, follows page 96).

The second approach is the opposite of the first. *Color is paramount*; little or no line is used for drawing. Shapes and forms are modeled by varying the intensity and the warmness or coolness of a color, in addition to changing its lightness or darkness. This is perhaps the purest form of painting; color is so organically integrated that even slight changes of tone, chroma, or temperature can destroy the image. Such painters as Claude Monet, Henri Matisse, and Pierre Bonnard typify the use of this method (Color Plate III, follows page 96).

The third approach combines both of the above methods. Paul Cézanne (Color Plate IV, follows page 96) perfected this technique. He built forms by manipulating the tone, intensity, temperature, and texture of small patches of color, but he also used line judiciously to emphasize shape and form.

All three approaches will be demonstrated in the exercises in this chapter.

Paints

Artist's paints—watercolor, oil, or acrylic—are composed of pigments, natural or synthetic, held together by a binder: watercolors by casein or gum; oil colors by oil; acrylic colors by an acrylic polymer emulsion.

Watercolors are preferred by beginning painters, sometimes for no better reason than that they have received a box of watercolors as a gift or because these materials are supplied in school. But working with watercolors is very difficult for the beginner; every stroke must be right the first time, since this medium does not permit corrections. For this reason, watercolors should not be used for the exercises in this chapter.

Oils are versatile and easier to handle but do present some problems. They are slow drying; some colors can take from one to four days to dry on the surface. However, beneath the surface some colors take weeks and months to dry. Waiting days for paint to dry can inhibit creative flow, while failure to

* Chroma refers to the intensity—strength or purity— of a color; temperature indicates the "warmness" or "coolness" of a color (see page 84).

carefully use slower drying mixtures over faster drying ones will eventually cause cracks in the painting.

Oils also darken with age, causing the color to lose its brilliance. Cleaning up requires the use of flammable solvents.

For these reasons, the use of acrylics is recommended for the exercises that follow.

Acrylics have gained wide acceptance and popularity because they combine many positive features of watercolors and oils, without the disadvantages. All the colors dry quickly (in minutes); no special precautions are necessary when overpainting; cleaning up is quickly accomplished with water.

Materials

You will need the following equipment for the studies in this chapter:

Acrylic colors—one tube each of the colors in the accompanying list. The handling characteristics of acrylics vary slightly with each manufacturer. You may wish to try a few tubes of each brand to find one that best suits you. Liquitex, New Temp, and Hyplar brands are of good quality.

Cadmium Yellow Light or
 Cadmium Yellow Hansa

Cadmium Yellow Medium or
 Yellow Medium Azo

Cadmium Orange

Yellow Orange Azo

Cadmium Red Light or
 Naphthol Red Light*

Cadmium Red Medium or
 Naphthol Crimson*

Acra Violet*

Dioxazine Purple*

Mars Black*

Titanium White

Cobalt Blue

Ultramarine Blue

Phthalocyanine Blue (Thalo)*

Permanent Green Light

Phthalocyanine Green (Thalo)*

Yellow Oxide

Raw Sienna

Burnt Sienna

Raw Umber

Burnt Umber

Red Oxide

Acrylic mediums—liquids used to thin the paints. Gloss medium imparts a shiny surface to the picture, while matte medium creates a satiny, nonglare effect. Gloss medium can also be used as a final picture varnish. Matte medium should not be used as a final varnish, but there are special matte varnishes available.

Gel medium—a jelly-like substance used for transparent impastos (see page 84) or whenever thick layers of paint are applied with a brush or knife.

Modeling Paste—used to build up very thick paint surfaces. Read the directions carefully; gel must be added when working on canvas.

Retarding medium—added to acrylics to slow down the drying time.

Gesso—used to prime boards or canvas prior to painting. Liquitex brand is particularly good.

Brushes—buy the best you can afford, they outlast and outperform cheaper ones:

Flat Bristle (Nos. 2, 6, and 9) produce short hard strokes.

Round Bristle (Nos. 1, 3, and 8) produce long fluid strokes.

Flat and Round Sable (Nos. 2, 4, and 8) are used for details, outlining, and glazing.

House painting brush (3-inch or 4-inch) is useful for gessoing panels.

Palette and Painting Knives—for mixing paint and applying it, instead of brushes, for special effects.

Palette—a piece of plate glass about 10 x 20. Bevel the edges for safety. Tape a piece of light gray paper to the underside.

To clean a glass palette that is full of

*These colors have very strong *covering power*. When they are mixed with colors that have less covering power, they will dominate the mixture. For example, it is only necessary to add a very small amount of Dioxazine Purple to a large quantity of Titanium White to turn the resulting mixture purple.

Beginners can avoid wasting paint by introducing very small amounts of these strong colors into any mixture.

dried paint, mist or sponge some water over the paint; let it stand for a moment, then scrape the paint off with a razor blade.

Easel—moderately priced, standard size made of wood or aluminum is adequate, unless you eventually plan to work on pictures considerably larger than 35 x 45.

Miscellaneous—two pint-size plastic or glass water jars; single-edge razor blades; a small perfume spray atomizer; fine sandpaper; an HB pencil; light brown and tan charcoal pencils.

Painting Surfaces—try both soft (canvas) and hard (wood or masonite panels). The surface should be primed with gesso (some canvas is sold preprimed). Follow the instructions on the gesso label.

If you decide to paint on canvas, you will find it economical to stretch your own. You will need a canvas plier; and either a hammer and tacks or a staple gun.

Stretching a Canvas

1. Join the corners of the wooden stretchers, hammering them tightly if necessary. Make sure the corners are square. Sand down any rough edges that might tear the canvas.

Canvas

Fig. 135

2. Cut the canvas at least 4 inches larger than the stretchers, to allow a 2-inch overlap all around (Fig. 135).

3. Put a tack in the center of side A, then pull the canvas tightly from side C and put a

Fig. 136

tack in the center of C. Put a tack in the center of B, then pull the canvas from side D, and put a tack in the center of D.

4. Still working from the center, pull the canvas back and out towards the ends. Put tacks on each side of the center tacks about 1 inch apart. Continue to stretch from opposite sides, A-C and B-D (Fig. 136).

5. Keep adding tacks 1 inch apart on each side of the centers.

6. When you reach the ends, fold one corner over the other (Fig. 137) and tack it.

7. There is usually some sagging or wrinkling. Remove the three center tacks from all four sides and tighten the center again. This should remove all the wrinkles and sagging.

Detail of corner

Tuck one corner under another.

Fig. 137

Techniques of Applying Pigment and Mixing Colors

Color Plate I (follows page 96) contains charts that demonstrate techniques of applying paint and the characteristics of color (hue, value, temperature, chroma, and environment).

The student may learn these techniques in two ways: 1, by studying Plate I in combination with the description below and then proceeding directly to Exercise 1, "Painting a Head: I." Or, 2, students who wish to proceed more slowly and thoroughly, should first do Exercises 5 through 9 pages 101-106) step-by-step, and then try Exercise 1.

Figure 1 demonstrates several ways of applying paint: *washes* (brushing on paint that has been thinned down to a watery consistency with medium); *scumbling* (brushing semi-opaque and semidry paint in small irregular strokes); *impasto* (the application of thick layers of paint with a brush or knife); *glazing* (painting a transparent tone or color over another tone or color). These techniques are described more fully in Exercise 5 below.

Figure 2 shows *temperature* and *value* changes A pure color (yellow, blue, or red) has been placed in the center of each chart; it is lightened going up, darkened going down; warmed to the left; and cooled to the right. In each case, the colors used to change the *value* or *temperature* maintain the maximum purity or intensity of each new color).* See Exercise 6 below.

Figure 3 teaches a method for reducing a color's intensity or purity (its *chroma*), while maintaining its lightness or darkness (its *value*). See Exercise 7.

Figure 4 uses pigment names of colors (*hues*) to construct a color circle from the three primaries (yellow, blue, and red), which can be used to study the relationships of colors: harmonies and contrasts. See Exercise 8.

Figure 5 shows the effects that different color environments have on a color. See Exercise 9.

* Note: Colors reproduced in the book may not have the intensity or purity of those actually mixed with paints.

Exercise 1
Painting a Head: I

For your first painting study, I will demonstrate a simple tonal approach—forms will be modeled with light and dark tones of colors—using little or no line. Refer to Color Plate V, Figures 1,2,3, as you proceed.

Setting Up and Painting Procedure

Fill two jars of water; keep them close to the palette with some rags (Fig. 138).

Important note: Before dipping any brush into acrylics or acrylic gesso, first moisten it in water, then wipe it almost dry on a rag. To clean paint out of a brush while working, merely shake it vigorously in a water jar. Keep the brushes moist during work sessions; if you allow paint to dry in the brushes, they will be very troublesome to clean. When you are finished working, clean each brush with soap and warm water.

Prime a panel (approximately 10 x 15) with gesso, following the directions on the label. When the panel is dry, sand down any bumps or brush hairs that might have dried in the gesso.

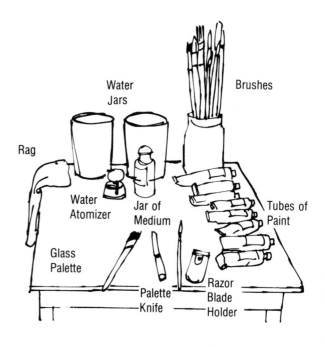

Fig. 138

Spread your paint tubes out at the back of the palette in related groups (yellows, greens, blues, reds, earths), so that you can find them quickly.

Some artists squeeze an inch or so of all the colors onto the palette and mix hues and tones as they go along. To use acrylics this way, add retarding medium to each batch of paint, mixing with a palette knife, and spray a mist of water with the atomizer over the paints at frequent intervals. This prevents the paints from drying too quickly on the palette.

Other artists prefer to squeeze out only small amounts of those colors for the particular passage they are working on. Experience will help you to decide upon the best method for your needs. In the following exercises, it will be practical to just put out the colors indicated.

To mix a color, first squeeze a couple of drops of medium and/or gel on the palette; add small amounts of paint to the medium and blend them together with a painting knife. (Be sure to recap the paint tubes *immediately*. If caps become stuck, hold the tube firmly in one hand and turn the cap *gently* with pliers.) Mist some water over the paint with the atomizer; this will keep it from drying too quickly on the palette while you paint.

When working on passages that require blending one tone or color into another, it is best to work wet into wet. Add some retarding medium to the paint; this will keep it wet longer by slowing down its drying time.

Mix a light brown color (almost a No. 1 value) using Cadmium Orange, a slight amount of Cobalt Blue, and White. Thin it with medium and water; paint an even tone of this color over the whole panel and sand it slightly when it is dry.

Draw the figure in line, very simply; use a light tan pastel pencil. When you are satisfied with the general composition, reinforce the line by painting it with Yellow Oxide, using a fine sable brush (Fig. 139).

Decide upon a color scheme. In this case, the model's skin, hair, and dress will be in warm, light hues, contrasted against a dark, cool colored background.

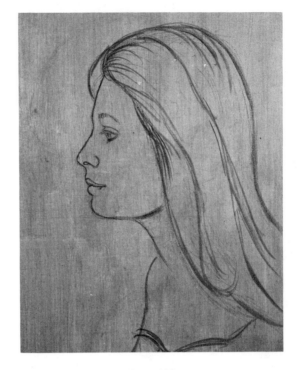

Fig. 139

First Stage: The Underpainting

In order to get the overall effect of the color scheme, it is advisable to lay in all the colors without attempting to finish any one section in detail. This procedure should be followed at all stages of the painting, to develop it organically as a whole rather than in isolated fragments (Color Plate V, Fig. 1).

1. *Background*—Mix Cobalt Blue with a small amount of Cadmium Orange (to gray it). Lighten it to a No. 5 value, with White; add medium to the paint and scumble it thinly over the background with a large bristle brush.

Permit some of the background color (the light orange tone), to work through the blue.

Where the blue meets the figure, keep the edges soft, by working with a semidry brush (after dipping it in the paint, wipe some of the paint off the brush before using it), using a light *whisking* stroke.

2. *Dress*—Mix Cadmium Orange with some Cadmium Yellow Medium; gray it slightly with a speck of Dioxazine Purple; lighten it with White to about a No. 2 value.

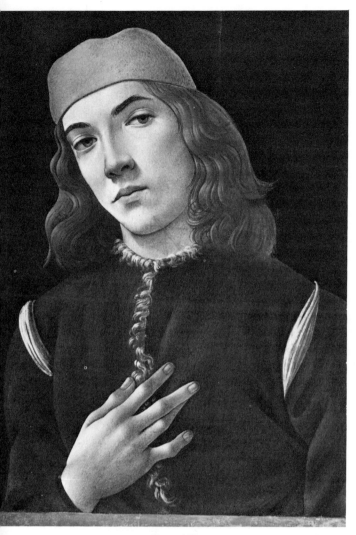

Fig. 140

SANDRO BOTTICELLI (ca. 1444-1510). "Portrait of a Youth." National Gallery of Art, Washington, D.C. (Andrew Mellon Collection)

Beginners often use too many tones and colors to render form; study of the masters quickly reveals that a limited number of values and hues, combined with a judicious use of line, provides more than enough of a visual vocabulary to produce an illusion of form. Notice how close a tonal range Botticelli uses for modeling.

This charming portrait is instructive in other respects. Like the Bellini painting (Fig. 38), the composition is based upon curves, which Botticelli builds into rich patterns; every edge undulates and pulsates with curving rhythms that create a subliminal life-giving excitement to the image. Notice too a subtle compositional device, the diagonal tilt of the head balanced by the opposing diagonal thrust of the hand. This tension keeps the simple placement of the figure from becoming too static. (Compare also Fig. 141).

Thin the color with medium and paint an even tone over the dress.

3. *Hair*—Thin down some Raw Umber with medium and water. Paint the darks; paint loosely, with broad strokes that follow the flow and movement of the hair.

Mix Yellow Oxide and Raw Umber; lighten it with White to an almost No. 1 value. Add some gel so that you can apply the paint heavily to the light areas, as a contrast to the thin, dark tones.

4. *Flesh tones*—The variety of flesh tones that it is possible to mix with paints can confuse the beginner, as can a large number of paint tubes spread out on the palette. Therefore, this study will demonstrate a simple approach to mixing flesh colors, using just two colors and White. Notice, for example, the extraordinary simplicity with which the head in Figure 140 is painted.

Look at the chroma exercise (Color Plate I, Fig. 3). Notice that the hues to the right of the pure orange could be used for middle or dark "flesh" tones. If each of those hues were lightened several steps with increasing amounts of White, we would soon have twenty or thirty flesh tones. That number could be increased by using other combinations of warm and cool oranges and warm and cool blues.

In this study we shall limit the flesh tones to Cadmium Orange, Cobalt Blue, and White; in addition, we shall keep the value range of the flesh tones quite close, between Nos. 1-plus and 3.

Mix Cadmium Orange and Cobalt Blue until it is grayer than it is orange (something like chroma No. 5 in Plate I, Fig. 3). Lighten it with a little White to about a No. 3 value; then thin it with medium, and paint the shadow areas.

Keep the edges of these dark areas soft by using the semidry brush technique described earlier. Use a round bristle brush.

Add a speck of Orange to the mixture (to warm it and strengthen its chroma) and more White, until it is almost a No. 1 value. Apply this paint to the lighter areas thickly (impasto). Vary the texture of the paint by applying some of it with a bristle brush and some of it with a painting knife. This will imbue

the "flesh" with vibrancy and life, and enhance the surface of the painting (Color Plate V, Fig. 1).

As you work on these passages, get up frequently, step back from the picture, and observe its effects at different distances.

Second Stage: Building the Overpainting

If there are any bumps of paint or brush hairs stuck to the surface of the painting, sand them down.

1. *Background*— Mix Ultramarine Blue with a little Yellow Orange Azo; add White until it is about a No. 6 value; add some gel and medium.

With a large bristle brush, scumble this mixture over the background. Remember to keep the edges soft, where the color meets the figure. Let some of the previous underpainting show through, to enhance the color and surface. (Notice that this blue is cooler than the background blue used in the first stage.)

2. *Dress*—Mix Cadmium Orange with a small amount of Dioxazine Purple to gray it; add White until the color is about a No. 3 value. Use this to paint the shadow tones of the dress.

Add more White to the mixture so that the color is a No. 2 value, and use it for the lighter tones. Scumble the paint on with a bristle brush, letting the underpainting work through the new color.

3. *Hair* —Gray down Raw Umber a bit by adding a small amount of its complement, Ultramarine Blue; lighten it to a No. 4 value with White. Thin the paint with medium and scumble over the shadow areas, using a bristle brush.

Gray down some Burnt Umber (with Cobalt Blue). Burnt Umber is warmer than Raw Umber; the contrast will create a subtle vibration with the shadows. Add some White until the value is No. 2; mix in some gel and apply the paint thickly to the middle tones. Add still more White and use the resulting tone for the lightest areas.

4. *Eyebrow*—Use the same colors for the eyebrow. Start with very light tones as an underpainting, then overpaint with slightly darker shades. Remember, whisk this paint on in a semidry state so that the edges are very soft. If they are sharp and too dark, the eyebrow will look pasted on.

5. *Flesh tones (dark areas)*—Though this study concentrates on *tonal* modeling—lights and darks of the same color—we will use the technique of utilizing weaker (grayer) chromas of the color as an adjunct to tonal modeling:

Mix Cadmium Orange and Cobalt Blue until it is grayer than orange and *slightly* bluer than the hue used for the underpainting flesh color. Lighten it with White to a No. 3 value. Thin it with medium and use it for some of the shadow areas: the corner of the eye; the area of the forehead near the hair; part of the cheek bone near the hair; the jaw and the area under the jaw; the shadows cast by the hair on the chest.

This color, being cooler and grayer (but not darker) than the color on the underpainting, will make the forms it is on stay back in space. These shadows should be very subtle; do not overdo them, create just enough difference between the hue of the first underpainting and this color to give them an interesting interplay.

6. *Flesh (mid-tones)*—Add some Cadmium Orange to the previous mixture to warm it slightly; add some White to lighten it, and scumble this color over the flesh mid-tones.

7. *Flesh (light tones)*—Add a bit more Orange and White to the last mixture and paint the light flesh areas. Apply the paint thickly, with a bristle brush and knife, to vary the textural quality.

8. *Lips*—Add a speck of Cadmium Red Medium to the last mixture to form a very pale pink; scumble it very softly on the lips.

At this point the drawing may need some linear redefinition. Use line sparingly: on parts of the eyes, the nostril, and between the lips. Use a No. 3 value of Raw Sienna and White for the lines (Color Plate V, Fig. 2).

Compare the paintings in Figure 140 and in Figure 141. Though they were painted 400 years apart, both utilize a close tonal range reinforced with a judicious use of line.

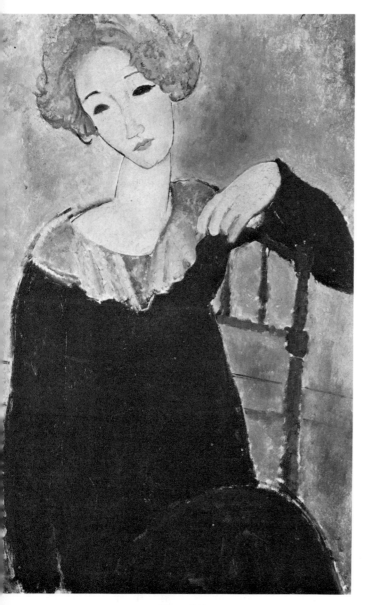

Fig. 141

AMEDEO MODIGLIANI (1884-1920). "Woman with Red Hair." National Gallery of Art, Washington, D.C. (Chester Dale Collection)

Though it was painted 400 years later, this modern portrait utilizes fundamental elements discussed in Figure 140: close tonalities within each shape and form; and a judicious use of outline to separate forms or shapes that are of similar value. Like Botticelli, Modigliani builds rhythmic patterns based upon curves, but he flattens and stylizes them to emphasize the two-dimensionality of the picture plane, which was an aesthetic concern at the time.

Third Stage: Finishing the Painting

As before, sand down any imperfections in the painting surface—bumps of paint and brush hairs.

1. *Background*–Mix Thalo Blue with a small amount of Cadmium Orange to gray it and add White to bring the value to a No. 8 shade. Add some gel to the paint and scumble it over the dark areas of the background.

Paint a soft shadow behind the head. This will create a feeling of "air" and "space" around the figure, so that it does not look as though it had been cut out and pasted down on the background.

Add some medium to the paint until it is transparent. Glaze this over the lighter parts of the background, allowing some of the previous underpaintings to work through.

Remember to keep the edges soft where the background meets the figure. Do this by varying the application of the paint—fluid, opaque, and transparent; and by varying the strokes—firm, hard, and whisking.

2. *Dress*—With a semidry mixture of Raw Sienna, on a thin sable brush, accent parts of the dress with line, but sparingly.

For the purpose of this study the dress is now finished. If you should want to refine the total effect of the color scheme, you would probably have to make adjustments in the hue, chroma, and values of the dress after the hair and face are developed.

3. *Hair*—Mix a glaze (add a lot of medium with the paint) of Raw Sienna; it should be quite transparent. Glaze it over the hair with a large flat sable brush. This will serve to pull the tones of the underpainting closer together.

Mix some Raw Sienna and White, close to a No. 1 value; use a bristle brush with semidry paint, and paint in some of the highlights with loose, bold strokes. Let some of the strokes follow the rhythm and flow of the hair.

4. *Flesh*—Mix a value between Nos. 1 and 2 of Cadmium Orange with a small amount of Cobalt Blue and White, until the color is much warmer (more orange) than the flesh colors of the two previous stages. Add gel and medium until the color is semitransparent. Scumble and glaze this hue over the

mid and high tones of the underpainting, but *not* over the shadows.

Add White to the last mixture, until it is almost white and work back into the light areas with thick applications of paint, using a bristle brush and painting knife.

5. *Lips*—Add a touch of Cadmium Red Medium to the last mixture and model the lips. Do not get this color too red or too dark. Keep the edges very soft so that they blend right into the adjoining flesh tones.

6. *Eye and eyebrow*—Redraw the lines of the eyeball and the iris, but do not make them too dark. Use a mixture of Raw Sienna and Raw Umber; apply the paint very delicately with a fine sable brush. Paint the eyelids with the same tone. Put a delicate off-white highlight on the eye. Paint a delicate, light gray shadow under the lid and in the corner of the eye (Color Plate V, Fig. 3).

To carry the painting further, many things would still have to be reviewed. Do all the elements of the *visual language*—the color scheme, the sequences of values, lines, shapes, forms, and textures—support the emotional content you wish the painting to convey? (Review Chapter I and the composition section of Chapter II.)

If you should want to make a substantial change of color or value, try it out on a separate piece of paper first (see page 107). If the change looks good on the paper and you want to make it on the painting, it is very easy and quickly accomplished with acrylics:

1. Sand down the area to be repainted. Do this lightly with fine sandpaper, just enough to rough up the surface a little; do not try to sand away the color.

2. Gesso the area (two coats may be necessary), and begin painting on the fresh clean ground.

Exercise 2
Painting a Head: II

In this demonstration study, we shall rely a little more on line to define the forms. In the first study, the underpainting was composed of colors similar to those of the overpainting. This time we shall use *cool* hues to enhance the warm overpainting colors.

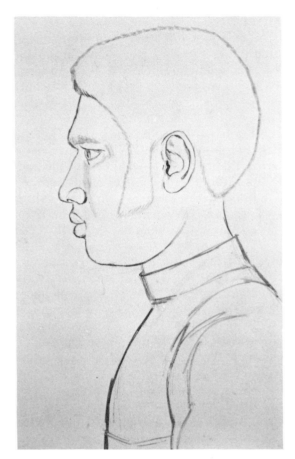

Fig. 142

Refer to Color Plate VI, Figures 1, 2, 3, as you proceed.

Setting Up and
Painting Procedure

After your panel is primed with gesso, mix a very light tone (value No. 2) of Raw Umber and White, thin it down with medium and water; brush it over the whole panel.

Draw the figure with a brown pastel pencil. When you are satisfied with the composition, reinforce the drawing with paint, using a thin mixture of Burnt Sienna; paint with a small round sable brush (Fig. 142).

In this study, too, we shall use a simple harmonious color scheme.The shirt will be a warm hue (red) and close in value to the head, so that the whole figure will stand out strongly against the lighter, relatively cooler background. As before, we shall develop the whole painting as we go along.

First Stage

1. *Background*–Mix Cadmium Yellow Medium, a speck of Dioxazine Purple (to gray the yellow slightly), and White to a No. 1½ value. Add some gel and medium to thin the paint down; lay this color in freely with a large flat bristle brush.

2. *Shirt*—Mix a No. 3 value of Cadmium Red Medium with a touch of Permanent Green Light (to gray down the Red a bit) and White. Thin it with some gel and medium and brush an even tone over the whole shirt area. When it is dry, paint a second coat over the shadow areas with a bristle brush.

3. *Hair and eyebrow*—Mix a No. 5 value of Raw Umber and a speck of Permanent Green Light (to cool the Umber). Lay an even tone of this color over the hair. When it dries, paint a second coat over the dark areas.

Paint freely—large bold strokes—with a large bristle brush. Where the edges of the hair meet the background or face, brush the paint on softly. Paint the eyebrow, keeping the edges very soft.

Brush a very light tint (add a small amount of White) of this color over the eye, including the white part.

4. *Flesh tones* —Mix Raw Umber with a speck of Thalo Green (to cool the Umber slightly). Add gel and medium, until the paint is quite thin. Put an even tone over the face and neck. When it dries, build the dark and shadow areas with successive glazes of the same mixture (Color Plate VI, Fig. 1).

Second Stage

With fine sandpaper, sand down any bumps of paint or brush hairs that may have become imbedded on the surface.

1. *Background* —Mix Cadmium Yellow Medium with a touch of Cadmium Orange (to warm the Yellow) and a touch of Cobalt Blue (to gray the mixture); add White until the hue is about a No. 1½ value; add some gel until the mixture is semitransparent.

Scumble the paint over the background, allowing some of the underpainting to come through in places. Where the edges of the background meet the figure or the shirt, vary the stroke (soft and hard) and the weight of the paint (thin and thick) so that the edges are

irregular. If the edge all around the figure is too hard and regular, the figure will look like a cutout that has been pasted on the background.

Next, darken the paint and gray it slightly, using its complement, Ultramarine Blue; use only a small amount so that the value is no darker than a No. 3. Use this color to suggest a light shadow behind the figure. It will create a feeling of space and "air" around the figure. Apply this color loosely, still allowing some of the underpainting to work through in places and vibrate against each other.

2. *Shirt*—Mix Naphthol Red Light (or Cadmium Red Light) with a speck of its complement, Thalo Green (to gray the Red slightly) to a No. 4 value. Use this color for the shadow areas.

Add some Cadmium Orange to the last mixture, to warm it; lighten it to a No. 2 value with White and apply it to the light tones. Use a large flat bristle brush, laying the paint on thickly and boldly. Vary the texture by pressing some of the paint on with a painting knife. Let some of the cool Red underpainting come through in places.

3. *Hair and eyebrow*—Mix a semitransparent glaze (use a lot of gel and medium) of Burnt Umber. Brush an even tone over the hair and eyebrow, but keep the edges soft by wiping some of the paint off the brush before applying it; use a delicate whisking stroke.

Add a bit of Thalo Green to the last mixture; this will cool and gray it slightly. Scumble it over the dark areas. Work with round and flat bristle brushes. Use short choppy strokes to get an effect of texture; let some of the lighter undertones show through.

4. *Flesh tones*—Mix a very transparent glaze of Raw Sienna and paint it over the flesh tones.

If the drawing requires redefinition, reestablish the line wherever necessary; but use line sparingly. Try to let the tones bring out the forms as much as possible.

Mix Burnt Sienna and White to about a No. 5 value; use this as a middle tone. Apply it with a flat bristle brush. Use bold, loose strokes and allow some of the underpainting color to show through between some of the strokes. (Notice the animation created by

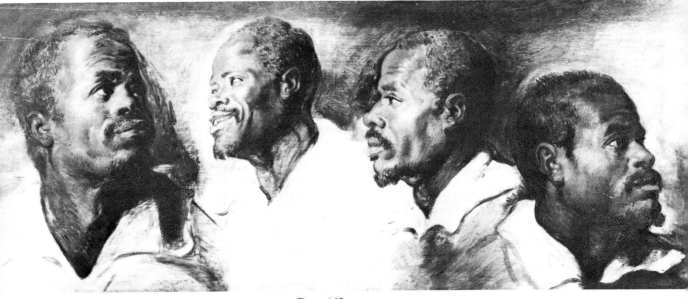

Fig. 143

PETER PAUL RUBENS (1577-1640). "Four Studies of a Negro's Head." J. Paul Getty Museum, Malibu, California.

In these studies Rubens used only tone to model form. Though the range of values is quite broad (from white to black), values used to articulate individual passages are close and simple. Notice the use of rugged brush strokes to suggest textures and the use of hard and soft edges.

Peter Paul Rubens' use of rugged brush strokes in Figure 143.)

Add a speck of Thalo Green to the last mixture (to cool, darken, and gray the color), and use it for the shadows. Paint freely so that the strokes have a rhythm and vitality of their own (Color Plate VI, Fig. 2).

Third Stage

If there are any surface blemishes—bumps or brush hairs—sand them down.

1. *Background*—To create more interest and vibrancy in the background color, use a cooler yellow for the overpainting. Mix Cadmium Yellow Light plus White and a touch of Dioxazine Purple (to gray the mixture slightly) to a value between Nos. 1 and 2.

Scumble this hue over the background, allowing the underpainting to come through. Keep the edges (where the background meets the figure) soft; here and there let the background color overlap slightly into the hair and shirt. Vary the application of the paint—sharp, hard strokes contrasted by soft diffuse ones.

2. *Shirt*—Cool and gray down the shadow areas. Mix Cadmium Red Medium and its complement, Permanent Green Light, to about a No. 6 value. Scumble it softly over the edges of the collar, chest, and shoulder.

3. *Hair and eyebrow*—Mix a semi-transparent glaze of Burnt Umber and a small amount of Ultramarine Blue to a No. 8 value. Scumble it over the dark areas of the head with short, choppy strokes. Allow some of the lighter undertones to show through; this will help create a rich textural quality.

Use the same color for the eyebrow. Avoid a harsh, sharp look by using the paint semidry (wipe some of it off the brush on a rag before applying it). Do not paint the dark color up to the edges of the skin tones; keep them within the lighter tones used for the second stage of the eyebrow.

4. *Flesh tones*—If some of the line needs reinforcing, redraw it with Burnt Umber mixed with a small amount of Black. Use a

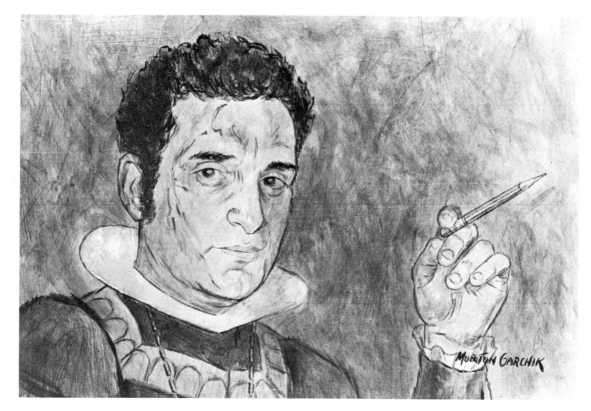

Fig. 144

MORTON GARCHIK "Portrait of Bernard." New York (Collection of the artist)

In this work, I relied chiefly upon line to establish the forms and supplemented it with some tonal modeling. The colors (blues, blue-violets, black, and white) were used to create the mood rather than describe the actual colors of the flesh or clothing.

fine sable brush and semidry paint. Avoid a hard, slick, regular outline; rather, weave the line in and out of the color, varying its thickness.

For the middle tones, scumble a warm hue mixed with Cadmium Red Light and a small amount of Thalo Green and White to a No. 5 value. Scumble it over the previous middle tones, allowing some of them to come through.

Add some more Red and White to the last mixture and bring it up to about a No. 1½ value. Use this for the highlights. Apply this paint heavily (impasto), with bold strokes and a painting knife. The knife will create

smooth textures that will contrast excitingly against the thinner, rougher strokes of the bristle brushes.

For the purposes of this demonstration, the painting (Color Plate VI, Fig. 3) will be considered finished. However, in practice, a good work of art is not "complete" until the artist has made maximum use of his/her skill to express the content.

For example, in this work, the color scheme may be too superficial for the thoughtful expression of the model. Therefore, other colors might be considered for the background and shirt, which would express that mood.

Throughout these painting exercises, step back from the picture frequently and squint at it, so that you can judge the patterns and rhythms without the distraction of the details. Review the principles discussed in Chapter I and the composition section in Chapter II. Turn the picture on its sides and upside down. Ask questions about each line, shape, form, value, color, and texture: How

might it be changed either to harmonize or contrast, and thus to contribute more effectively to the mood you wish to express?

Assignment

Having worked on these two studies, you will have learned more than you realize. On your next visit to a museum or gallery, be aware of how your increased sensitivity to painting manifests itself in the critical way you are able to look at pictures with an eye that is becoming more experienced and perceptive.

Compare the use of line and tone in Figure 144.

Exercise 3
Painting a Still Life

In this demonstration we shall explore a style that relies primarily upon line to describe forms and space. Color and values will be used to create rhythms and patterns, and only secondarily to reinforce forms and space.

The use of bold outlines, in this manner, has two important aspects: the lines become active, independent elements; their character—precise, spontaneous, nervous—contributes to the expression of the picture. They also create a stained-glass effect and to a degree "hold" colors and values which might otherwise not remain in their positions. This allows for a freer and more imaginative use of color and tone. Refer to Color Plate VII, Figs. 1, 2, 3.

Setting Up and
Painting Procedure

On a primed panel, about 10 x 15, sketch a still life. Use a light gray pastel pencil. Work from a few household items—a cup and saucer, a vase and flowers, a few pieces of fruit, and a table napkin (Fig. 145).

Remember the lessons from the chapters on the Visual Language and Drawing. Have a mood or feeling in mind and create linear movements, shapes, forms, a viewpoint, and distance which suggest that mood.

On a separate piece of paper, make a

Fig. 145

rough sketch of your drawing and work out a value plan in black and white.

Make a few more rough copies of your drawing, on separate pieces of paper and experiment with some color schemes. Do these very simply; just paint flat colors and tones, without details. Select a combination of colors, whose chromas, values, and temperatures look as if they will function with the mood you intend. Use this color sketch and the still life itself as guides as you begin to build the colors and values on the painting. But remember, while a value sketch, a color sketch, and the actual still life save time and groping in the initial stages, the painting will make its own demands as the work progresses.

Mix a No. 7 value gray (using Black and White paint) and with a No. 8 round sable brush paint the composition in line. Draw the lines expressively so that they are important in themselves, not just outlines of objects.

First Stage

Now we shall build the colors of the color sketch on the painting itself. But we shall build them indirectly by underpainting with different but harmonious hues and then glazing in some areas and scumbling in others.

1. *Wall*—Anticipating a rich, dark, cool red (see the third stage of the painting Color Plate VII, Fig.3), begin with a light, warm red: Naphthol Red Light and Cadmium Orange mixed with medium until it is semi-transparent. The transparency will enable you to paint freely and even overpaint the lines, which will show through.

2. *Table top*—The final color will be a light gray-green hue. Underpaint the area with a dark blue-green (Cobalt Blue and Permanent Green Light, No. 5 value). Add medium to the paint and brush it on thinly.

3. *Cloth*—A warm gray (Cadmium Red Medium, Permanent Green Light, and White) is used for the underpainting, anticipating lighter-toned hues that will be scumbled over it at a later stage.

4. *Front edge of table*—This area will be a warm hue, related to the warm reds of the background. The underpainting is a mixture of Yellow Oxide and Raw Sienna.

5. *Vase, fruit, and some flowers*—Underpaint with a thin wash of Hansa Yellow (Color Plate VII, Fig. 1).

Second Stage

Study the picture from a distance; turn it on its sides and upside down. If any changes are necessary, make them by first sanding the area down slightly and then painting a fresh white ground of White and gesso.

1. *Wall*—Mix a semitransparent glaze of Naphthol Crimson and a touch of Burnt Umber. Glaze it over the wall, allowing some of the underpainting to show through. Leave the right side lighter in tone. The contrast of this light vertical area may be needed as a compositional balance to the weight and activity of the left foreground. (Note too, in our example, this vertical was repainted so that it tilts to the right, counterbalancing the left tilt of the vase.)

A very transparent glaze of the same hue can be used for the small piece of fruit (front right).

2. *Table top*—If the underpainting is lighter than a No. 7 or 8 value, scumble another coat of the same color over it before proceeding.

Mix a warm green of Yellow Oxide, Permanent Green Light, and a speck of Dioxazine Purple (to gray it) and a touch of White. Scumble this color on, allowing some of the underpainting to show through. Apply the paint with a bristle brush and a painting knife so that you begin to build rich textures, which will contrast the smooth glazes of the wall colors.

Paint freely; do not be afraid to go into or over some of the lines. This style requires a continuous interweaving of color and line as the image develops.

3. *Cloth*—Here, too, if the previous underpainting seems too light, darken it before proceeding.

Mix a No. 1½ value of a cool white (White with a touch of Cobalt Blue) and scumble it over the parts of the cloth on the top side of the table.

Gray the color and darken it slightly (by adding small amounts of Cadmium Orange and Black) for the part of the cloth that folds over the front of the table. Use a brush and a knife to vary the textures; allow some of the underpainting to show through.

4. *Pear*—Lay a thin glaze of Cadmium Orange over the center portion, allowing the yellow of the underpainting to show around the edges. When the paint dries, scumble a second coat within the center area of the first coat of Orange, to build some darks.

5. *Vase*—Mix a very transparent glaze of Thalo Blue, a touch of Raw Sienna, and White. Glaze the center portions of the vase; as before, leave some of the yellow underpainting show around the edges. Apply a second coat to the most central portions, to build some darks.

6. *Cup*—Follow the same procedure as steps 4 and 5, using a glaze mixture of Yellow Oxide, Permanent Green, and White.

This color may be used to scumble on the front edge of the table and some of the flower areas.

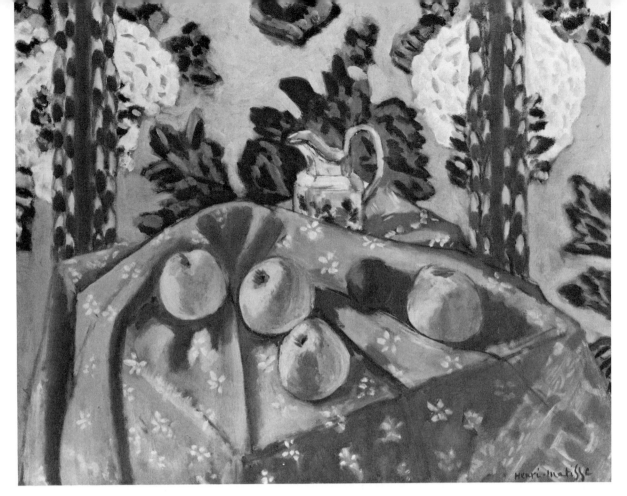

Fig. 146

HENRI MATISSE (1869-1954). "Still Life: Apples on Pink Tablecloth." National Gallery of Art, Washington, D.C. (Chester Dale Collection)

Matisse's paintings are primarily concerned with color and lose much of their beauty in a black and white reproduction. Even so, they are highly instructive. Notice how the underlying compositional structure—the linear movement, the patterns of the textures, the rhythms of lights and darks—is firmly established by the tonal values.

7. *Small fruit* (in the foreground)—Glaze it with a mixture of Thalo Green and a speck of Cadmium Red Light and White.

8. *Edge of table*—Scumble a mixture of Burnt Sienna and White.

9. *Flowers*—Build the colors with light tones (values Nos. 2, 3, and 4) of grayed greens (Permanent Green Light, Orange, and White), grayed yellows (Cadmium Yellow Light, Dioxazine Purple, and White), and off-whites (White and Raw Umber).

Vary the application of these colors by using a bristle brush and knife to create soft, thin, and thick textures (see Color Plate VII, Fig. 2).

Compare the use of line, tone, and pattern in Figure 146.

Third Stage

Once again, stop and evaluate the picture. Look at it in a mirror and upside down; squint at it.

In our demonstration study (Color Plate VII, Fig. 2), some of the compositional considerations are:

The colors of the cloth are not related to the other colors; one possible solution might be some repetition of the colors of the background and table top.

The area around the cup and saucer is not satisfactory; the small areas of green are too even. It might be better to simplify the area by eliminating the saucer. In addition, the color or value of the cup and saucer does not work well. It pushes too far forward; the

top of the cup lines up too evenly with the small piece of fruit on the right side of the picture; the cup might function better as a shape if it were enlarged and taller.

The composition is weighted heavily on the left side, but several elements counterbalance this: the line on the wall and the light-toned panel to the right of it; the curves to the right made by the diagonal movements of the flower stems; the curve made by the eye linking the cup and fruits. Finally, the small isolated piece of fruit on the right creates a tension with all the "activity" on the left, and it acts as a "point" (see page 20) that continually attracts the eye. Care should be taken to retain and reinforce these devices as the painting develops.

Redraw the line, where necessary; do not merely trace around shapes and forms; try to keep the line spontaneous and sensitive; weave it in and out of the colors and the lights and darks.

1. *Wall*—Mix a semitransparent glaze of Naphthol Crimson, Burnt Umber, and a speck of Acra Violet. Glaze and scumble the mixture over the wall area, allowing some of the lighter underpainting to show through; leave the vertical panel on the right predominantly light in value.

2. *Table top*—Note: in the demonstration study, Color Plate VII, Figure 3, the saucer has been taken out and the cup has been enlarged.

Mix a No. 3 value of a gray-green (Permanent Green Light, Cadmium Red Medium, Yellow Oxide, and White). Scumble it on the table top; allow some of the underpainting to work through.

3. *Cloth*—In order to relate the color of the cloth to the major color areas of the picture (the red wall and the green table top), find a way to redesign the cloth in order to repeat those colors. This can be done in many ways—for example, a floral pattern could be created, which would repeat some of the curves of the cup, vase, or fruit; or a simple checkerboard pattern, which would allow the alternation of the two colors.

The colors should not be repeated exactly, for this would be monotonous, but rather, in a variation. For example, for the green, use a very gray green (Permanent Green Light, Cadmium Red Medium, and

White); for the red, use a grayed red (Cadmium Red Medium, Permanent Green Light, and White).

Alternate these colors in the pattern, using them dark for the front of the cloth that folds over the table into the shadows and for the shadows cast by the fruit, vase, and cup; but lighten the colors for the squares on the top side of the cloth.

4. *Vase*—Mix a very transparent glaze of Thalo Blue, Raw Sienna, and White. Glaze this over the center portions of the vase, but allow some of the underpainting to show through.

The same color can be used for the dark tones of the small yellow fruit in the foreground.

5. *Pear*—Using a mixture of Cadmium Orange, Raw Sienna, and White, glaze the dark areas in the center.

Add more White to this color and use it for some of the flowers.

6. *Cup*—Because of its color and value contrast, the cup pushes too far forward, almost on the same plane as the pear. Therefore, its tone and chroma must be lowered. Mix some Yellow Oxide and medium and glaze it over the cup, to tone it down. For the center portions, gray the color down by adding some Dioxazine Purple and White.

Variations of this color, made by adding different amounts of White to it, can be used in some of the flower areas.

If the cup still pushes forward too much, paint over it a very light glaze of Thalo Green (a very small amount of paint and a lot of medium) and then darken the center portions some more, with a grayer and darker mixture of Yellow Oxide. The latter hue can be used to tone down the yellow edge of the table.

The shadow areas cast by the cup and the fruits on the table can be painted with a thin mixture of the warm gray-green of the table top grayed down with some Dioxazine Purple and White.

7. *Flowers*—Mix a rich, warm, dark green (Thalo Green and Raw Umber) to a No. 8 value; use it to accent some of the leaves and foliage.

Mix several hues of light yellows and light oranges and light Yellow Oxides, and use them for the larger flowers. These colors

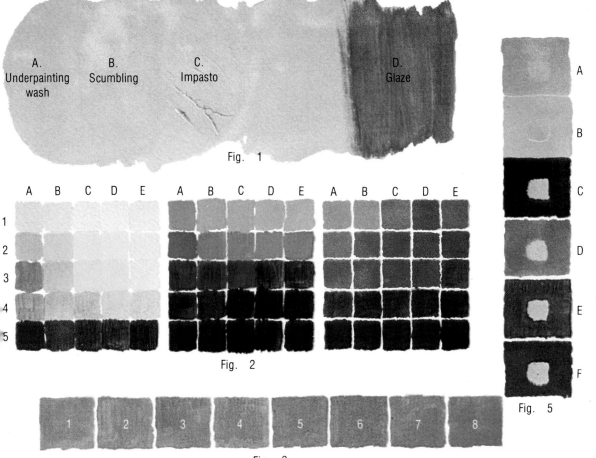

A.
Underpainting
wash

B.
Scumbling

C.
Impasto

D.
Glaze

Fig. 1

A B C D E

1
2
3
4
5

Fig. 2

A
B
C
D
E
F

Fig. 5

Fig. 3

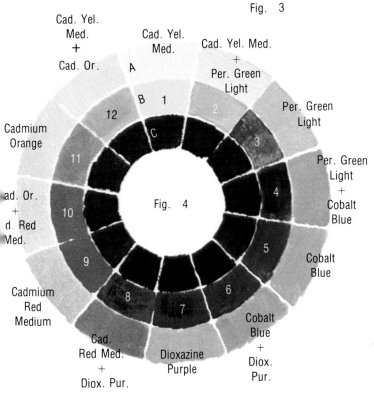

Cad. Yel.
Med.
+
Cad. Or.

Cad. Yel.
Med.

Cad. Yel. Med.
+
Per. Green
Light

Per. Green
Light

Cadmium
Orange

Per. Green
Light
+
Cobalt
Blue

ad. Or.
+
d. Red
Med.

Cobalt
Blue

Fig. 4

Cadmium
Red
Medium

Cobalt
Blue
+
Diox.
Pur.

Cad.
Red Med.
+
Diox. Pur.

Dioxazine
Purple

Fundamentals of Color

These illustrations show the fundamental techniques of paint handling, color mixing, and color theory. Step-by-step procedures for doing these techniques are given in Exercises 5 through 9, on pages 101-106.

Figure 1 illustrates various methods of applying paint. Figure 2 shows how to make a color *warmer, cooler, lighter,* or *darker,* while maintaining maximum intensity. Figure 3 illustrates how to reduce a color's *chroma,* while maintaining its *value.* The color wheel in Figure 4 illustrates the relationships of *primary* and *intermediary* colors. Figure 5 shows the effect on a color of changing its color environment.

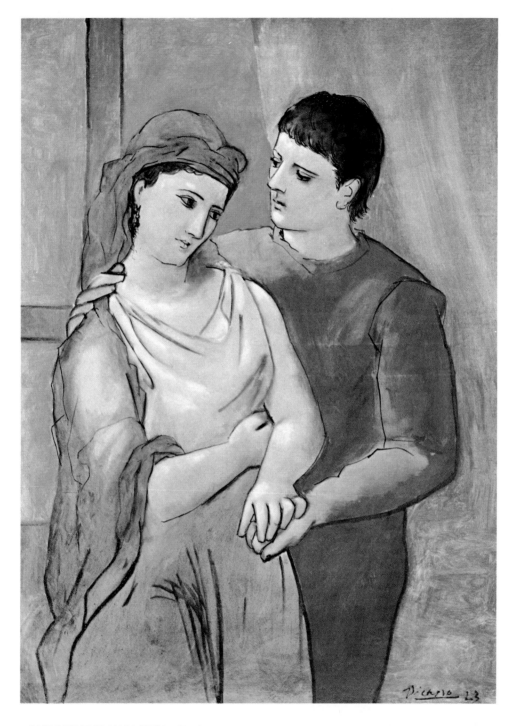

PABLO PICASSO (1881-1973). ''The Lovers.'' National Gallery of Art, Washington, D.C. (Chester Dale Collection)

Picasso's canvas typifies one of the three basic ways painters use color. The shapes and forms are drawn with outlines. Color is *added* as description, as decoration, or to create a mood. Forms are modeled by making each color lighter or darker, rather than by changing its *chroma* or *temperature*.

The second basic way painters use color is demonstrated in the painting by Monet (Color Plate III). Color is paramount; little or no line is used for drawing. Forms are modeled by varying the intensity and the warmness or coolness of colors, in addition to changing their value.

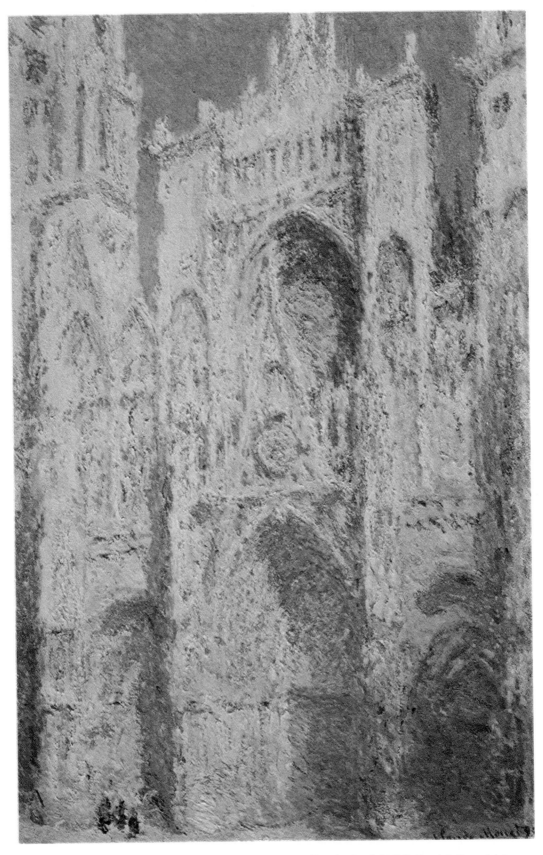

CLAUDE MONET (1840-1926). "Rouen Cathedral, West Façade, Sunlight." National Gallery of Art, Washington, D.C. (Chester Dale Collection)

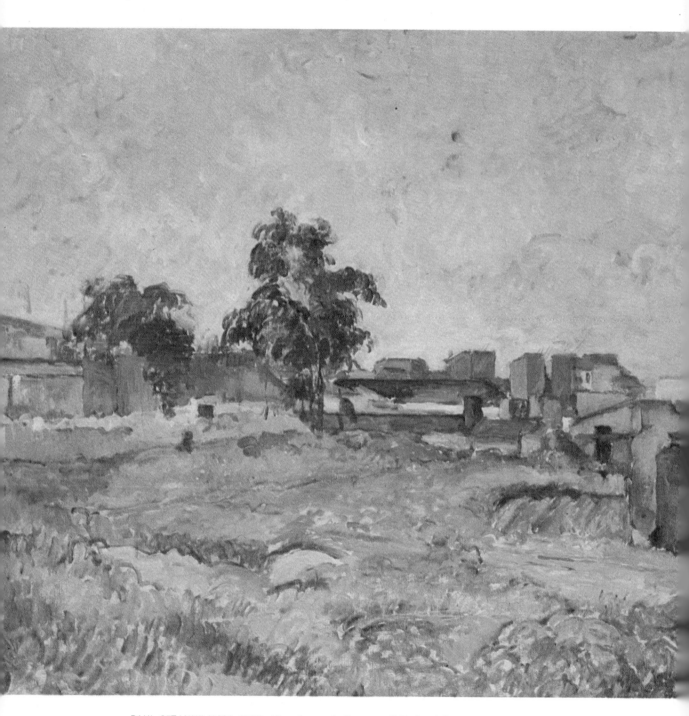

PAUL CEZANNE (1839-1906). "Landscape in Provence." National Gallery of Art, Washington, D.C. (Chester Dale Collection)

The third method of using color, a combination of the first two (Color Plates II and III), is illustrated in this work by Cézanne. Form and space are created by a judicious use of line and the full exploitation of color's fundamental properties—value, chroma, and temperature. That is, the illusion of form and space is achieved by careful manipulation of each color area's lightness or darkness, warmness or coolness, and brightness or dullness. Each brush stroke is considered as if it were part of a great mosaic or intricate musical theme. It fits perfectly in its own position and relates to all the others by being either in harmony with or in controlled contrast to them.

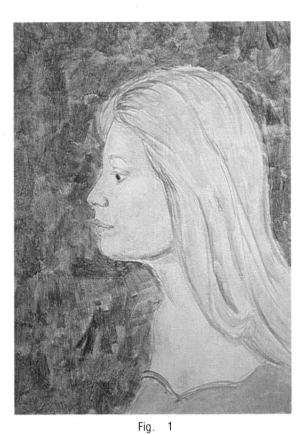

Fig. 1

Painting a Head — 1

This sequence shows a tonal method of painting (modeling form with light and dark values of a color); and the use of a warm *underpainting*. Underpainting is a method of building up colors indirectly in layers. Each succeeding layer is more transparent and permits the underpaintings to work through the upper layers, giving the colors richness and vibrancy. Detailed, step-by-step procedures are given on page 84.

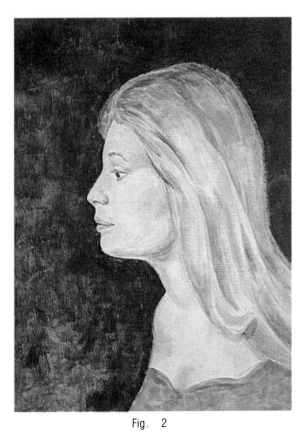

Fig. 2

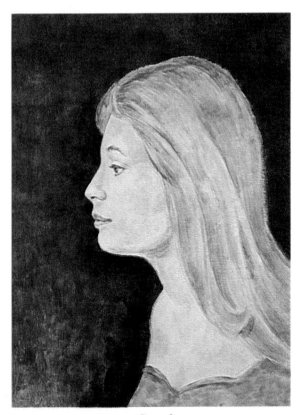

Fig. 3

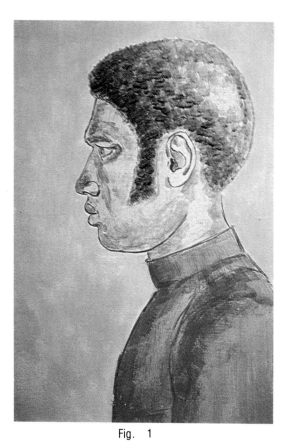

Fig. 1

Painting a Head — 2

This series shows the stages of developing a tonal painting (modeling form with light and dark values of a color); the use of line; and underpainting with cool colors.

In Color Plate V, the warm underpainting harmonized with the overpainted colors. In this technique, the cool colors of the underpainting contrast with the warm-hued overpaintings. The step-by-step procedures for this Plate are given on page 89.

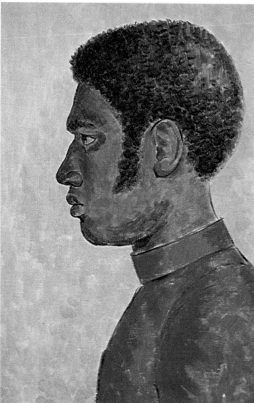

Fig. 2

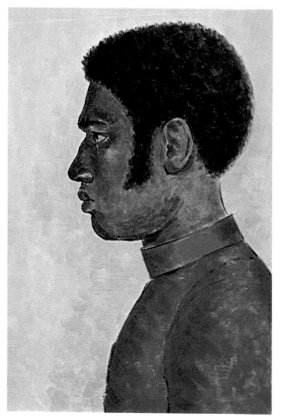

Fig. 3

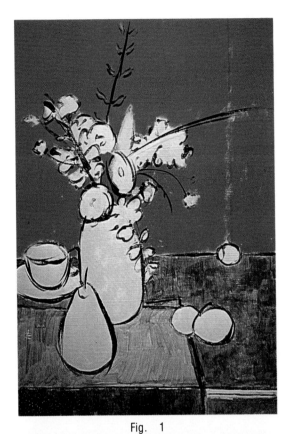

Painting a Still Life

This demonstration explores the style that relies primarily upon line to describe forms, shapes and space. Colors and values are used chiefly to create rhythm and patterns, and secondarily to reinforce forms and space. This use of line as a major element has two important features: 1. Lines become independent elements with their own power of expression. 2. They create a stained-glass effect and "hold" colors in place, permitting a freer color arrangement. Complete instructions for this procedure are given on page 93.

Fig. 1

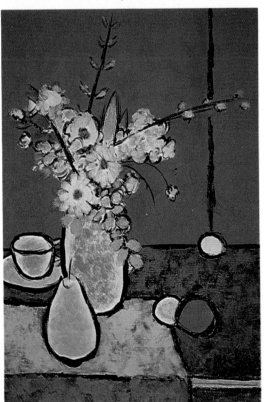

Fig. 2

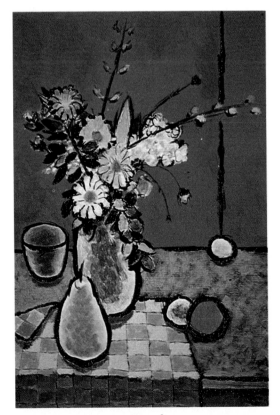

Fig. 3

COLOR PLATE VIII

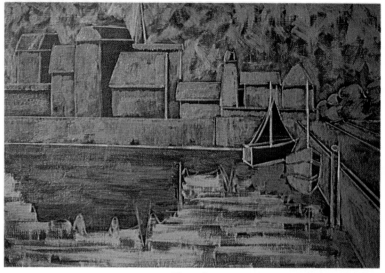

Fig. 1

Painting a Landscape

This study demonstrates a style which concentrates on modeling form by controlling the chromas, values, and temperatures of colors, while using a minimum of line. The sequence also illustrates the procedure for developing a picture from a dark underpainting and incorporating textures as a vital element in the composition. Complete instructions for this procedure are given on page 97.

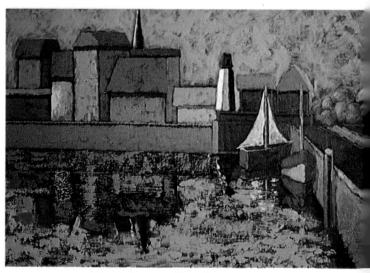

Fig. 3

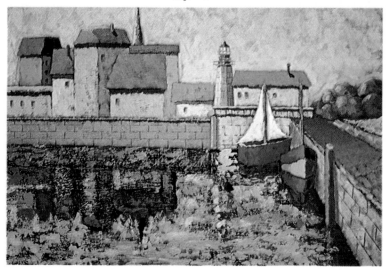

Fig. 2

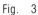

can be applied as impastos, which will give them a handsome contrasting quality against the thin glazes of the background.

Notice that in our example (Color Plate VII, Fig. 3), some more compositional changes have been made:

Another stem and flower have been added to help carry the eye to the right and balance the activity and weight of all the forms on the left.

The left side of the tablecloth has been redrawn, creating a diagonal that echoes those of the stems and contrasts the horizontal and vertical patterns of the cloth. It also breaks up the too even shape of the table top, above the cloth.

The picture can, of course, be refined even more. Each line, shape, form, texture, value, and color can be evaluated for possible ways to make them either harmonize or contrast to better effect.

In carrying out these exercises, you are gaining considerable knowledge and experience in handling paint, mixing color, chromas, and values; and in glazing and scumbling. In addition, you are learning how to organize and develop a painting as a total entity. In the next exercise, you will learn still another style and technique.

Exercise 4
Painting a Landscape

In this study, we will use a minimum of line to describe forms, modeling them instead with lights and darks, which are reinforced by warming and cooling the colors or by graying them. We shall also build the colors up from a very dark ground and make use of textures obtained by applying paint heavily with a knife. Refer to Color Plate VIII, Figures 1, 2, 3.

Setting Up and
Painting Procedure

Gesso a panel (about 10 x 15). When it is dry, sand it down slightly and give it a coat of a dark-toned blue (about a No. 9 value of Ultramarine Blue and Black).

Subdivide the panel into quarters with a white pastel pencil (to aid you in working out

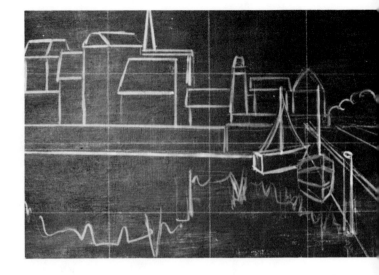

Fig. 147

the composition). Work the composition up in a yellow pastel pencil. When you are satisfied with it, paint it in with Yellow Oxide (Fig. 147).

First Stage

As in the previous studies, the entire picture will be underpainted in order to develop it in a unified manner. In terms of composition, we shall divide the picture into two main tonal areas: the buildings, boats, and piers will be of a medium-dark value; while the sea and sky will have a light tone. Within those shades we can create variety through a few extremes of lights and darks, and a few strong colors used judiciously.

1. *Sky and water*—Use a dark blue-gray underpainting: Ultramarine Blue, a speck of Cadmium Orange, and White, mixed to a No. 5 value; add some gel and medium so that you can apply the paint heavily, with a large flat bristle brush. Use broad horizontal strokes, leaving some of the dark ground show through in places.

Use the same color as the sky for the areas of the water that will *not* have the reflections of the buildings and pier. Again, use broad horizontal strokes.

Darken the color one or two values with some Black and paint it over the areas that *will* have the reflections.

2. *Buildings, piers, and boats*—Mix a

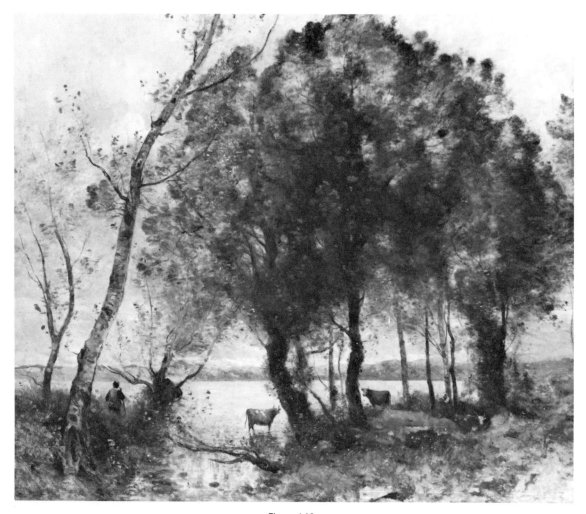

Fig. 148

JEAN BAPTISTE CAMILLE COROT (1796-1875). "The Lake." Copyright the Frick Collection, New York

As noted in the Chardin still life (Fig. 116), an artist can create a monumental and eloquent visual statement using a few humble forms as a starting point. Corot often used the most modest landscapes as an inspiration and composed them into delicate harmonies of tone, color, and texture, which became images of great lyric expression. In this example, the humans, the animals, and the countryside are fused—through artistic means—into a serene, poetic tableau. Notice in particular how Corot unifies everything by using close value relationships and soft edges.

warm gray composed of Raw Umber, Ultramarine Blue, and White to a No. 7 value. Paint it loosely in the areas of the buildings,

piers, and boats that will be light and warm in the final painting.

For the moment, let the dark of the ground serve as the dark side of the forms (Color Plate VIII, Fig. 1).

Second Stage

The value and temperature divisions that were established in broad simple patterns in the first stage will help maintain that compositional pattern as more colors, chromas, tones, and textures are introduced.

1. *Sky and water*—Mix Cobalt Blue, Raw Umber, and White to a light blue-gray (about a No. 2 value). Use this for the sky, applying the paint with a large flat bristle brush. Allow some of the underpainting to

show through; keep the strokes free and spontaneous.

2. *Buildings, piers, and boats*—Build the forms by modeling them with warm, light colors on the light sides and cool, gray hues on the dark sides. For example, the roof of the third building from the left (the tall rectangular one) is painted as follows:

For the light side, mix Cadmium Red Medium, Burnt Umber, and White to about a No. 4 value; apply the paint heavily (add gel to the pigment) with a bristle brush and painting knife.

To paint the dark side of the roof, deepen the color and gray it slightly by adding Burnt Umber and Permanent Green Light; apply this paint thinly with a brush.

The front side of the building is painted with the same color as the front of the roof, but with the addition of some Burnt Umber and White. Add some gel to the paint so that you can apply it thickly with both a brush and knife. Let some of the thinner underpainting show through so that there will be an interesting contrast of textures.

The dark side of the building is obtained by adding more Burnt Umber and a speck of Thalo Green to the previous color, to darken and gray it. Apply this hue thinly. Use the same color for the shadow under the front roof. Add more Umber and Green for the shadow under the side of the roof.

These colors can also be used in the areas of the water that reflect the building. As with the reflections of the sky, apply this paint boldly with a painting knife, allowing some of the dark underpainting to show through.

With the experience you have gained, studying or painting the previous three pictures, you should be able to look at the reproduction of the second stage of the study (Color Plate VIII, Fig. 2) and analyze the color mixtures of the other buildings; do so and complete the second stage.

Study Figure 148 with particular attention to the delicacy of the tones and textures.

Third Stage

Before proceeding, let us study the second stage (Fig. 2) and see what composi-

tional problems have developed and how they might be solved.

The colors of the buildings on the left (with the exception of the first gray one) seem to work well together; they have variety, which creates interest, but they are also sufficiently related in hue and value so that they combine into an entity that is greater than the parts. The gray of the first building is neutral; it neither contributes nor detracts.

The greenish-blue roof of the horizontal building (which is almost in the center) seems too bright and intense, at this stage, but it may work when the surrounding colors are strengthened.

Similarly, the left side of the lighthouse is so light in value that it pushes forward, out of its position and space.

The two buildings to the right, above the boats, are too even in weight.

The composition is built upon variations of rectangular forms with a few related triangular and conical ones (Fig. 24). Contrasts are created by the strong diagonal thrust of the pier on the right and the curves of the shrubbery in the rear right. These curves seem isolated and unrelated to anything else in the picture; but a subtle repetition can be created by treating the edge of the building reflections, on the lower left, as a group of echoing curves. This is more desirable than an obvious solution such as repeating another clump of trees on the other side of the picture or adding a few clouds with shapes similar to the foliage.

Regarding the color scheme: While all the colors have been muted (grayed down), the red on the left side of the boat is pure (it may not be quite so bright in the reproduction). Yet, because it is small in area, it seems to hold its place in space. However, because of its brightness and tendency to push forward, the muted blues and yellow on the other boat seem dull and weak by comparison. Keeping these considerations in mind, continue as follows:

1. The two buildings on the right are redrawn; they are combined into one horizontal shape which harmonizes with the other buildings and carries their rhythmic movement across the picture.

2. The sky is lightened and the

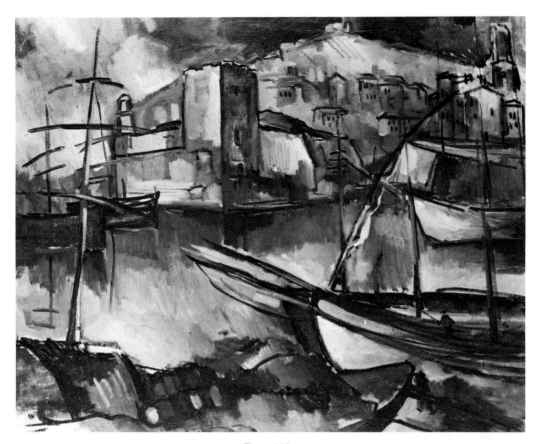

Fig. 149

MAURICE DE VLAMINCK (1876-1958). "The Old Port of Marseille." National Gallery of Art, Washington, D.C. (Chester Dale Collection)

Vlaminck was a member of a group of artists called the *Fauves* ("savage beasts") active from 1905-1907. They wanted to free themselves from traditional ideas and techniques, and they did so by using the elements of the visual language (see Chapter I) in a free, almost totally abandoned manner that was independent of subject matter. Those elements became as important as the subject matter itself in creating expression.

Despite so radical an approach, if we compare this painting to the Corot (Fig. 148), we find similar basic factors at work; both artists have taken nature as a starting point and expressed their response to it. To communicate that response effectively, both organized the elements of the visual language (see Chapter I) into unified patterns and rhythms. In the Vlaminck, these elements dominate the subject matter, marking this type of painting as a prelude to full abstraction (which indeed followed a few years later, see also Chapter VI). Its vitality and expression are achieved chiefly from our response to lines, tones, textures, shapes, forms, colors, and the very energy of the brush strokes themselves.

brushwork simplified (though some of the underpaintings are still permitted to show through in places) to act as a smooth background, against which all the patterns and textures of the other elements may play. A delicate pink is added to the right side of the sky, for variety and also to resonate with the warm tones on the left side of the picture.

Do *not* lighten the reflection of the sky; instead, mix a very transparent glaze of Thalo Blue and a touch of Raw Umber; wash it over the entire water area. This will tone down the colors and values, creating a subtle contrast between the colors of the buildings and sky and their reflections.

3. Add some of the details: chimneys, windows, brickwork, and the features of the lighthouse. Keep their edges soft and not too dark; otherwise they may look like holes in the picture, or they may seem to jump forward.

The picture (Color Plate VIII, Fig. 3) could be developed still further. Put it away

for a few days. When you look at it again, with a fresh eye, many things that appeared to be acceptable during the concentration required in the first stages will suddenly look wrong.

Evaluate the entire composition and then individual sections, asking questions discussed in the composition section.

Compare the handling of landscape by Maurice de Vlaminck (Fig. 149) with that in Figure 148.

Assignment

The four exercises you have done, have introduced you to the major techniques of painting. Now you will certainly want to use these techniques freely for self-expression and the creation of beautiful images.

You may want to paint compositions of your own devising, or you may try doing the exercises again but with greater complexity—for example, a three-quarter view or full-face view, or a full figure; a still life with many more objects; a more complicated landscape.

The Charts on Color Plate I

If you have had trouble mixing colors or understanding their relationships, it will be of great benefit for you to go step by step through the process of painting the charts shown on Color Plate I. Work on a 10 x 15 gessoed panel.

Exercise 5
Applying Pigment

Since the late nineteenth century (see Chapter VI), paintings have been considered objects in their own right, rather than illusions of other objects. Part of that philosophy has been reflected in the attention paid to the surface quality of pictures. Artists strive to achieve a textural surface that has the intrinsic beauty and sensuality of a fine piece of wood, stone, or fabric. This exercise will teach the technique of applying pigment.

Washes. Squeeze about ½ inch of Cadmium Yellow Medium onto the palette. Using a No. 5 flat bristle brush, thin the paint down with water and several drops of medium, until the paint has a watery consistency. Brush it onto the panel, covering about an 8 x 3 area.

Acrylics, used this way, have the brilliance and luminosity of watercolors, with the advantage of drying waterproof. That is, you can work over that color without disturbing it.

Scumbling. After that first wash of color has dried (see A in Fig. 1)—it will take just a few moments—squeeze another ½ inch of Cadmium Yellow Medium onto the palette. Use a No. 3 round bristle brush (first moistening it and wiping out the excess water on a rag), and dab little strokes of pure paint over the wash (see B in Fig. 1).

Impasto. Squeeze out another dab of the Yellow and mix in an equivalent amount of gel (with a painting knife). Apply it in thick dabs with the knife (see C in Fig. 1).

Acrylic impastos must be handled judiciously. Applied thickly, directly from the tube, acrylics dry with a cheap, rubbery-plastic look. To avoid this, always add gel to impastos. To build extra thick impastos, add modeling paste and gel to the color.

Glazing. Squeeze ¼ inch of Cadmium Red Light on the palette. With the palette knife, mix it thoroughly with medium until the mixture is very thin and transparent. Using a No. 6 flat sable brush (first moistening it and then wiping it almost completely dry), brush the paint thinly over part of the yellow underpainting (see D in Fig. 1). Glazing has the effect of laying one piece of colored glass over another. It permits the underpainting (yellow, in this instance) to show through and "mix" with the transparent red glaze, to create a rich, luminous orange color.

Assignment

Practice brushing on paints in different degrees of thickness and thinness (adding water, medium, or gel to the paint). Scumble over these washes with different tones and colors of semidry paint. Practice glazing; build up colors with successive layers, by overglazing with the same color several times, and also with different colors.

In addition to learning the effects different brushes and knives create with different consistencies of paint, practicing this assignment will develop your sensitivity to paint surfaces.

Exercise 6
Mixing Colors

This exercise will teach you to mix colors: how to change *values* while maintaining maximum intensity (*chroma*); see Color Plate I, Figure 2.

Rule ½-inch squares as shown. Number down the units from 1 to 5 and across the tops from A to E.

Begin with the yellow chart. First we will change the *value* (lightness or darkness) of this color.

1. Place Cadmium Yellow Medium in the center square (3-C) of the yellow chart.

2. To lighten it, merely add White. Add enough so that it is two or three values lighter than the Cadmium Yellow Medium; paint it in square 2-C. Add more White until the value is almost off-white; paint it in square 1-C.

3. To darken it, add Yellow Oxide to the Cadmium Yellow Medium until the value is two or three values darker; paint it in square 4-C. Next, add Burnt Umber to the previous mixture, until it has about a No. 8 or 9 value, and paint it in square 5-C.*

Now we will change the *temperature* of the yellow, making it warmer, moving through orange toward red, on the left side of the chart; and cooler, moving through green toward blue, on the right side of the chart.

4. To cool the yellow, paint Cadmium Yellow Light or Yellow Light Hansa, which are cooler than Cadmium Yellow Medium, in square 3-D.

5. Add White to it for squares 2-D and 1-D.

6. To darken Cadmium Yellow Light, add Yellow Oxide for square 4-D and Raw

*Space has limited us to charts of 25 squares. You may wish to try 100-square charts, which will enable you to include more steps. For example, many more steps are possible between squares 4 and 5 in the 25-square chart. The same will be true when moving from left and right of the center squares.

Umber for 5-D. Raw Umber has a cool, greenish cast; Burnt Umber is warmer—that is, redder.

7. Mix Cadmium Yellow Light or Yellow Light Hansa with a speck of Permanent Green Light, and paint it in square 3-E.

Add White to the 3-E mixture for squares 2-E and 1-E; and Yellow Oxide and Raw Umber to the 3-E mixture for the darker squares, 4-E and 5-E.

8. To warm yellow, mix Cadmium Yellow Medium with a speck of Yellow Orange Azo; paint it in square 3-B.

Add White to the mixture for the lighter squares, 2-B and 1-B.

Add Yellow Oxide and some Burnt Umber to the 3-B mixture for square 4-B; and just Burnt Umber to the 3-B mixture for square 5-B.

9. To warm the yellow further, mix some Cadmium Yellow Medium with an equal amount of Yellow Orange Azo; paint it in square 3-A.

Add White to the mixture for the lighter squares, 2-A and 1-A.

Add Yellow Oxide and some Burnt Umber to the 3-A mixture for square 4-A; and just Burnt Umber to the 3-A mixture for square 5-A.

To paint the blue chart, follow these steps:

1. Use Cobalt Blue, which is neutral in temperature, in square 3-C. Lighten it with White for squares 2-C and 1-C. Black can be used to darken most blues, because the resulting values are quite dark and loss of intensity is not easily discerned. However, if you wish to mix more value-steps than are shown between squares in the 25-square Color Plate, it is necessary to use a blue darker than Cobalt (one that is related to it in hue) before adding Black. Add equal amounts of Thalo Blue and Cobalt for square 4-C and then add a little Black to that mixture for square 5-C.

2. To cool the blue, add green. For square 3-D, add a small amount of Thalo Green to the Cobalt Blue of 3-C. For squares 2-D and 1-D, lighten with White. For squares 4-D and 5-D, darken by adding Black to the mixture of Cobalt Blue and

Thalo Green in 3-D.

3. To cool blue still further, add more Thalo Green than was used in the 3-D mixture and paint in square 3-E. For squares 2-E and 1-E, lighten the 3-E mixture with White. For squares 4-E and 5-E, add Black to the 3-E mixture.

4. To warm the blue, make it redder. Ultramarine Blue has a purple cast and can be used for square 3-B by adding a speck of Dioxazine Purple to it. For squares 2-B and 1-B, add White to the 3-B mixture. For squares 4-B and 5-B, use Ultramarine Blue plus a speck of Dioxazine Purple and Black.

5. For the warmest column, add more Purple to the Blue for square 3-A. Lighten it with White for squares 2-A and 1-A. For squares 4-A and 5-A, darken the 3-A mixture with Black.

The red chart is painted as follows:

1. Use Cadmium Red Medium for square 3-C. Squares 2-C and 1-C have White added. Square 4-C is darkened by adding Raw Sienna to the Red. For square 5-C, add Burnt Umber to Raw Sienna.

2. To cool the red, move it toward blue by first adding purplish-reds. For square 3-D, use Cadmium Red Medium plus Naphthol Crimson. For squares 2-D and 1-D, lighten by adding White to the 3-D mixture. For squares 4-D and 5-D, Burnt Umber and a touch of Black are added to the 3-D mixture.

3. The coolest column in the red chart is based on Acra Violet in square 3-E. White is added for squares 2-E and 1-E. For squares 4-E and 5-E, Black is added to Acra Violet.

4. To warm the red, move toward orange; use Cadmium Red Medium plus Cadmium Yellow Medium for square 3-B. Lighten with White for squares 2-B and 1-B. For square 4-B, add Burnt Sienna to mixture 3-B. For 5-B, add Burnt Umber to mixture 4-B.

5. For the warmest red, in square 3-A add even more Cadmium Yellow Medium to Cadmium Red Medium than in 3-B. Squares 2-A and 1-A are lightened with White. For 4-A, add Burnt Sienna to the 3-A mixture. For square 5-A, add Burnt Umber to the 4-A mixture.

Exercise 7
Chroma

Chroma refers to the intensity or the degree of purity or grayness of a color. This should not be confused with value (lightness or darkness). For example, two blues may have the same value, but one can be bright and the other dull.

It is important to understand the uses of chromas and how to mix them. You may wish to paint a passage of a particular color (orange, for example), but the pigment as it comes from the tube (Cadmium Orange) might be too strong or pure. It is not possible to use Black or Burnt Umber to reduce its strength or purity (chroma) and still maintain its general ("orange") character and its value. Black would both lessen the intensity of Cadmium Orange and change its color; on the other hand, Burnt Umber would merely darken the Orange, making it an intense dark orange.

To lower a color's chroma, mix it with its complement. Complementary colors are opposites. (To find the complement of Cadmium Orange, look at the color wheel, Color Plate I, Figure 4. The color opposite Cadmium Orange is Cobalt Blue.) Complements neutralize each other; that is, when approximately equal amounts of any color and its complement are mixed, they produce a gray. This phenomenon makes it possible to use complements to lower the chroma—to "gray" each other down—while maintaining a relationship to the original hues.

To apply these principles to a particular example, proceed as follows:

1. Rule off eight rectangles as shown in Color Plate I, Figure 3. Paint Cadmium Orange in rectangle 1.

2. Mix a little Cobalt Blue into the Cadmium Orange; notice that the orange now appears slightly duller, less intense, and a bit darker. Add a little White to the mixture until its value is the same as that of the original Cadmium Orange. Test this by holding the painting knife, with the paint on it, over the rectangle with the Cadmium Orange and squinting at it. When the values are the same, they will seem to merge. If the new hue is too light, add more Cadmium Orange and Cobalt Blue, to darken it. (Different paints and

mediums dry slightly lighter or darker than they appear when painted. Generally, wet colors look darker than they will when they are dry. Experience will enable you to compensate for this when mixing values.)

When the second value is correct, paint it into rectangle 2.

3. Add some more Cobalt Blue and White to the second mixture and paint it into rectangle 3.

4. Continue the process for at least eight steps.

If you have worked carefully, all the rectangles should have equal value, but each rectangle should be less intense (lower in chroma) as you look across from left to right.

As more Blue is added—steps 6, 7, and 8 (and 9, 10, etc., if you are using more rectangles than are shown in Figure 3)—the hues can be classified as grayed Blues rather than grayed Oranges.

It should also be noted that an infinite range of grays can be obtained by combining complementaries and that they are considerably more interesting than those mixed with just Black and White.

Exercise 8
Color Relationships

The preceding exercises were concerned with the characteristics of individual colors. This exercise will help you to study colors in relationship to each other.

Yellow, blue, and red are called *primary* colors; from them, all other colors are mixed: if you mix yellow and blue, for example, you get green; on the other hand, there are no colors you can mix to obtain yellow, blue, or red. Thus, mixing approximately equal amounts of any two primaries produces what are called *secondary* colors: green from yellow and blue, as mentioned; violet (purple) from blue and red; orange from yellow and red. It is possible to buy secondary colors as pigments, premixed in tubes, and most artists find it more convenient to do so; accordingly, both premixed primary and premixed secondary colors are used in this exercise.

1. Draw a color wheel as shown in Color Plate I, Figure 4. Divide the three rings into twelve equal sections.

2. Paint the three primary colors in the rings: Cadmium Yellow Medium in section 1 of the middle ring (B); Cobalt Blue in section 5 of the middle ring (B); and Cadmium Red Medium in section 9 of the middle ring (B). (Note: Pigment names of colors are given initial capital letters to distinguish them from the common, or generic, names for hues.)

Add White to each color and paint the resulting tint in the sections of the outer ring (A). Consult the color charts (Color Plate I, Fig. 2) for the correct mixtures for the dark shades, and use these to paint the sections of the inner ring (C).

3. In ring B, paint Permanent Green Light in section 3; Dioxazine Purple in section 7; and Cadmium Orange in section 11. In ring A, lighten the same three sections with White; and in ring C, darken them with the appropriate colors (consult the charts in Fig. 2).

Primaries and secondaries are complementary colors: yellow and purple; green and red; blue and orange. Complements or opposites have, in addition to the neutralizing effect discussed in Exercise 7 (Chroma), the ability to enhance each other. A blue or yellow will appear "bluer" and "yellower" when placed next to each other than they will when placed next to any other color.*

4. Now complete the wheel with a third group of *intermediary* colors:

Mix approximately equal amounts of Cadmium Yellow Medium and Permanent Green Light until you get a color that is about halfway between the two — a yellow-green. Paint it in section 2 of ring B. Lighten it with White for ring A and darken it with Black for ring C.

5. Mix a blue-green color (halfway between green and blue) with Permanent Green Light and Cobalt Blue, and paint it in section 4 of ring B; lighten and darken it appropriately for the other rings.

6. Mix Dioxazine Purple and Cobalt Blue to obtain a blue-violet color, and paint it in section 6 of ring B; lighten and darken it appropriately.

*A yellow may appear very *bright*, when it is surrounded by a dark gray or black, but this is due to *value* contrast rather than *color* contrast (see Fig. 5).

7. Combine Cadmium Red Medium and Dioxazine Purple into a red-violet hue, and paint it in section 8 of ring B; lighten and darken it.

8. Mix Cadmium Red Medium and Cadmium Orange to a hue halfway between them—a red-orange—and paint it in section 10 of ring B; lighten and darken it.

9. Finally, mix Cadmium Orange and Cadmium Yellow Medium to a yellow-orange, and paint it in section 12 of ring B; lighten and darken it to complete the color wheel.

This wheel represents general color theory. However, because of the peculiarities of the chemicals and pigments from which paints are made, the mixtures derived from the directions given above are not as pure and vibrant as the theory states. Thus many artists prefer to use a modified system in order to obtain maximum chroma and vibrancy. The system uses a double set of primaries: a warm and cool yellow; a warm

and cool blue; and a warm and cool red. Thus, for example, a yellow-green (section 2 on Figure 4) mixed with Cadmium Yellow Light (which has a slightly greenish cast) and Permanent Green Light will produce a much more intense color than one mixed with Cadmium Yellow Medium (which has an orange cast and therefore grays the resulting color slightly).

Assignment

Paint another color wheel using the double primary system (Fig. 150). Compare it to the first wheel.

Uses of the Color Wheel

The color wheel can be used as a basic guide to color relationships. It should be borne in mind that the wheel shows just a few colors and a light and a dark shade of each. If we increased the number of steps

Fig. 150

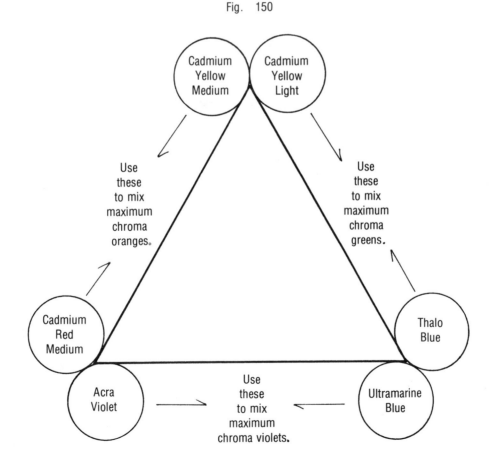

between each primary and secondary color, and then lightened and darkened them so that every color had at least nine values; and then mixed nine-step chroma changes for each of those values, we would have hundreds of hues, values, and chromas available as a color "vocabulary" to work with.

Studying the wheel, with a few simple rules in mind, will keep you from being overwhelmed by the vast number of possible color choices. The first rule is simplicity. Do not attempt to use large numbers of colors all at once.

Harmonious color schemes are created by using adjoining colors on the wheel. Two adjoining colors obviously harmonize easily, because they are almost monochromatic, but such a color combination would be monotonous unless it had a great many value contrasts. Three adjoining colors would be more interesting, because there is more color contrast within the harmony. A good all-around formula is to use five colors that adjoin on the wheel, preferably with the middle color dominant—for example, a color scheme with Cadmium Yellow Medium predominant and lesser amounts of colors 11 and 12, and 2 and 3. Another helpful rule, if you use a lot of colors that contrast: Do not use too many value contrasts.

If the mood of your picture requires a less harmonious color scheme ("less harmonious" does not imply "disorganized")—one with colors that are not related by being close to each other on the wheel—you can build color structures based upon complements. For example, a picture could be basically composed of Cadmium Yellow Medium and its complement Dioxazine Purple, with one of them dominant and many different values and chromas of each included. Because they are opposites, they will generate visual color excitement even though there are only two hues. Color Plate VII is a good example.

A variation of this method is to use indirect complements; that is, instead of Dioxazine Purple as a complement of Cadmium Yellow Medium, use No. 8 (Cadmium Red Medium plus Dioxazine Purple) and No. 6 (Cobalt Blue plus Dioxazine Purple).

These "rules" and "formulas" should not be thought of as unbreakable. They are sound principles, with which many artists begin. Later they are altered to create a personal color style.

Exercise 9
Color Environment

We shall examine one more important aspect of color relationships: environment, the effect of surrounding colors upon an individual hue.

We seldom view an isolated color. A color seen against a black or a white background (each considered a condition without color) is affected by that background, if only in terms of value. Look at Color Plate I, Figure 5; the same yellow has been painted in several different environments.

In A, the background is a very light orange, which offers both a weak color and value contrast; consequently the yellow almost disappears in its environment.

The value contrast in B is still weak, but there is a bit more contrast between the "color" of the white background and the yellow.

The black environment of C, creates a maximum value contrast, causing the yellow to stand out strongly.

In D, a darker orange than the one in A causes a stronger contrast of value than it did in A, but not a strong color contrast, because the colors are closely related on the color wheel.

The dark green of E is a strong value contrast to the yellow, but in terms of color it is relatively harmonious, because green is close to yellow on the wheel.

The environment of F, violet, is the strongest color contrast to the yellow because it is its opposite, its complement. It brings out the "yellowness" of the yellow as no other color will. Notice that in C, while the yellow looks very strong, it is due to the value contrast. If we used a still darker violet (Dioxazine Purple, which is almost as dark as black), it would create the greatest contrasts, both of value and of color.

Thus it is evident that a color in itself is, in a sense, neutral. Its temperature, intensity, and value must always be considered in

relationship to the temperatures, intensities, and values of colors that surround it.

Exercise 10
Color Schemes

1. Prime a 10 x 20 masonite panel with gesso; draw an abstract design (Fig. 151).

Fig. 151

Fig. 152

2. On a piece of paper, trace or copy the design and work out a value pattern (Fig. 152).

3. Using the value pattern as a guide, paint a version of the design in a blue harmony on your panel. That is, use different values of Cobalt Blue as the dominant hue and the colors that are adjacent to it on the color wheel (Nos. 4 and 6) as subordinate colors.

4. Trace shape "X" of the design several times on a piece of paper. Cut out the shapes and paint them each a different value and chroma of Cadmium Red Medium, Cadmium Orange, and Cadmium Yellow Medium.

5. Place these colored cutouts, one by one, over the shape on the painting and observe how each hue, chroma, and value changes the mood, compositional balance, and spatial relationships. For example, warm, intense colors—reds, oranges, and yellows with strong chroma—tend to push forward.

By practicing this exercise, you will begin to appreciate how the slightest change of color, chroma, value, or temperature affects the composition and expression of a picture. It is in this sense that a great colorist manipulates color, rather than using it only as decoration or for the description of objects.

6. Cut out paper shapes of other areas of the design and paint them with different colors, chromas, and values. Lay them over their corresponding shapes on the painting. Observe the effects and ask questions: Does it help or confuse the mood you wish to express? Does it jump forward or recede too much? Does it upset the value pattern or composition, by changing the balance?

Sometimes you may like the effect of a new color even though it upsets the balance. In that case, experiment with ways of integrating it into the painting, by changing some of the other areas of the picture.

Assignments

Continue the previous exercise with several different designs and color harmonies. They will increase your sensitivity to the effects of color and help you learn to solve compositional problems.

When visiting museums or looking at good color reproductions in books, ask questions about the use of color: Why did the artist use a particular blue of a particular intensity and value in a certain area? Does it really "work"; that is, does it hold its place in two-dimensional and three-dimensional space, or does it seem to jump forward or recede too much? Does it harmonize with the colors near it or does it contrast with them (according to the rules of the color wheel)? Try to imagine a different color in its place.

Finally, does the artist create an original color "statement"; that is, did the artist create expression through the use of color or has she/he merely *listed* the colors of things?

Study James McNeill Whistler's "The White Girl" (Fig. 153). It incorporates excellent solutions to the painting problems discussed in this chapter.

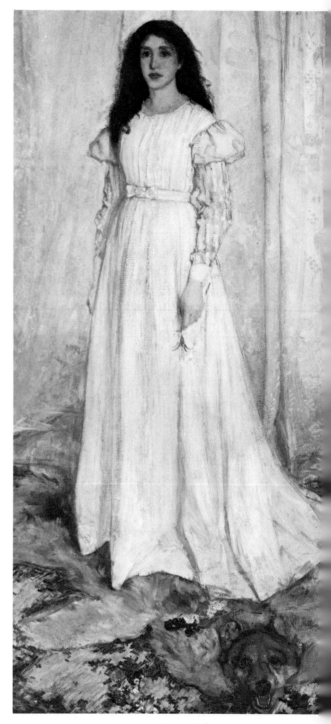

JAMES McNEILL WHISTLER (1834-1903). "The White Girl (Symphony in White, No. I)." National Gallery of Art, Washington, D.C. (Harris Whittemore Collection)

The works of Whistler are instructive to our analysis of drawing, tone, and color in painting, because he synthesized them so ably. Even in 1862, the year this was painted, Whistler was deeply concerned with the effects of the pure visual elements in painting, and as his subtitle indicates, he was seeking analogies to the abstract, expressive elements of music. He was also influenced by Japanese prints (see Fig. 273), with their emphasis on dynamic two-dimensional patterns. He was able to integrate that influence with his love of traditional drawing and achieved an effective combination of spontaneity within a highly ordered design structure.

Notice how Whistler composes the tonality: The overall key is light; each form is modeled in a close value range; the strongest contrast is used around the face, created by the dark tone of the hair, which also balances the middle tones massed in the lower portion of the picture.

Whistler was also concerned with making a psychological statement about the model. He did this not only by his selection of tonal key and other compositional devices, such as his placement of the figure, but by contrasting her uncommitted stance and masklike expression, with symbols (the downcast flower she holds and the dead but ferocious beast she is standing on) of some inner turbulence he knew the young woman to be struggling with.

Fig. 153

FUNDAMENTALS
OF SCULPTURE

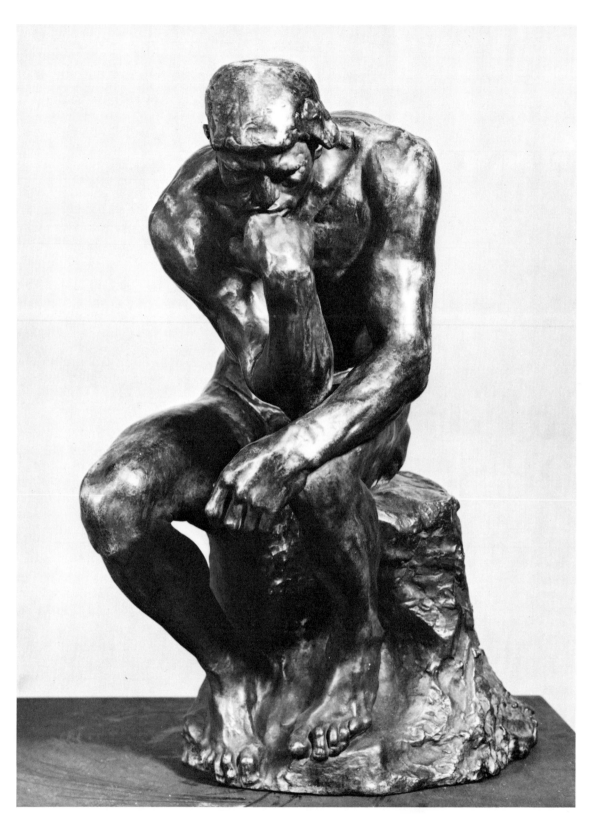

AUGUSTE RODIN (1840-1917). "The Thinker." National Gallery of Art, Washington, D.C. (Gift of Mrs. John W. Simpson)

Chapter IV

FUNDAMENTALS OF SCULPTURE

SCULPTORS, LIKE PAINTERS, utilize the descriptive and expressive powers of the visual language: line, shape, form, texture, value, and color. In addition, they must also consider a sculpture's unique feature: its relationships of real forms in real space.

While painting traditionally encompassed a broad range of subject matter, until the twentieth century sculpture dealt primarily with the human figure (Fig. 154). The influence of modern painting expanded sculpture's scope. Sculptors began to work with abstract forms and unorthodox materials. They also departed from the prevailing concept that sculpture is essentially a solid mass in space. They became concerned instead with integrating space with the solid mass. For them space surrounded the piece and spaces moved through the piece, creating a larger, more complex artistic entity (Fig. 155).

Despite these changes, the fundamental principles of sculpture remain the same: *carving*, the relationships that result when parts of a material are cut away; and *modeling*, the relationships that result when materials are added to each other.

Carving

Since prehistoric times, wood and stone are the materials that have been generally used for carving, because of their natural beauty and relative permanence. In addition, the qualities of a particular piece of wood or stone may influence the design of the final carving (Fig. 156).

Both materials are heavy, cumbersome, and expensive. Wood that you find must be allowed to dry for at least a year to be certain that no serious cracks develop. Carving tools are also expensive and require skillful sharpening. Moreover, the carving process itself is extremely slow and can prove discouraging for the novice. For these reasons, the beginner is advised to start with clay.

Modeling with Clay

The two types of clay used by sculptors are *wet clay* and *plasteline*. Both are made of a certain kind of earth; the former is mixed with water, the latter with oil.

Both are nonpermanent media. Plasteline remains permanently soft and thus is easily damaged; however, it can be used over and over again. Clay, if allowed to dry, breaks easily. To make a clay sculpture permanent, it must be baked in a kiln, which hardens it like ceramic, or it must be cast in a permanent material, such as plaster or bronze. Casting is complicated and some of the techniques are dangerous, thus, many sculptors have their casts made by professionals (page 123).

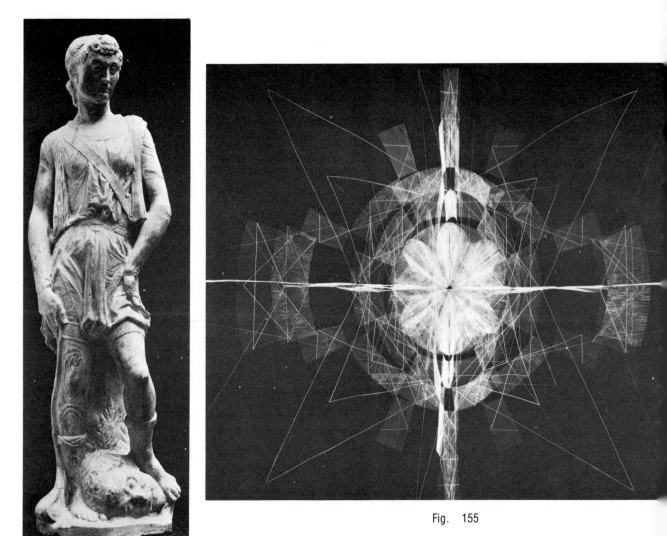

Fig. 154.

Fig. 155

DONATELLO (ca.1386-1466). "The David of the Casa Martelli." National Gallery of Art, Washington, D.C. (Widener Collection)

RICHARD LIPPOLD (1915-). "Variation within a Sphere, No. 10; The Sun." Metropolitan Museum of Art, New York (Fletcher Fund)

For centuries, sculptors had to restrict their works to a relatively solid mass, because they worked primarily in wood or stone. Those materials had to be carved in a way that would support their own weight and protect fragile projections—arms, legs, etc. The image was confined within the dimensions of the original log or block of stone. Notice how Donatello's "David" is carved within what must have been a simple vertical block of marble; its arms and legs are designed so that they attach firmly to the body.

Under the influence of modern painting, sculptors began to experiment with new materials, which quickly opened the way to new concepts and greater creative possibilities. Lippold's piece, constructed of gold-filled wire, typically incorporates the spaces between the forms (negative space), which become as important as the forms themselves.

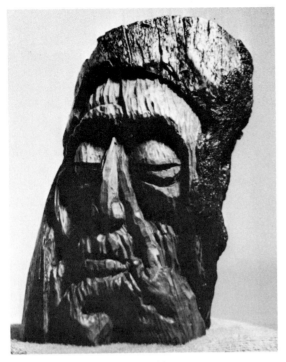

Fig. 156

MORTON GARCHIK. "Patriarch." New York (Dr. Vita and Dr. Bernard Tauss Collection)

The shape and form of a piece of stone or wood often inspires or influences the conception of a work. Here I retained some of the lovely bark textures and developed a contrasting textural pattern by using only large gouge strokes. The forms were kept bold, rugged, and simple, to emphasize the theme.

Materials

Plasteline—four 2-pound packages of medium-firm consistency.*

Modeling tools—they come in a variety of sizes and materials; an inexpensive plastic set and one or two made of wood and wire will suffice for this study. Your fingers will be your most sensitive tool; an ordinary table knife and some toothpicks are also useful (Fig. 157).

Wooden 12-inch ruler

Calipers—several types are used by sculptors, including those that will mechanically scale measurements taken from the

*Materials are available in art stores or may be ordered from Sculpture House, 38 East 30th Street, New York, N.Y. 10016; or from Sculpture Associates, 114 East 25th Street, New York, N.Y. 10010.

model, up or down. For this study, an ordinary compass divider or carpenter's compass will do.

Armature—a framework that supports the clay as it is built up and modeled. Armatures of metal tubing and wire can be purchased ready-made. An adequate substitute can be built from scraps of wood and wire (Fig. 158).

Getting Familiar with the Tools and Plasteline

First, make a simple stand out of wood (Fig. 159).

Press a block of plasteline over the wedge, down to the baseboard. Try each of the tools, and notice their uses. Some cut; others poke and press indentations into the plasteline; some can be manipulated to smooth out small or large areas; and some can be used for incising and texturing (Fig. 157).

Fig. 157

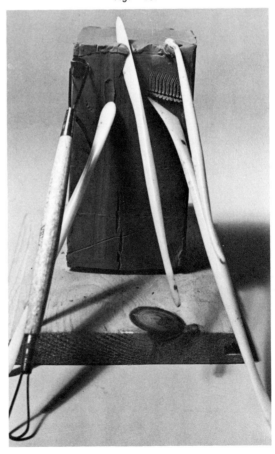

Fig. 158

To model large pieces in clay or plasteline, an armature must be used for support. It can be purchased ready-made or you can build one from scraps of wood: a piece of 2 x 4 wood about 1 foot long has been glued and nailed to a wooden base. Small pieces of wood have been glued and nailed to the sides, front and back. Other small pieces have been glued together in the form of small crosses and suspended from wires, which are attached to a nail on the top of the 2 x 4; these are called "butterflies," and are used to support the plasteline as it is built out from the center. The whole structure should be coated with shellac so that the wood will not absorb the oils in the plasteline causing it to dry out and become brittle.

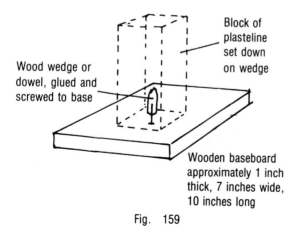

Wood wedge or dowel, glued and screwed to base

Block of plasteline set down on wedge

Wooden baseboard approximately 1 inch thick, 7 inches wide, 10 inches long

Fig. 159

Exercise 1
"Sketching" with Plasteline

Because of its pliability, plasteline is used by sculptors as a "sketching" material and for preliminary studies. Sketching with plasteline is an excellent way for students to get the feel of the medium, before using it for a more ambitious piece.

1. Remove the block of plasteline from the baseboard and cut it in half; put one half aside (to be used later for the features). Knead the other half between your hands. As it becomes soft and pliable, shape it in the form of an egg. It does not have to be perfect—this is just an introductory exercise.

2. Hold the egg-shaped form on its end in one hand, and with an incising tool scratch a line midway from top to bottom and another midway from side to side; and divide the bottom half in half again (Fig. 160).

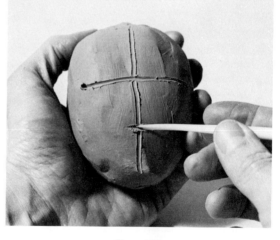

Fig. 160

3. With either a wire tool or one of the knifelike tools, scoop out the eye sockets, beneath the horizontal line.

Take a lump of plasteline from the reserve pile, roll it in your hands, form it into a triangular wedge shape and press it on the egg form, in the position for the nose (Fig. 161).

4. Roll two small pieces of plasteline into balls and press them into the eye sockets.

Roll two small sausage-like pieces of plasteline and press them into position for the lips.

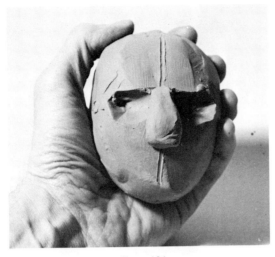

Fig. 161

Roll a small ball-shaped form and attach it to the chin area.

Roll two sausage-like forms; curve and flatten them slightly and attach them to the sides of the head—approximately in the center of the profile, lined up with the eyes and bottom of the nose (Fig. 162).

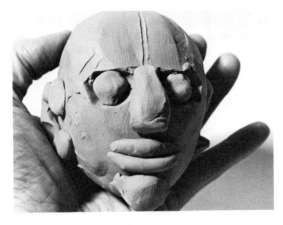

Fig. 162

5. Now, using your fingers as tools, pinch, poke, incise, squeeze, smooth, pull, and twist the plasteline. (Incidentally, if this tactile contact with the plasteline really excites you, sculpture may turn out to be your primary medium.)

Experiment with the facial expression by changing the angles of the eyebrows and mouth. Add pieces of plasteline to fill out forms, or cut some off to create deeper recesses and shadows (Fig. 163 and Fig. 164).

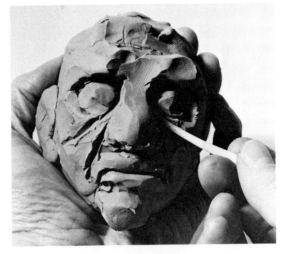

Fig. 163

Most importantly, as you work, become aware of the abstract language of three-dimensional forms. The principles of design and composition, which you learned in Chapters I and II, can be applied here. Rhythms and patterns that you create must be organized and controlled from many viewpoints: front, back, sides, top, and bottom, and from the numerous views between them. Notice the way the lights and shadows help accentuate the forms and establish their own patterns and rhythms.

Making a clay sketch should be approached with the same sense of fun and exploration as the work you do in a sketch book. The exciting potential of different forms emerging beneath your fingers will suggest many possibilities for more detailed and finished pieces.

Fig. 164

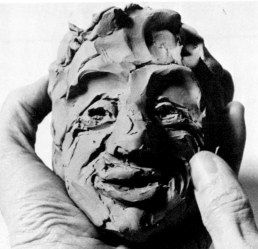
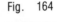

Exercise 2
Modeling a Head From Life:
First Stage

Work from a live model. Ideally he/she should be seated on a rotating platform and your armature should be on a rotating stand, to facilitate your viewing the model from different angles. If you cannot arrange such a set-up, just seat the model comfortably in the center of the room with her/his head on eye-level with your armature, and move around the model as necessary.

Decide what size you would like the sculptured head to be. If you work life-size, it will simplify transferring measurements from the model to the sculpture. If you wish to work on a smaller scale, half-size is convenient because you can simply divide by two the measurements taken from the model.

1. Cut a chunk of plasteline from a block with a knife and knead it in your hands to make it pliable. Lay it over the top of the armature, pressing firmly against the wood. Continue to knead small pieces of plasteline and attach them to the pieces already on the armature until you have covered the armature with a layer that is the length of the model's head. Knead the plasteline well and pack it tightly so that it is built up as a solid structure (Fig. 165).

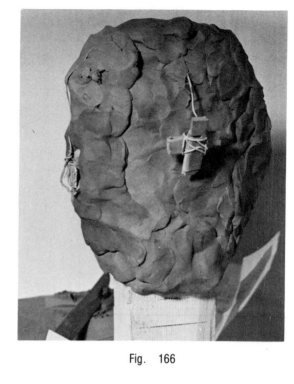

Fig. 166

Do not cover the butterflies yet; they will be needed later to support the plasteline, as you build it out from the center of the armature.

2. Study the model's profile and measure accurately the relationship between the height of the head and the width of the profile. Add plasteline to the front and back of the armature and build the general shape of the profile to the correct width. Work on both profiles, continuing to pack the plasteline firmly, after kneading it in your hands (Fig. 166).

3. Study the model from the front and the back. Take measurements and start filling out the sides. Walk around the model frequently; concentrate on the *roundness* of the head.

A common error made by beginners is to build a square head—a front view and a side view. Think of the head as egg-shaped or cylindrical, with no fixed viewpoint but rather a multitude of continuous views.

As you begin to reach the widest limits of the form, pack the plasteline around the butterflies so that they will support it. If any of the butterflies are too long or short, adjust them by shortening or lengthening the wires.

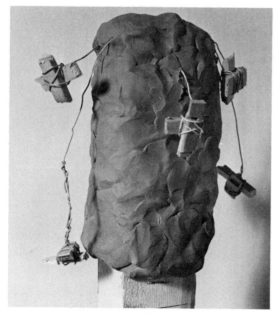

Fig. 165

Fill out the general shape of the head, but not the features; the hair, eyes, nose, lips, chin, and ears will be added later. Now recheck the basic dimensions very carefully. If you are striving for a likeness and the underlying dimensions of the piece are not accurate, you will have a lot of trouble trying to correct them later.

Check the height, from the chin to the top of the head (not including the hair).

Check the width of the profile, from the front of the face (not including the nose) to the furthest extension of the back of the head.

Mark off the position of the eyes, the length of the nose, the position of the ears and their size, and the mouth (Fig. 167).

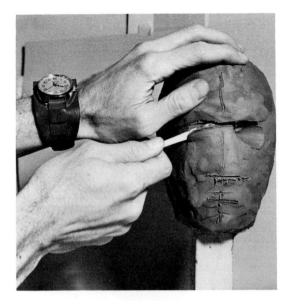

Fig. 168

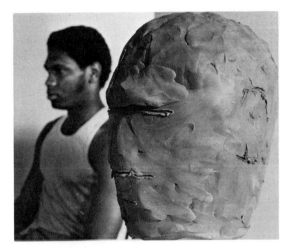

Fig. 167

In addition to the ruler and calipers, utilize your drawing experience with grid lines and unit measurements (Chapter II).

4. Begin working on the features. Treat them as simple masses, without detail for the moment.

To locate the eyes, cut out the hollows beneath the brow (Fig. 168).

For the nose, add a triangular piece of plasteline.

Roll two pieces of plasteline into small coils and lay them in position for the lips.

Add a ball-shaped piece of plasteline for the chin.

Form two curved, coil-shaped pieces of plasteline for the ears.

Add blocks of plasteline for the large masses of hair (Fig. 169).

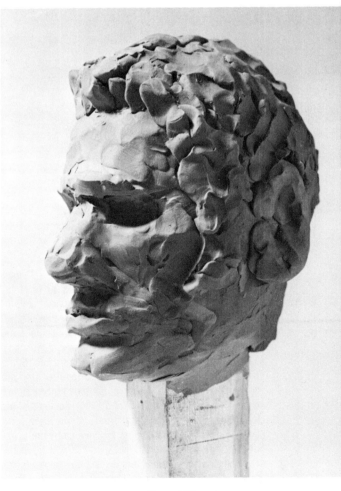

Fig. 169

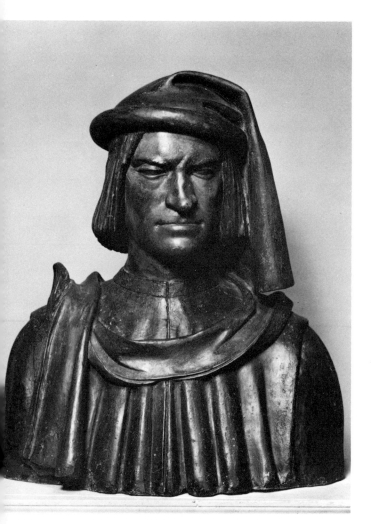

Fig. 170

ANDREA DEL VERROCCHIO (ca. 1435-1488). "Lorenzo de' Medici." National Gallery of Art, Washington, D.C. (Samuel H. Kress Collection)

The organization of visual elements, discussed in Chapter I, applies to sculpture as well as drawing or painting. Notice some of the rhythmic devices the Italian sculptor Verrocchio utilizes in this stunning portrait. The strong, commanding head is built on vertical and horizontal axes; almost all the other linear movements and forms emphasize this by their diagonal and curving contrasts. Some of the rhythmic patterns are in the form of theme and variations. For example, the linear patterns of the hair are echoed in the powerful strokes of the massive folds of the cloak; the curve of the hat's brim and the downward curving thrust of the hat's top are answered by the counterbalancing effect of the scarflike garment, which sweeps across and down the shoulders. Notice how all the forms are designed as bold, powerful elements, which contribute to the stern expression of the prince.

Second Stage: Refining the Forms

An artist can control the effects of light and shade in a painting so that they remain constant. Such control is not possible for a sculptor; the finished piece may be seen under many different lighting conditions, perhaps quite different from those under which it was created.

The way to anticipate and deal with this problem is to work with different light sources as the piece develops. If you bear this in mind, you will avoid the mistake of thinking that you have designed some dramatic effect into the piece when, in fact, such an effect may be entirely caused by a very specific lighting condition—as will become painfully obvious after you move the work to another light source.

A sculpture that is designed rhythmically—one in which the patterns, sequences of shapes and forms, have subtle repetitions and interesting contrasts—will work well under any lighting. Many of these problems are admirably solved in Andrea del Verrocchio's "Lorenzo de' Medici" (Fig. 170).

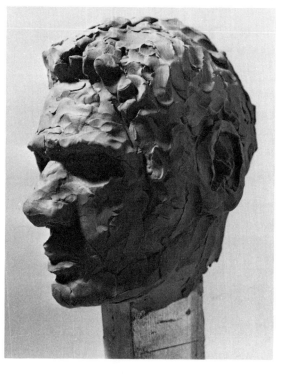

Fig. 171

1. Recheck the measurements and the placement of the features.

2. Work on the profiles: "draw" (model) the outlines as if your fingers and the modeling tools were pencils and the plasteline were the paper.

3. Proceed to the back and front views. Again, recheck the measurements carefully as you observe the model. Begin to shape the individual features—not in detail, just the main forms and the directions of their planes: sides, front, top or bottom, and three-quarter view.

4. Do not neglect the three-quarter views of the whole head. Remember, you are building a form that turns in space, not just connecting front, sides, and back.

5. Begin the eyes by first placing round spheres in the scooped out sockets. The lids will be added later.

Do not try to get the face exactly symmetrical; very few faces are. Concentrate on expression and rhythm (Fig. 171).

Third Stage: Completing the Head

The degree of finish to which a sculpture may be carried depends upon the type of expression the sculptor intends it to have. Compare the Settignano portrait (Fig. 172) with the Rodin (Fig. 173).

Settignano's was undoubtedly a commissioned portrait and the artist's intent, even obligation, was to produce a likeness without introducing any extraneous elements into the work. The highly finished surface of the marble, imitating as it does the soft delicate flesh, is well suited to the subject.

Rodin's bronze portrait (cast from modeled clay) was also a commissioned portrait, but the artist went far beyond what would have ordinarily been expected, even though, to the untrained eye, the work looks *unfinished.*

There were several reasons for this. From his earliest days as an artist, Rodin waged a creative rebellion against the stagnant formulas that prevailed in sculpture. Many artists felt that the new medium of photography, with its ability to produce por-

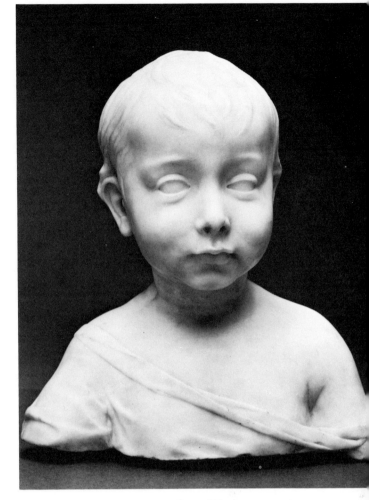

Fig. 172

DESIDERIO DA SETTIGNANO (1428-1464). "Bust of a Little Boy." National Gallery of Art, Washington, D.C. (Andrew Mellon Collection)

traits of great realism, freed painters and sculptors from mere copying, so that they might explore new ways of depicting a sitter's personality; in addition, the radical works of the Impressionists and Post-impressionists stimulated new approaches to sculpture. It is interesting to note that criticism of some of Rodin's work—that it was sketchy and unfinished—was the same as that hurled against the Impressionists.

Rodin's portrait (and the final statue of Balzac, for which it was one of many studies) is not the "sketch" its appearance may suggest. Rodin was a superb draftsman, as many of his drawings and carvings attest. In

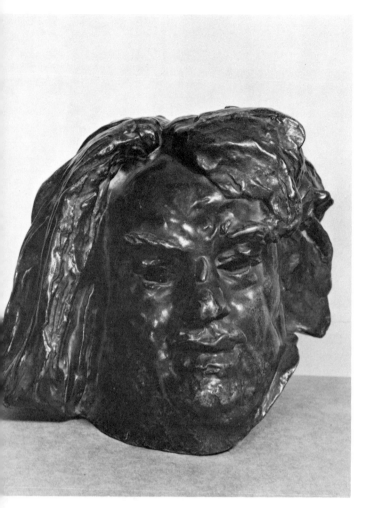

Fig. 173

AUGUSTE RODIN (1840-1917). "Head of Balzac." National Gallery of Art, Washington, D.C. (Gift of Mrs. John W. Simpson)

It was the reality and spirit of this likeness that Rodin tried to express—not by a high degree of finish, but with vigorous modeling, bordering on abstraction, which takes on expression of its own, echoing the character of the sitter.

Apply the lessons learned from the discussion of the Settignano and Rodin portraits to the head you are modeling. If the person you are sculpting is young, a smoother finish, like the Settignano, will be more in keeping with her/his expression. If the person is older or more rugged looking, a rougher style of modeling may be more appropriate.

1. Once again check your measurements.

2. Finish the eyes. Roll small pieces of plasteline into thin coils; these are for the eyelids. Place them on the eyeballs, following their round form. Connect them to the surrounding areas: the brow, cheekbones, and inner bridge of the nose (Fig. 174).

Look at your sitter and observe the eyelids carefully. Notice the subtle turns and

addition, he did extensive research for the portrait over a period of years, studying all of Balzac's writings and the details of his life. For a guide to the likeness of the deceased writer, Rodin used a daguerreotype and a realistic sculpture by an earlier artist. Moreover, there was an intense and exciting verbal description by the writer Lamartine:

> It (Balzac's face) was a face of an element...hair dishevelled...like a mane...eye of flame...colossal body...(with) so much soul that it carried it all lightly; the weight seemed to give him force, not take away from him.

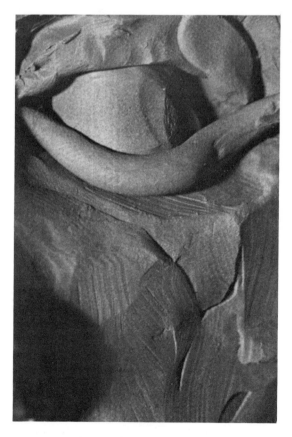

Fig. 174

gradations of the planes; model them with your fingers, fingernails, and small tools.

The iris and pupil, which can be rendered with great expression in drawings and paintings, present a problem in sculpture, because of the way lights and shadows change when a piece is seen under different lighting conditions. A thoughtful expression of the eyes, as they were modeled in one light source, may take on a vapid or even grotesque stare when they are seen in another light. Some sculptors (such as Settignano, Fig. 172) delineate the eyes with extreme delicacy (which barely shows up in the reproduction). This technique eliminates the possibility that poor lighting will result in a distorted expression in the eyes; but it leaves them neutral, perhaps even vacant looking.

Rodin used a variety of techniques to solve this problem. In the head of Balzac (Fig. 173) he simply did not fill the eye sockets. The deep shadows create a sense of mystery; we almost think we see the eyes,

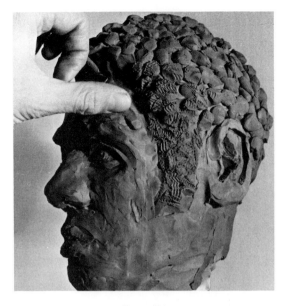

Fig. 176

even though they are not there.

In our demonstration study we use still another method: The iris is outlined with an incised line (use a pointed toothpick); and the illusion of a dark pupil is created by two small, deep indentations made with a pencil point (Fig. 175).

3. Continue to adjust and develop the forms. Cut away plasteline where it is not needed and add some where it is, by first kneading small pieces into pellets, attaching them to a form, and then modeling with the fingers or a tool (Fig. 176).

4. The hair has been built up with textures created by massing small pellets of plasteline; the sideburns and eyebrows have been incised with the teeth of a modeling tool, to create another texture.

When working on textures, be sure to follow the form beneath them so that the textures become an integral part of the form rather than meaningless decoration.

5. The nose should be treated simply, particularly the underside; but study the views from below carefully—they will help you to understand the subtle planes of the nostrils (Fig. 177).

6. The ears are a fascinating complex of shapes and forms but they contribute little to expression. (In countless great paintings and sculptures of heads, the ears are covered by hats or hair with no loss of expression.)

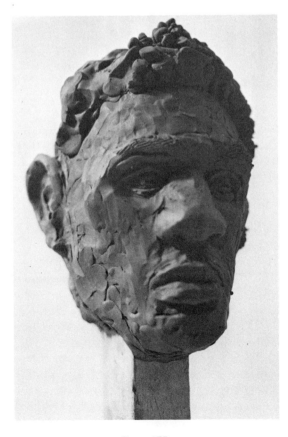

Fig. 175

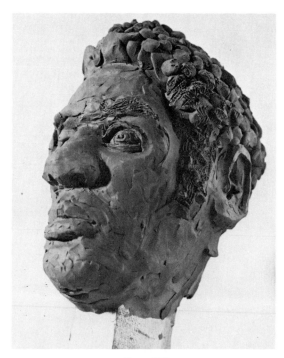

Fig. 177

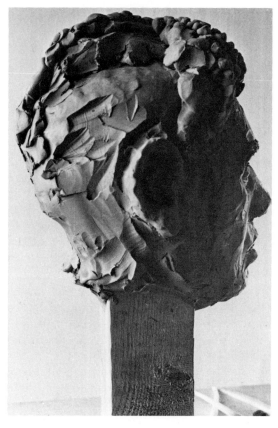

Fig. 178

Therefore model them simply so as not to detract from the more important features.

Do not work on one side of the head too long, without working on the other. The piece should grow organically as a whole. Keep viewing the sitter from all sides and at all angles, as you work (Fig. 178).

7. The lips often give beginners trouble. The most common error is neglecting to curve them enough. Lips follow the shape of the mouth, forming almost a complete half-circle (an 180° arc) from corner to corner. Pay particular attention to how the lips join the surrounding areas of the face.

8. As discussed in previous chapters, there comes a point when a work takes on its own life and makes its own demands. When you reach that point with your sculpture, refer less to the sitter and concentrate on the work itself.

Study it carefully and ask questions: Do the relationships and rhythms of the forms, shapes, linear movements, textures, and lights and darks support the mood of the piece? Consider the planes and edges: Would some be better if they were sharper or rounder? Might the piece be improved if you took liberties with the hair—for instance, designing it to repeat some of the movements, rhythms, and patterns of the forms in the face?

Notice that in the demonstration study the hair has been filled out and extensive changes have been made in the eyes—they have been made larger and simplified, to eliminate the harsh stare they had earlier (Figs. 179, 180).

Assignment

Try several more heads, using different sitters for models. The individual characteristics of each person will present new challenges, from which you will learn much.

Visit museums and galleries. Work in a three-dimensional medium will open up a profound new visual world to you. The sculptures of the masters, as well as everyday objects, will take on a heightened beauty as you see them with eyes and intellect trained to be more sensitive to the relationships of forms in space.

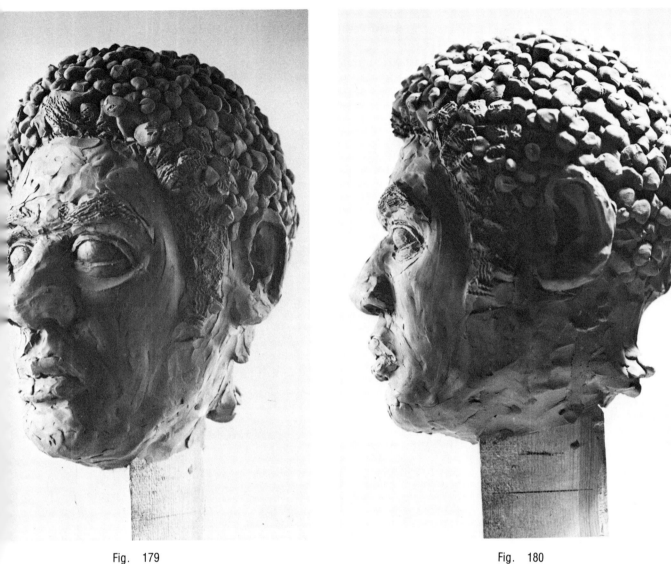

Fig. 179 Fig. 180

Casting

Casting is the process of converting or duplicating a model (originally created in a medium such as plasteline, clay, or plaster) into metal or plaster. Figures 181, 182, and 183 illustrate one method. In a different technique, the original model is first covered with a substance such as liquid plaster. When the plaster hardens, it is taken apart and the model is removed, leaving a *negative* impression (mold) of itself in the plaster.

The pieces of the mold are rejoined, and molten bronze or other substances (for example, mixtures of sand and marble dust) are poured into the empty mold. When it dries, the mold is once again taken apart, revealing a bronze duplicate (a cast) of the original piece.

Molds can be used over and over; thus many casts can be made from the same original. These are numbered like print editions (see page 148).

Because of the complexities, the cost of machinery, and the hazardous nature of the work (which involves handling molten metals), sculptors usually contract their casting to professional foundries.

It should be noted that casting—a pro-

cess of duplication—lends itself to fakery and forgery, which the artist and collector must guard against. For example, the practice of using casts in place of original models in making molds, and then passing off the casts duplicated by such molds as authentic works, has been a documented form of art forgery throughout history. As an artist you can help educate the public by sharing the knowledge you acquire about abuses you become aware of.

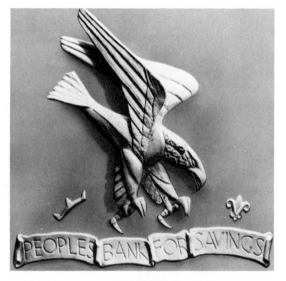

Fig. 181

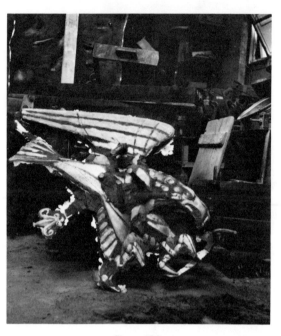

Fig. 183

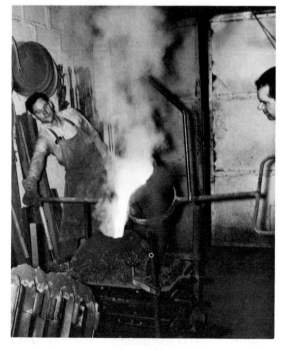

Fig. 182

MICHAEL LANTZ. "Swooping Eagle." Commissioned by the People's Bank for Savings, New York. Bronze casting by Bedi Makky, Brooklyn, New York.

Figure 181 shows a plaster model ready for casting. A sand mold is constructed around the model and molten bronze is poured into it (Fig. 182). After the bronze has cooled and hardened, it is removed from the mold; the sculptor can then add finishing touches (Fig. 183).

FUNDAMENTALS OF PRINTMAKING

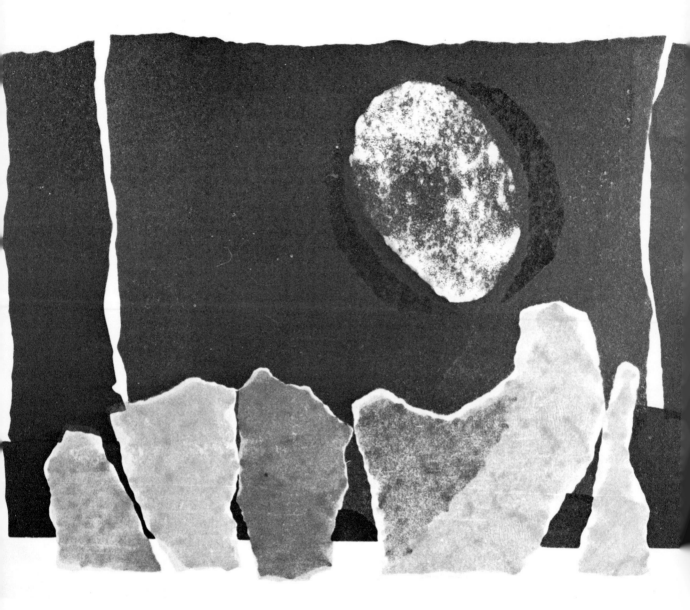

MORTON GARCHIK. "Sea Sky Rocks Moon." (Collection of the Minnesota Museum of Fine Arts)

Chapter V

FUNDAMENTALS OF PRINTMAKING

THIS CHAPTER CONCENTRATES ON WOODCUT, the simplest printmaking medium. Other printmaking techniques—intaglio, serigraphy, lithography, collagraphy, and photomechanical—require expensive and sometimes dangerous materials, which should not be used without professional supervision.*

Read the whole chapter through to get a complete picture of the entire process. Making a woodcut print is actually much simpler than it sounds in the written description. If you enjoy working with your hands, and you exercise care following the step-by-step instructions, you will have little trouble in achieving excellent results.

What Is a Print?

A print is an image that is transferred from a prepared surface (called a *plate*) and can be duplicated many times. Historically, the idea evolved from stamping. Artisans in ancient civilizations carved designs into wood and then stamped them into soft substances, such as wax or clay. Printmaking as we know it today became possible with the invention of paper, which occurred in China. The earliest dated print we know of is a Chinese woodcut done in the year 868. Since that time, a variety of printmaking techniques have been developed and used by artists all over the world.

The duplication of images by the printmaking technique has been utilized throughout history primarily in order to distribute and sell pictures in quantity. However, many artists have turned to prints to take advantage of the expressive visual qualities they offer—qualities that are not obtain-

able in other art media. That is the approach we shall pursue in this chapter.

The Woodcut Print

Relief printing means printing from the surface. Wood is one of the oldest relief surfaces used. It is still widely used, along with newer materials including linoleum, plastic, and cardboard.

In relief, the image is drawn on the woodblock and the areas around the image are cut away (Fig. 184). Ink is then applied to

Fig. 184

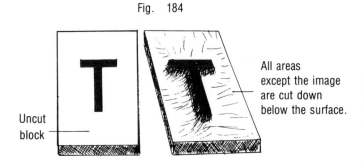

Uncut block

All areas except the image are cut down below the surface.

* These techniques are described in detail at the end of the chapter.

127

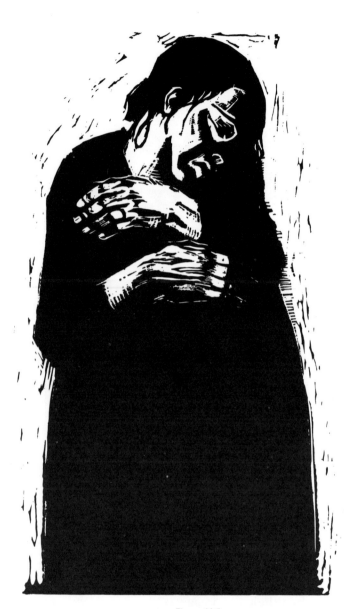

Fig. 185

KAETHE KOLLWITZ (1867-1945). ''The Widow—I''

Kollwitz's powerful print demonstrates the qualities unique to woodcut: simple, dramatic shapes and forms, which reflect the interplay of the knife and wood. It has a mysterious feeling sometimes associated with carved sculpture. The nature of the particular piece of wood actually influences the image as it emerges.

the raised (relief) surface, with a roller. Printing paper is placed on the inked block and either hand-rubbed or squeezed in a press, thus transferring the image from the block to the paper.

Woodcuts are the primary relief medium today. They are characterized by bold, dramatic shapes and forms that result from the interaction of the cutting tools and the wood (Fig. 185).

Woodcuts can also be printed in many colors and tones, and in varying degrees of opacity and transparency, which accentuate the beautiful wood grains and textures (Fig. 186).

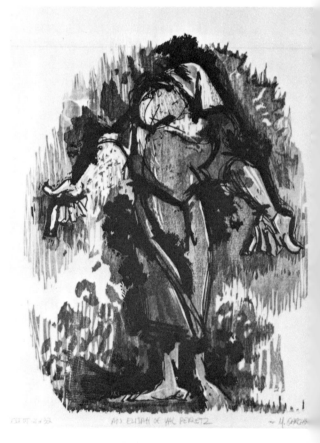

Fig. 186

MORTON GARCHIK. ''An Elijah of Yal Peretz.'' Courtesy of Associated American Artists, New York City

In addition to black and white, woodcuts can be printed in many colors and tones. The use of opaque and transparent inks helps bring out the beautiful grains and textures of the wood.

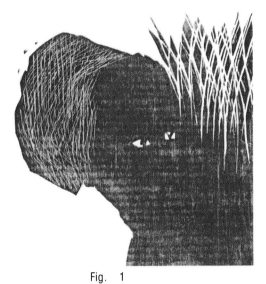

Fig. 1

Color Woodcuts:
The Addition Method

In this technique, a separate woodblock is used for each color. An impression of the first color is shown in Figure 1. Impressions of both the first and second colors are shown in Figure 2.

It is possible to obtain "extra" colors by overprinting. Notice that in Figure 2 the areas of the hat and face overlapped on both blocks, causing those colors to mix and create a third color.

In Figure 3 is shown an impression of the last block overprinting the two previous impressions. Complete directions for cutting, inking, registering, and printing the blocks are given on page 141.

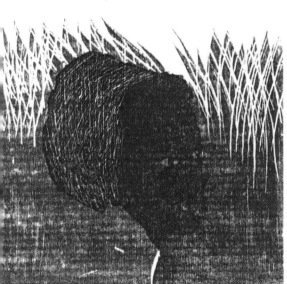

Fig. 2

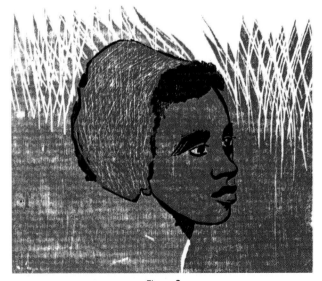

Fig. 3

COLOR PLATE X

Fig. 1

Fig. 2

Color Woodcuts:
The Subtraction Method

In this technique, only one block is used to print all the colors. The first color impression is shown in Figure 1. In Figure 2 the areas that are to remain red in the final picture are cut off the block and the second color is printed. In Figure 3 all the areas that are to appear orange in the print are cut off the block and the final color is printed. The advantages and disadvantages of this method are discussed in detail with complete instructions on page 145.

Fig. 3

Making a Woodcut

It is possible to learn the fundamentals with a few simple and inexpensive tools: a knife, a gouge, a piece of wood, a tube of ink, a roller, paper, and a spoon (Fig. 187). Later, you may wish to acquire some of the other equipment listed below. *

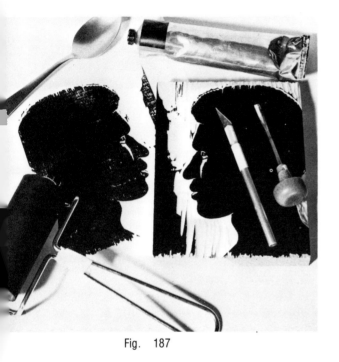

Fig. 187

Materials

Wood—see the following section of this chapter.

Roller (sometimes called a brayer)—firm rubber, 1¾ inches in diameter, 6 inches long. Later you may wish to use rollers of several sizes and degrees of hardness for larger, complicated prints.

Power tools—drills, etc.; optional, and not necessary for the projects in this chapter.

Inks—oil-base inks are preferred. Buy just a few tubes to start with: black, red, blue, and yellow. Later, you may wish to buy large cans of ink, which are very economical. You can then mix many tints of your own preference and put them into tubes yourself.

*If you do not have access to a good art supply store, print-making supplies can be ordered from Graphic Chemical & Ink Co., P.O. Box 27, 728 North Yale Ave. Villa Park, Ill. 60181

Ink extenders—these are added to inks to make them transparent; optional.

Varnishes—No. 00 Burnt Plate Oil thins ink; optional.

Paper—inexpensive newsprint pads for pulling trial proofs; old magazines or old telephone books for clean-up work; a tracing pad. There are many fine papers for printing editions (Goyu, Kochi, Masa, etc.).* Try a few sheets of each; when you find one that you like, order it in quantity, thereby reducing the cost.

Printing tools (sometimes referred to as burnishers)—see Figure 188.

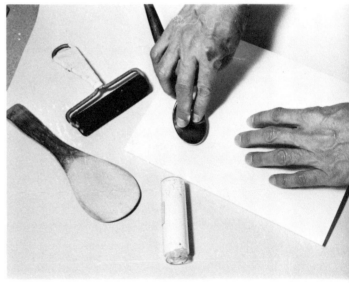

Fig. 188

Woodcuts can be printed by hand with a variety of tools: an ordinary soup spoon is shown being used to rub a print; below it, a glass jar (filled with plaster to give it extra weight); left, a wooden Japanese rice spoon; and above it, a hard rubber photographer's roller. The heel of the hand itself can be used; fingernails are excellent for small delicate details.

Palette—a piece of glass or an aluminum cookie sheet; anything that is smooth and cleans easily.

Carbon paper
Rubber cement

* A paper catalog may be purchased from Andrews, Nelson, Whitehead, 31-10 48th Ave., L.I.C., New York 11101.

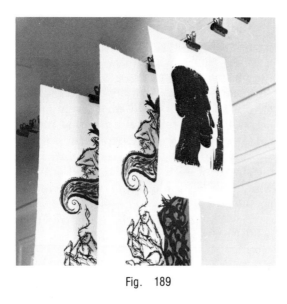

Fig. 189

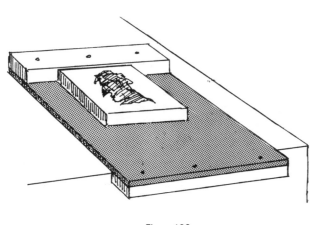

Fig. 191

The simplest method of drying prints is to hang them from squeeze clips obtainable in stationery stores, or from clothespins with holes drilled through them so they can slide on a wire.

Masking tape
Drying device—see Figure 189.
Rubber cement thinner
A rubber cement pickup
Rags
Turpentine and kerosene
Block holder—this can easily be constructed from pieces of scrap wood (Fig. 190).

Fig. 190

Glue and nail a 10- x 15-inch piece of plywood or masonite and two 1- x 2-inch strips of wood, as shown in the picture. Placed on the edge of a desk or work table, it will hold the block securely while you cut and gouge.

The wooden-handled tools are traditional gouges and knives. The all-metal tool is the contemporary X-Acto knive (No. 1, with No. 11 blades). While not made specifically for woodcuts, it is excellent for very fine and delicate cutting.

Pencils, pens, brushes, and india ink
Protective goggles
Cutting tools—in sets or individual gouges and knives (Fig. 191); also an X-Acto knife.

Wood

Almost all woods can be used for relief printing. Each has different characteristics, and you should try several kinds. For the projects in this chapter, buy a few pieces of *common pine*, approximately 5½ x 8 inches, obtainable from any lumber yard.

Common pine has irregularities and knots; they can be integrated into images or used as backgrounds. For clean surfaces, free of blemishes and knots, buy a few pieces of *clear pine* as well.

Pine is easy to work with—soft enough to cut with facility, but hard enough for fine lines to hold up under repeated printings.

To bring out the beautiful grains of wood, dampen the wood with a sponge, then rub it in all directions with steel wool or medium sandpaper. This wears down the softer wood between the harder lines of the grain, and therefore the harder lines will be accentuated in the printing process.

Precautions and Use of Tools

The cutting characteristics of wood vary from piece to piece, and even from area to area on the same piece. Do *not* begin cutting before reading the instructions accompanying Figures 192, 193, 194 and 195. Careless handling of sharp tools can cause injuries. Always check a new piece of wood for splinters, and when you find some, sand them down.

To avoid accidentally scratching the

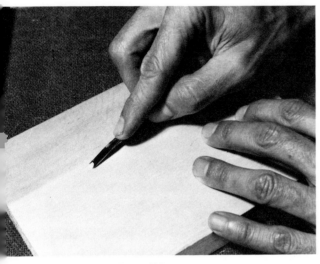

Fig. 192

CORRECT HAND POSITION WHILE GOUGING. Note: The free hand is kept *behind* the gouge.

Fig. 194

CORRECT CUTTING ANGLE FOR THE GOUGE. It should be almost horizontal, no more than 10° or 20°. Push it gently, while rocking it slightly to facilitate the cutting action.

Fig. 193

WRONG POSITION FOR FREE HAND WHILE GOUGING. Here the free hand is directly in the path of the gouge. The resistance of the wood varies and the tool can slip or skip unexpectedly and cause injury.

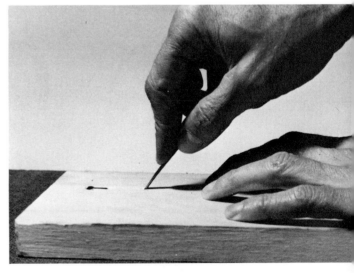

Fig. 195

WRONG CUTTING ANGLE FOR THE GOUGE. Do *not* drive the gouge at a sharp angle. Do *not* use it like a crowbar to pry out pieces of wood; it will break. If you accidentally drive a gouge too deeply into the wood, back it out gently with a rocking motion.

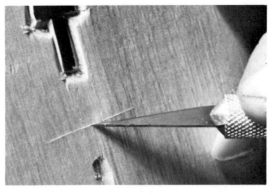

Fig. 196

block itself, keep your work area clean and free of wood chips. Do not wear metal items—a wrist watch or finger ring—while working; they can indent and mar the surface of the wood.

Cutting tools are sharp; they are also fragile and will break if not used as directed.

If you run into hard areas of wood near a knot, or into knots themselves, do not try to cut them with a knife or gouge. Knots are extremely hard and will break your tools. If you must remove an area with a knot, use a saw or a carpenter's chisel. Be careful of flying chips and fragments of wood when chipping out knots; wear protective goggles.

Wood grain runs the length of the plank. It is easier to cut cleanly in the direction in which the grain flows.

To cut across the grain cleanly, proceed as follows: Use a knife with a very sharp blade; do not cut too deeply on the first stroke, just enough to establish a "track" for the blade to ride in (Fig. 196).

Then go back through that track several times; each successive cut will work its way deeper into the wood and the cross cut will be clean.

When gouging out unwanted parts of a block, a previously cut part of the image may be accidentally splintered off. It is sometimes possible to glue it back in place. It is also possible to mortise a new piece of wood into the damaged area and to recut it (Figs. 197 and 198).

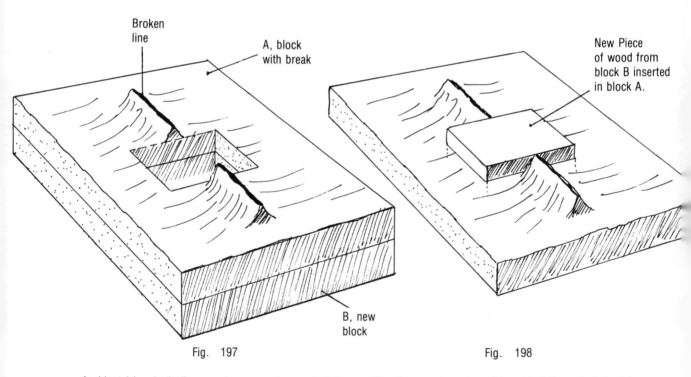

Fig. 197

Fig. 198

Accidental breaks in lines or shapes can be repaired by mortising a new piece of wood into the damaged block. Place a fresh piece of wood (B) under the block (A) with the break. Hold them together with clamps or a vise. Drill four corner holes, and saw through *both* blocks.

Glue the new piece of wood from block B into the hole of the first block. If there is still space where the broken lines meet the new wood, stuff in some wood filler, or glue and hammer in a thin wedge of wood. When the glue sets, you can recut the line.

Fig. 199

Fig. 201

These difficult repairs are best avoided by the following precaution: Before gouging around a line or shape that has already been cut, make very deep cuts around it (Fig. 199).

Now when you gouge, the pieces will splinter off before they reach the image.

The X-Acto knife can be held like a pencil and gives excellent control for fine, delicate cutting (Fig. 200). Do *not* use it to poke

into the wood by pulling the open end of the cutting edge across the grain.

Delicate and thin lines must be cut in a way that protects them when they are printed. This is done by leaving a wide base of wood beneath them (Fig. 202).

Fig. 200

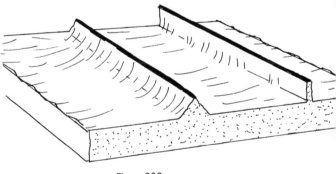

Fig. 202

The line on the left is correct. It has a pyramid-like base (45°), which will support the line when it is being printed. The line on the right is incorrect. Its base is too thin; pressure exerted during printing will snap it off.

or pry out pieces of wood; the blade will break. If the X-Acto blade becomes dull, sharpen it on a sharpening stone, or snap a small piece of the tip off with a plier.

Like other gouges, the V- and U- shaped tools should be pushed at a shallow angle (about 20°), in the direction of the grain (Fig. 201).

They scoop out thin, even lines; these gouges can also be used to scratch textures

Large areas around the image need only be gouged out deep enough to avoid picking up ink during the inking process. Experience will guide you. Start with shallow gouging, about ¼ inch deep; you can go deeper later, if necessary.

Practice cutting until you feel that you understand how the tools function.

First Woodcut Project

Look at the Kollwitz woodcut again (Fig. 185). For your first project try to create a picture with the same features: simple, bold shapes and forms with a minimum of detail.

1. On a block (the surface of which has been painted black with India ink), make a light sketch of a head. Use a soft lead pencil or a white charcoal pencil. Do *not* press too hard or you will scratch the block. Sketch lightly and gently. Don't make a detailed drawing, just an indication of the composition and large forms (Fig. 203).

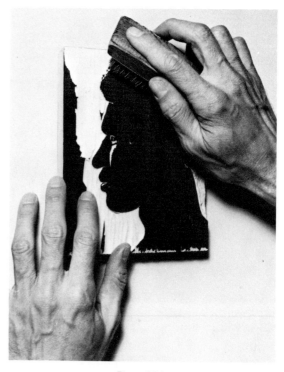

Fig. 204

thinly by rolling in different directions: forward, backward, and side to side. Lift the roller after each sweep. If you don't lift it, you are merely rolling the same film of ink back and forth and it will not thin out well. The ink must be *very* thin. If thick ink is applied to the block, it will clog delicate and shallow cuts (Fig. 205).

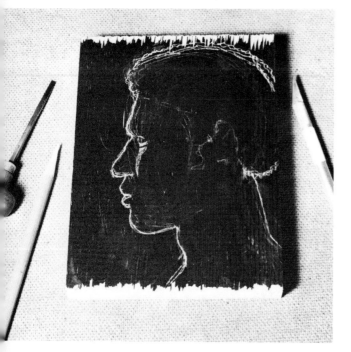

Fig. 203

2. Begin cutting. Leave as much wood as possible; cut away just enough wood to establish bold, simple forms. Let the image evolve from the interaction of the knife, gouge, and wood.

3. When the image looks finished, blow out any loose wood shavings that remain on the block. Then, using a soft brush, gently dust out any that still cling to it (Fig. 204).

Printing

1. Squeeze a few dabs of ink on the palette, and with the roller spread it out very

Fig. 205

2. Ink the block by sweeping the roller across it several times in different directions. Do *not* press down on the roller, just push it lightly across the block (Fig. 206).

ject.* This will keep the paper from shifting and smudging during the next steps (Fig. 209).

Fig. 206

Fig. 207

3. Repeat the inking process several times: "Reload" the roller by sweeping it across the palette a few times. Examine the block. If it has an even shine of ink on the whole surface you are ready to pull a "proof."

4. Make a *slip-sheet** as follows: Cut a piece of newsprint paper to the same size as the woodblock; then cut it in half. Mark one half "left" and the other half "right."**

5. Place the slip-sheets lightly on the inked block as shown (Fig. 207).

6. Position the printing paper on top of the slip-sheets (Fig. 208).

7. When the printing sheet is centered on the block (on top of the slip-sheets), weight the left side down with a heavy ob-

Fig. 208

* The purpose of the slip-sheet is to prevent accidental smudging, while placing the printing paper on the inked block.

** Using a "left" and "right" slip-sheet prevents ink, which builds up on the underside of the sheets, from offsetting onto clean areas of the block and then onto the printing sheet.

* A heavy book will do; the tape dispenser, shown in the picture, is excellent. Cushion its bottom with felt or a rubber pad so that it does not scratch or dent the surface of the block.

Fig. 209

Fig. 210

8. Lift the right side of the printing paper, taking care not to shift it, and remove the "right" slip-sheet (Fig. 209).

9. Lay the right side of the printing sheet directly down on the block. Press it gently to the block with your fingers; it will adhere slightly to the ink.

10. Hold the right side of the paper to the inked block with your fingertips to keep the sheet from moving. Lift the weight *vertically* and put it down gently and vertically on the right side. The vertical movement is stressed because, if you slide it, the paper can shift and smudge the print (Fig. 210).

11. With the weight in place on the right side, lift the left side of the printing paper and remove the "left" slip-sheet. Lower the left side of the printing paper directly down to the block (Fig. 211).

Fig. 211

12. With a burnishing tool, gently rub the left side of the printing paper until it adheres to the ink. Remove the weight and burnish the entire block (Fig. 212).

Vary the rubbing pressure: Rub gently over the delicate lines and the edges of the image, which might be easily crushed or bent; rub firmly over large flat areas.

13. Inspect the proof. First, put the weight gently back on the left side of the sheet; carefully peel back the sheet from the right side. Do *not* pull it all the way off, just up to the weight.

14. If the impression looks too light or streaky, it is either because the block has absorbed some ink, or because it was insuffi-

ciently or unevenly inked. In either case, add some ink to the palette and roll it thin. Ink the block in sections: Move the weight to different positions, lift the paper part way up, and ink the section below it. Be careful not to let the paper slip; be careful not to touch the paper with the roller (Fig. 213).

15. After the block is completely inked, remove the weight and rub the print. It may be necessary to repeat the re-inking procedure a few times, but do not rush by over-inking the block. The finished print should have rich, dark blacks, but over-inking will destroy the quality of the wood textures and grain. (After pulling several proofs the block "warms up" and the printing goes very

Fig. 212

Fig. 214

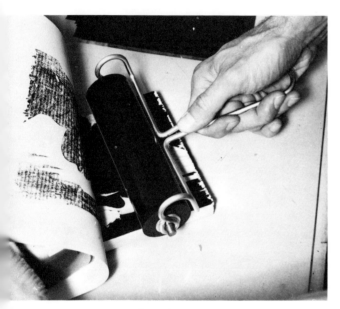

Fig. 213

Fig. 215
A proof pulled from the block

quickly.) Peel the sheet off the block slowly and carefully (Fig. 214).

If the image needs corrections or modifications, you can make them at once and continue printing. Though it is messy to cut on a wet block, you may wish to plunge right in if you are an impassioned worker.

If you prefer unhurried contemplation of the picture before making changes, hang the print up to dry (Fig. 215). Clean up.

Cleaning Up

Do not let ink dry on the block or roller. Clean up promptly after each printing session.

1. Place a clean magazine page over the block (avoid using newspapers—they can leave fibres on the block), and rub it as if you were pulling a proof. Do this several times with clean sheets. This removes most of the ink, and is sufficient if you plan to print only

Important: Recent ecological concerns and studies have revealed that many products that artists use can be harmful. Read labels carefully. Always work in well ventilated rooms. Avoid getting paints, inks, or solvents on your hands. Use gloves if possible during clean-up procedures.

a small edition (approximately 30 prints—see editions, page 148). Let the block dry thoroughly in a dust-free place; then put a piece of cardboard or a few sheets of paper over the surface to protect the image.

If you plan to print a very large edition, wad a clean rag into a smooth ball (so that the rag will not snag the edges of the block), douse some turpentine on the rag, and wipe the block. This will remove all the excess ink. Blot the block dry by pulling a couple of "proofs" with magazine paper. The reason for this special cleaning is that in the printing of large editions, or after every 20 to 30 prints, ink begins to build up on the block. It can clog and fill in the textures and grain; it can also thicken up thin lines.

2. Clean the palette by scraping off most of the ink with a razor blade or palette knife; wipe the remainder up with rags and turpentine.

3. Clean the roller by first rolling it across some magazine sheets (or old telephone book pages). Most of the ink will "roll" right off. Wipe the remaining ink off

with a rag and kerosene, or whatever solvent the roller manufacturer recommends. Finally, dry the roller by rolling it a few more times on magazine paper.

Hang up rollers when they are not in use. Do *not* let a roller surface rest on anything hard for long periods of time; it will lose its shape.

Store or dispose of rags safely—they are flammable.

Now you can study the proof and make changes on the block. Make a notation on the proof that it is a "first state." A unique feature of prints is that if you do extensive proofing

MORTON GARCHIK. "Gimpel the Fool." Courtesy of Associated American Artists, New York City. (Left: the woodblock. Right: an impression taken from the block)

The image was drawn on the block with a pencil, using a light pressure so that the pencil would not make indentations in the wood. During the cutting process, the pencil drawing was used as a guide and was interpreted by the interaction of the knives, gouges, and wood.

Fig. 216

Fig. 217

and cutting to develop an image, you will have an interesting visual record of the picture's progress.

Second Woodcut Project

Take a clean block, but this time do *not* paint it black. Instead, draw directly on the block with pencil or ink. The image should be more detailed and complex than your first block.

Remember, don't dig into the wood with the drawing tool; draw lightly on the surface of the block (Fig. 216).

This time, when you cut the block, do not think in terms of pencil lines or shapes made by a brush and ink, but rather, of interpreting those lines and shapes with the knife and gouges (Fig. 217).

Pull proofs and make corrections as described above in the first project. You now should be ready for something more complex.

Third Woodcut Project

Complicated compositions can be traced onto the block with carbon paper, but the results often lack spontaneity. A better way to transfer a drawing to the block is to glue the drawing itself to the block and then to cut directly through the drawing:

1. Coat the paper on which the drawing has been made, with rubber cement. If the paper is opaque, coat the *back*. If the paper is transparent, coat the *front* of the drawing. (The rubber cement should be thin—about the consistency of milk.)

Coating the front of the drawing has an advantage: The printed image will appear as you originally drew it, instead of reversed, as is usual in prints. This is especially helpful if you plan to use words in a design (Figs. 218 and 219).

2. Coat the surface of a clean block (not painted black), with rubber cement. Wait until the cement is dry on both the drawing and the block.

MORTON GARCHIK. "Sonnet." Courtesy of Associated American Artists, New York City. (Left: the woodblock. Right: an impression taken from the block.)

The original drawing, hand lettering, was done on transparent paper, which was pasted *face down* on the block. The letters were cut right through the paper. This was done because relief printing reverses. Had the letters been cut frontwards on the block, the words would have come out as a mirror image when printed.

Fig. 218

Fig. 219

3. Make slip-sheets out of wax paper (it will not adhere to the paper or block), and place them on the cemented block.

4. Place the drawing cement-side down over the slip-sheets. Weight the left side down (as you do when placing a printing sheet on an inked block). Raise the right side of the drawing and remove the "right" slip-sheet. Now raise the left side of the drawing and remove the "left" slip-sheet. Smooth the drawing out carefully on the block to make sure it has adhered all over (Fig. 220).

Fig. 221

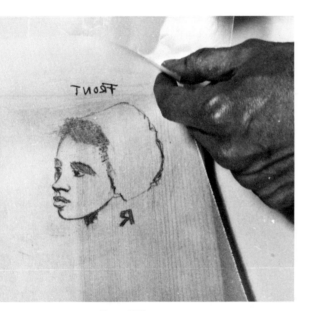

Fig. 220

A drawing has been pasted *face down* on the block (notice the word "front" is backwards). When it is printed, the image will appear frontwards, exactly as it was originally drawn. All the nuances of the original drawing can now be cut with precision.

5. You can now cut right through the image as if it were drawn directly on the block (Fig. 221).

This technique has advantages—it enables you to draw freely on paper; drawing on the block can be inhibiting. You can cut your drawing very precisely, retaining all of its original qualities and nuances, which would not have been possible by tracing it. However, guard against letting your prints degenerate into a method for merely "reproducing" your drawings.

Always think in terms of the knife, gouge, and wood, and how their interaction creates the final effect. The drawing should only be the starting point in the creative printmaking process.

6. When you have finished cutting, there will still be paper cemented to the block (the image). Try to peel it off carefully by slipping the X-Acto blade under it. If you can't, squirt some rubber cement thinner over the paper; do small sections at a time, and it will then lift off easily (Fig. 222). When all the paper has been peeled off, let the thinner dry for a few minutes: Some cement particles will still be stuck to the wood; use a rubber cement pickup to gently rub them off (Fig. 222). Then brush off the block, and it is ready for printing.

Fig. 222

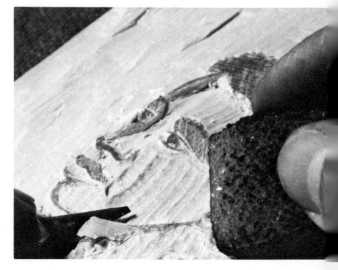

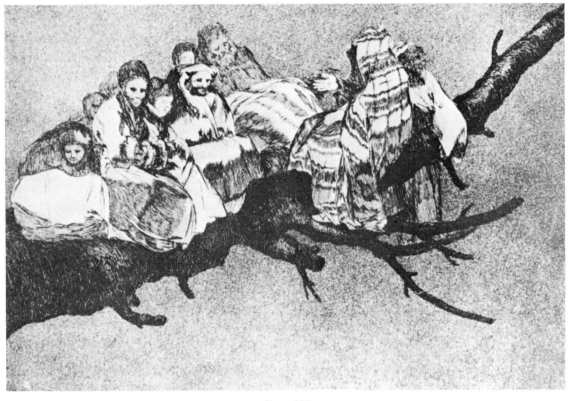

Fig. 223

FRANCISCO JOSE DE GOYA (1746-1828). "Strange Folly" (from *The Proverbs*)

A Final Word About Black-and-White Art

We are about to take up color printmaking. In doing so you should not think of the black-and-white work you have been doing as a preliminary step towards color. Of course, color broadens the creative potential of any visual art form; it is very beautiful and seductive. But the student should realize that black-and-white art has been a powerful and intimate means of expression throughout history.

We live in a "color" world; black-and-white art transforms that world by illusion. In a sense, it is a truly abstract, almost "magical" tool that many artists have used for their most personal statements.

The monochromatic etchings and drawings of Goya (Fig. 223), for example, are a tribute to the eloquence of black and white as an art form. They are analogous to the late chamber music of Beethoven, which also abandons the "colors" of a large orchestra and achieves expression through the compact "black-and-white" tonalities of a string quartet or solo keyboard instrument.

In our own time, Picasso limited himself to black and white to express one of the most powerful political protest paintings in the history of art, "Guernica."

Color Woodcuts

There are two methods of making color woodcuts: The addition technique, which uses separate blocks for each color; and the subtraction method, in which only one block is used for all the colors. The advantages and disadvantages of each will be discussed below.

Like black-and-white woodcuts, color prints can be approached spontaneously—plan as you go—or they can be preconceived with elaborate color studies, which you render with great precision. The number of colors and tones you may use are unlimited!

Color Printing by Addition

1. Pull three or four proofs of one of your black-and-white blocks; it will be referred to as the *key block*. Print it in black for this project (Fig. 224).

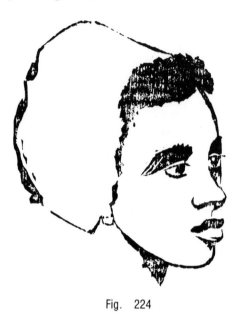

Fig. 224

2. When the prints are dry, make a color sketch by drawing directly on one of the proofs with pastels or crayons or watercolors (use approximately colors that correspond to the colors of the inks you plan to print with). In this instance limit yourself to three colors: black for the key block and two others. You may also plan for a fourth color by overlap-

Fig. 225

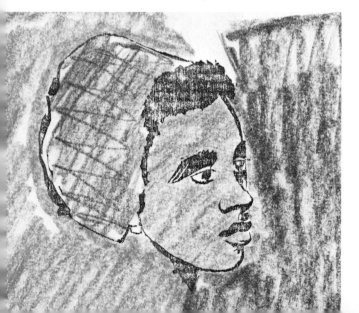

ping two colors—for example, blue over-printing yellow will produce a green.

In Figure 225, the dark tone on the right and the light tone on the left overlap in the face and hat, and will produce a fourth color (Color Plate IX, Fig. 3, follows page 128).

Successful color printing depends upon precise *registration*—getting the paper and blocks in exactly the same relationship each time you print a color. It is accomplished by using a registration guide (Fig. 226) and registration tabs (Fig. 227).

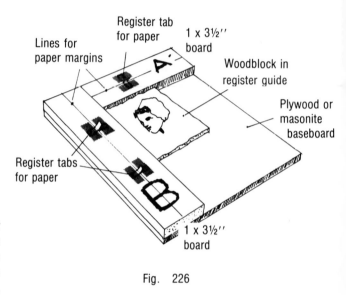

Fig. 226

A register guide can be easily constructed with wood strips and a piece of masonite or plywood, 10 x 15 inches, a convenient size that will accommodate larger as well as smaller blocks. Make sure strips A and B are at right angles, firmly glued and screwed to the base. Any loose movement in the guide will cause faulty registration.

Draw lines on A and B, about 1¾ inches in from the inside edges; these will establish margins for the printing paper. Tape *register tabs* on strips A and B as shown above.

Registering the Color Blocks

1. Place a piece of *wax* paper, slightly larger than the block, in the register tabs.

2. Tape the edges of the wax paper to strip B, near the tabs; this will insure that the paper does not move.

3. Ink the key block with black ink.

4. Carefully lift the wax paper back along strip B (Fig. 228).

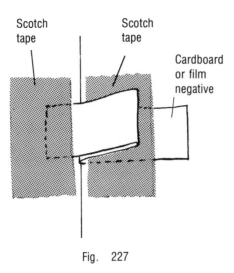

Scotch tape Scotch tape Cardboard or film negative

Fig. 227

Register tabs can be made from pieces of stiff cardboard or old film negative. Fold them as shown. The purpose of the tabs is to fix the printing paper in the same position each time you print a color.

5. Slide the block into the guide. Always slide it in the same way; place the long side of the block against strip B, and while holding it firmly against B, slide it towards strip A until it touches A.

If you don't do this consistently, any slight inaccuracies in the squareness of the

Fig. 228

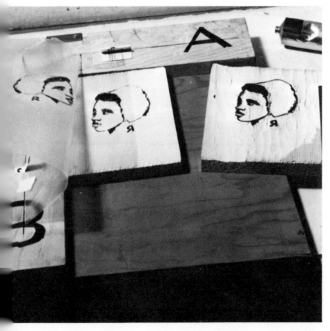

strips, or the block itself, will cause a misregister and a ruined proof.

6. Rub a "proof" of the key block on the wax paper, but do *not* remove the wax paper; leave it taped in place. Just lift it back sufficiently over strip B to remove the key block.

7. Place a new, clean block in the register guide. Remember, slide it in carefully, the same way you inserted the key block.

8. Let the wax paper fall back into position onto the new block, and rub the wax paper on the new block as if you were pulling a proof.

This will "offset" the image from the wax paper onto the new block. Lift the wax paper again, and remove the block (Fig. 228).

9. Re-ink the key block, place it in the guide again, burnish the wax paper on it again (this re-inks the image on the wax paper). Remove the key block, insert another new block and repeat step 8.

If you performed the steps carefully, all three blocks are now in perfect register. Clean up the key block. Let the ink on the new blocks dry. When they are dry, you can sketch or trace the color areas from your color drawing onto the color blocks and proceed to cut them. *Remember*, any areas that overlap must be on both blocks.

Printing Color Woodblocks

There is no rule for the order of printing colors. Usually dark colors overprint the light ones, but reversing the order can produce interesting results. In our example (Color Plate IX, Fig. 2), the light tan color overprints the dark brown where they overlap (in the face and hat).

1. Place a sheet of printing paper in the registration tabs. Do it very carefully, making sure that it is fully and squarely in the tabs. Tape its edges to strip B, near the tabs, to keep the paper securely in place.

2. Ink the first color block (in our example, brown) and insert it into the guide. Pull a proof (Fig. 229 and Color Plate IX, Fig. 1).

Colors may be printed wet over wet or dry over dry. In the former method, you would leave the paper taped in the tabs; remove the first color block (brown); ink the next color block (tan); place it in the guide;

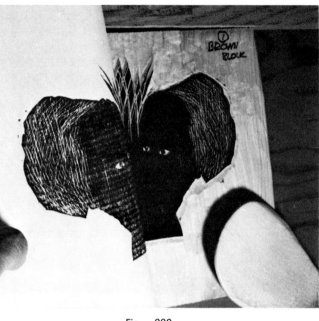

Fig. 229

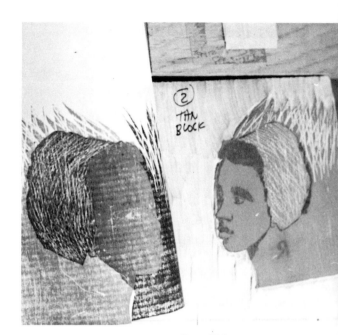

Fig. 230

burnish it; remove it; still leave the paper taped in place; ink the black block; insert and burnish it; and the print would be completed.

This method has the advantage of keeping the same sheet of paper in register throughout the printing process. However, wet-on-wet printing softens the colors (which may or may not be desirable). In addition, you will also need a separate roller for each color.

3. In the dry-printing method, a given number of sheets are printed with the first color and hung up to dry before proceeding to the second color.

When the image of the first color block has been rubbed onto the paper, remove the paper and hang it up to dry. Do this by peeling the tapes up from register strip B. Leave the tape on the paper for future use.

Print five or ten sheets with the first color, following the procedure described above. Clean up. When the sheets are dry (the time will vary from one to several hours, depending upon the particular color, the absorbency of the paper, and the weather), continue.

4. Re-tape into the register tabs a sheet that has the first color on it. Ink the second block (in our example, light tan) and insert it into the register guide (Fig. 230). Color Plate

IX, Figure 2 shows the tan printed over the brown. Print the remaining sheets; hang them up to dry; clean up.

5. Again, re-tape a dry sheet (which now has the first two colors printed on it) back into the tabs, ink the key block, insert it into the guide and print (Fig. 231). Print the remaining sheets. You should have perfect color prints (Color Plate IX, Fig. 3).

Troubleshooting

Any blurs or misregisters are caused by the following errors:

Fig. 231

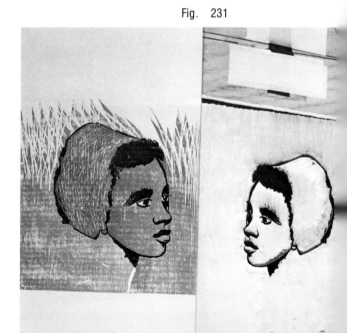

1. When offsetting the key block image from the wax paper onto the new blocks, any of the blocks may have been placed in the register guide carelessly. This can be corrected. Determine whether or not the faulty block is too close or too far from strip A or B. If too far, sand down either the side or end of the block which will bring the block closer to the guide. If the block is too close to either guide strip, paste thin strips of cardboard to either the side or end of the block. This will correct the position of the block.

2. The wax paper may have shifted during the inking or offsetting procedure. It may still be possible to realign any of the faulty blocks by the method described above.

3. Any of the blocks or sheets may have been carelessly placed in the guides while printing. There is no help for this; discard the imperfect print.

Do not be discouraged if you have register problems the first few times. Experience and practice will solve them.

Color Printing by Subtraction

An aspect of this method which you must consider is that the whole edition must be printed at one time. Only one block is used to print all the colors, but it is destroyed in the process. Therefore, you must decide at the outset how many prints you want in your edition (see Editions, page 148), and consider whether or not you want to invest the time in printing it all at once.

It will also be necessary to print a few more sheets than you want. For example, if you are planning an edition of 50, start with at least 60; a few sheets are likely to be lost along the way, through mishaps or changes in the concept, as the print evolves.

1. When using the subtraction method, it is best to have a color sketch, or at least a color notation (Fig. 232).

2. Trace or sketch the picture on the block. Then cut away all the wood around the entire outline of the largest shape. Print the whole remaining shape red. Print *all* the red sheets of your total edition *now*! Hang them up to dry. Clean up (Fig. 233 and Color Plate X, Fig. 1 faces page 129).

3. Cut away all the areas on the block that are to remain red on the finished picture.

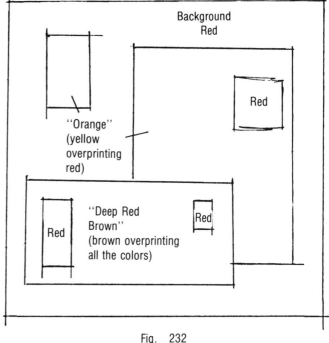

Fig. 232

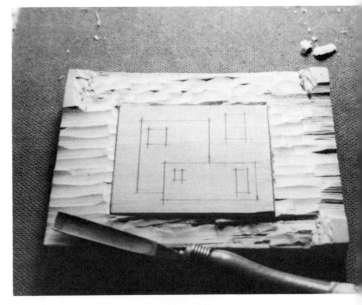

Fig. 233

Print the remaining shape yellow *on all the sheets*. Hang the sheets to dry. Clean up (Fig. 234 and Color Plate X, Fig. 2).

4. Cut away the area on the block that is to remain "orange" (the yellow overprinting the red) on the finished picture. Print the remaining shape brown on all the sheets (Fig. 235 and Color Plate X, Fig. 3).

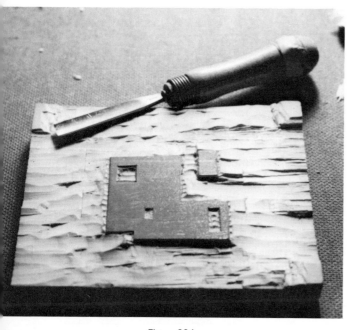

Fig. 234

Fig. 236

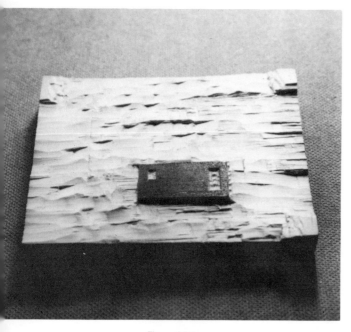

Fig. 235

Top left of the block: A rasp has scratched the wood and been hammered against it; the outlines and shapes of a piece of metal, a screw head, a large screw thread, washers, and a piece of metal picture wire have also been hammered on to the surface of the wood; an ice-pick was used to poke holes in the wood. *Bottom* of the block: A piece of sandpaper, a button, and a piece of sewing thread have been glued to the block; next to the sandpaper, some glue has been dripped onto the block; and lines have been "drawn" into the glue with a stick.

Contemporary Relief Techniques

In recent years artists have experimented with relief methods to create a variety of new effects. Essentially this means either "cutting" the block with unorthodox tools, such as power tools, or *adding* foreign substances to the surface of the block. A few possibilities are shown in Figure 236.

Figure 237 is a proof taken from the block. It indicates some of the vast potential this approach affords, but you should use it judiciously. It is easy to get carried away by such experiments and lose sight of the fact that, though they extend the artistic vocabulary, they are not ends in themselves.

Because this technique creates variations in the depth of the block's surface, inking and printing are difficult to control. Hard and soft rollers may be necessary to bring out everything *on* or *in* the surface of the block. Do *not* attach anything to the block which is so high or sharp that it will cut the rollers.

In order to get exactly the same image each time, you may need ingenuity when

Fig. 237

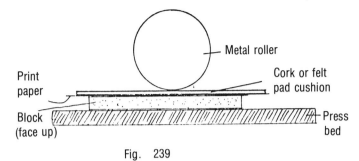

Fig. 239

Side view of block and paper in etching type press.

A press can speed the printing process, but some hand-printing may still be necessary to correct spots that do not print well because of irregularities in the block.

One limitation of a press is size. Hand-printing is limited only by the size of paper available (Fig. 240).

MORTON GARCHIK. "Norma Dancing." Winner of the Olivet Fifth National Print Purchase Award. (This print is 3 x 6 feet.)

Fig. 240

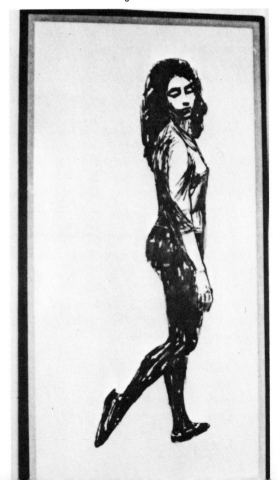

printing and many different tools (including your hand, fingers, and fingernails for details).

Other Printing Methods

Woodcuts can be printed with presses such as an old-fashioned bookbinder's press (Fig. 238).

An etching press may also be used. The block should be a hardwood and free of warps. It is also necessary to place some cushioning between the block and the metal of the press rollers or bed (Fig. 239).

Fig. 238

5/50 SQUARE AND CIRCLES John Artist, imp.

Fig. 241

Still another printing method is to use your own weight as a press. Place a pad of newsprint or a felt pad on the floor (or on a piece of plywood, if the floor is not smooth and even). Place the printing paper on top of the pad; place the inked block *face down* on the paper; and stand on it. Carefully "rock" the block slightly as you stand on it; this will work it into the paper. Peel the paper back partway to check the impression, re-ink the block as necessary, and "press" again. Minor touch-up printing can be done by hand-burnishing.

Editions

The unique feature of print media—their ability to duplicate images—has enabled artists to distribute their works widely and, at the same time, it has given collectors the opportunity to acquire hand-made, hand-signed works of art at moderate prices.

The actual number of duplications—the size of an edition—is somewhat arbitrary. It should be limited by the quality and consistency of the printing. The point at which an image begins to alter, because the printing surface has worn down, is a natural stopping point for an edition. The first and last proofs of an edition should look exactly alike. These considerations have led artists to issue *limited editions*; the artist limits the number of proofs pulled from one set of blocks or plates, and numbers each print.

After the edition is printed, the blocks are usually either completely destroyed or defaced so that no further impressions can be taken from them, thus insuring that the edition is indeed limited.

There is, however, much historical precedent for second editions, and they should be so marked. Some artists make changes in old blocks, in effect, creating new works; but buyers should be made aware of the fact.

Prints are sometimes signed and numbered in pencil, as shown in Figure 241.

The notation "5/50" indicates that this is the fifth print of an edition of 50. The letters "imp." after the artist's signature is the traditional method of indicating that the artist him/herself printed the proof.

Artist's Proof (sometimes abbreviated a/p) refers to a small number of proofs (10 or 20) which the artist keeps when the regularly numbered edition is sold outright to a dealer (Fig. 242).

It is not necessary to print an entire edition at one time (except in the subtraction method, see page 145). You can print five or ten proofs as convenient. If those are sold or distributed, you can then print more. Thus, you should keep careful notes on your printing procedures, the names of colors and their printing order, etc. It is also important to keep accurate records of the edition numbers you already used.

What Is an Original Print?

The word "print" traditionally described etchings, engravings, woodcuts, lithographs, and serigraphs created by fine artists.

Today it is used loosely to cover a variety of graphic work from fine art prints to posters and reproductions. Posters, reproductions, and all pictorial matter we see in books or magazines are *reproduced* by machines: A drawing or painting is photographed with a special camera; printing plates are made mechanically from the photographic negatives; and the reproductions are printed from those plates on high-speed commercial presses.

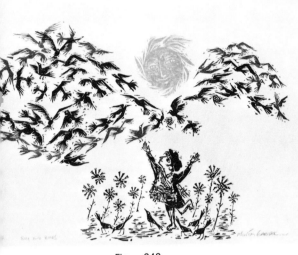

Fig. 242

MORTON GARCHIK. "Boy and Birds." Courtesy of Associated American Artists, New York. (Library of Congress Collection)

The stylization of forms and shapes in this color woodcut is a direct result of the interaction of the knife and wood, which translated the rounded forms of the original drawing into unified sharp, flat, bold patterns.

The techniques for doing this—letterpress, rotogravure, offset lithography, and commercial silkscreening—developed from their fine art predecessors (relief, intaglio, lithography, and serigraphy). Thus it is sometimes difficult to distinguish between an authentic fine art print and a reproduction.

The matter has been compounded and further confused, in recent times, by some contemporary printmakers who, in a sincere effort to experiment with and expand the graphic vocabulary, utilize commercial photomechanical techniques.

Unfortunately these techniques have also been abused by some artists and dealers seeking merely to produce and sell large quantities of pictures quickly. It is not unusual to see advertisements describing "limited edition reproduction prints" (some of which are even sold through museums) to an unwary public willing to pay large sums of money for *reproductions* that are manufactured at a fraction of their selling price.

It is important to understand and maintain the difference between a fine art print and reproductions that pass for "prints." According to a traditional definition:*

> An original print is a work of art, the general requirements of which are:
> 1. The artist alone has created the master image in or upon the plate, stone, woodblock, or other material, for the purpose of creating the print.
> 2. The print is made from the said material, by the artist or pursuant to his/her directions.
> 3. The finished print is approved by the artist.

This is the definition of prints used in this book. The problems of forgery, fakery, and misrepresentation have been part of art since it became a marketable commodity. As an artist you can help educate the public by sharing the knowledge you acquire about abuses you become aware of.

Exhibiting Your Work

There has been a great revival of printmaking in the past half-century all over the world. Museums and galleries hold frequent exhibitions of prints, and some galleries specialize in their exhibition and sale. Art schools and colleges have active print workshops.

There are many opportunities for new artists to exhibit and sell their work. Art magazines list upcoming exhibitions and where to write for entry forms. Often you need only send a color slide of your print for the initial jurying. If your print is accepted you will then have to mail it, matted or unmatted, according to instructions. Send a clean, accurate proof. Should several people order prints from one of your editions, they have the right to expect that the proof they receive looks exactly like the one they saw on exhibit.

Should you sell some of your prints, you will enjoy a benefit unique to the medium, that of retaining a "copy" of the picture for yourself.

Standards for Print Dealers, New York, Print Council of America, 1964

Other Printmaking Techniques

The other major printmaking techniques in use today are intaglio, serigraph, lithography, collagraphy, and photomechanical.

You may wish to try them. Unlike woodcut, they require elaborate, expensive, and sometimes dangerous equipment. Therefore it is recommended that you study them under supervision, in a workshop.

Below is a description of each process, with examples that demonstrate the qualities of each technique.

Intaglio

"Intaglio" refers to a drawing that is incised *beneath* the surface of metal. It is a word used to describe etchings and engravings. The earliest dates from 1446.

The image is either incised directly into the metal (drypoint or engraving) or drawn through an acid-resistant coating of wax that has been spread on the surface of the metal. In the latter technique (etching), the coated metal plate is placed in acid, which bites (etches) the drawing into the metal (Fig. 243). The wax coating is then removed.

Fig. 243

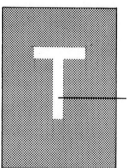

The image is drawn through an acid-resistant wax, exposing the metal.

After the acid bites down the exposed metal, the wax is removed.

The image is now below the surface ready for inking.

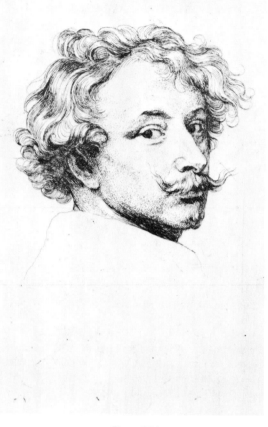

Fig. 244

ANTHONY VAN DYCK (1599-1641). "Portrait of the Artist" (Detail). The Frick Collection, New York

An exquisite example of the delicacy obtainable with an etching needle and acid. Linear patterns describe the texture of the hair, while stippled dots model the forms of the face by creating an illusion of subtle tonal nuances.

In contrast with the wood block, with its inked raised surface, the surface of the etched plate is wiped free, and ink is left only in the image areas below the surface.

The plate is then put in a press, which forces the paper under intense pressure into these subsurface image areas to receive an impression of the image.

Etchings made in this way are capable of producing a variety of lines, from those that are extremely fine and delicate to those that are coarse and bold (Fig. 244).

Etchings are also capable of producing rich graded tones of blacks and grays (Fig. 245).

Fig. 246

The pores of the screen are blocked; only the image is left open so that ink can be squeezed through.

A piece of silk stretched over a wooden frame is the printing surface for making serigraphs. All the areas around the image are blocked. A thick ink is squeezed through the pores of the screen in the unblocked image areas to the printing paper beneath the screen.

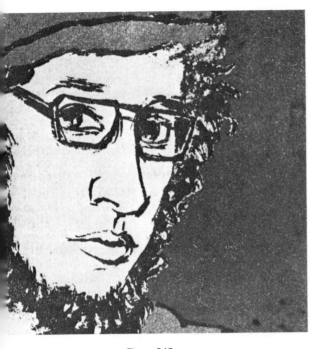

Fig. 245

MORTON GARCHIK. "Self-portrait" New York (Collection of the artist)

In addition to delicate line effects, etchings can produce rich gradations of tones.

Serigraphs

Sometimes called silkscreen prints, serigraphs evolved from stencil techniques, which may have been used first by primitive people who pressed colored dyes through holes in thick leaves, to repeat designs on fabrics.

In this medium, all the areas around the image are blocked out (Fig. 246). It is printed by ink being *squeegeed* (pressed) through the pores of the screen that are left unblocked (the image) onto the paper beneath the screen.

Serigraphs offer a wide range of effects, dependent on the tools used to draw the image on the screen: crayon, brush and ink, pens, or knives which are used for cutting stencils that are affixed to the screen. In addition, screen inks are thick and permit a heavy build-up of paints, which lend a painterly feel to the prints (Fig. 247).

Fig. 247

WILL BARNET. "Woman and White Cat." Courtesy of Associated American Artists, New York

Serigraphs are generally characterized by flat tones and sharp edges, but Barnet's charming piece demonstrates that the medium is also capable of subtle textural effects.

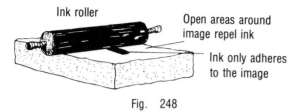

Ink roller

Open areas around image repel ink

Ink only adheres to the image

Fig. 248

Lithography

Lithography differs from the other print media in that the method of transferring the image is chemical. The image is not on a raised surface (woodcut); it is not below the surface (intaglio); nor is it the open portion of a screen (serigraph). The image is drawn on the surface of a grained stone or metal plate and then treated chemically, so that the image itself is receptive to ink, while the area around the image is repellent to ink (Fig. 248). Lithographs have a large tonal range, which can mirror the effects of crayons, pen and ink, and watercolor washes (Fig. 249).

MORTON GARCHIK. "Philosopher Ascending." Courtesy of Associated American Artists, New York

Lithographs are capable of producing a wide range of tones and colors, faithfully reflecting the spontaneity and freshness with which they are drawn on the plate.

Fig. 249

Fig. 250

CLARE ROMANO. "Journey." Courtesy of Associated American Artists, New York. Cincinnati Museum of Fine Arts Collection. Prize: 1968 Society American Graphic Artists

Romano's five-color collagraph is printed from a plate that combines both relief and intaglio elements. It is an excellent example of the creative innovations prevalent in contemporary printmaking.

Collagraphy

The collagraph is a recent development in printmaking that combines relief and intaglio, offering the range of both techniques in one image. Cardboard, masonite, or metal may be used as a plate upon which a variety of shallow-depth forms are molded or attached, including intaglio plates.

The collagraph becomes, in effect, a collage of reliefs and intaglios, requiring imaginative and skillful inking. It is printed under pressure on an etching press (Fig. 250).

Photographic Techniques

Photographic techniques can be utilized with etching, lithography, serigraphy, and collagraphy. They are discussed in the section on Editions, page 148.

THE FUNCTION
OF ART AND THE
EVOLUTION OF STYLE

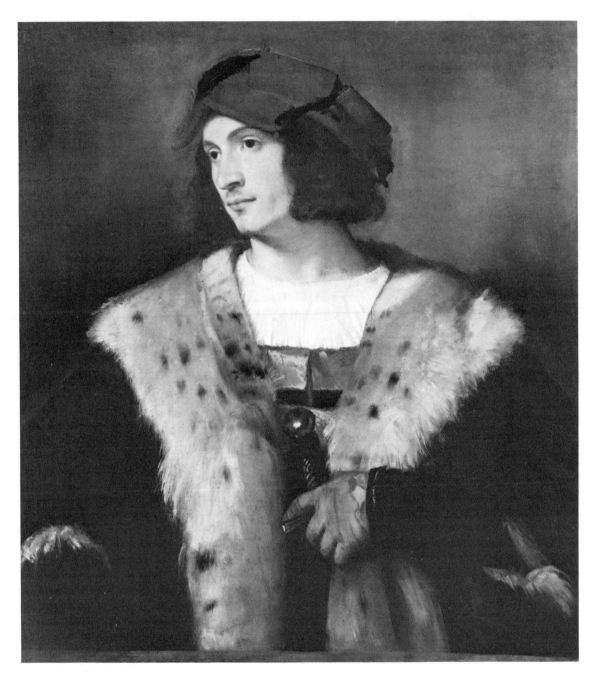

TITIAN (1477-1576). ''Portrait of a Man in a Red Cap.'' Copyright the Frick Collection, New York

Chapter VI

THE FUNCTION OF ART AND THE EVOLUTION OF STYLE

S TUDENTS LEARNING THE TECHNIQUES OF ART should not neglect its historical background. Understanding the art of the past, the position of the artist in society, and the vast vocabulary of styles is an important part of the education of a contemporary artist.

Before recorded history, some people, seeing footprints or shadows, must have had the realization that a *graphic image* could symbolize objects and communicate ideas and feelings (Fig. 251). People have always exhibited a love of decoration—adornment for their bodies, clothing, and environment—possibly influenced by natural patterns and designs on the bodies of animals, insects, and birds and the colorful forms and shapes of the plant world.

These early responses to graphic symbols and decoration were the first stirrings of creative expression. They led to the making and appreciation of art.

The word "art" is used in reference to many visual media—especially drawing, painting, sculpture, and printmaking, but also architecture, industrial design, fashion design, pottery, weaving, illustration, quilting, etc. The primary function of the latter group is utilitarian: a plate can hold food even though it is not aesthetically decorated; a building that may not inspire an artistic response can afford adequate shelter.

The art traced in this chapter is that which serves spiritual rather than utilitarian needs. The art treasures that have come down to us—great literature, painting, music, and dance—neither feed, shelter, nor clothe us; but they nourish our spirit. The focus will be on how the functions and styles of that art have evolved throughout history.

The Evolution of Art

Among the oldest art works that have survived the destructive forces of time are cave paintings (Fig. 252). It is believed that they fulfilled public functions as prayer images to assure abundance in the hunt, and as visual aids to instruct inexperienced hunters about animals. But the obvious sensitivity to line, shape, form, color, and texture in these works indicates a concern with artistic qualities quite apart from the requirements of their public function.

The aesthetics of an image, independent of its function in society, are important and are present throughout history. For example, the animals in Figure 252 might have been drawn in a diagrammatic style, like a medical illustration, and still perform their intended function. But the artists who made such drawings made them beautiful as well as functional.

155

Fig. 251

UNKNOWN ARTIST(S) (date unknown). Images of Hands. Gargas Cave. Aventignan, France

Even before recorded history, people demonstrated a realization that a graphic image could symbolize objects and communicate ideas. These "drawings" of hands were made by a person dabbing colored earth pigments around a hand that was held against the wall. When the hand was removed, a negative impression of it remained.

UNKNOWN ARTIST(S) (ca. 15,000-10,000 B.C.). Cave Paintings. Lascaux, France

Though the purpose of these images is thought to be utilitarian, we appreciate them today for the artists' obvious sensitivity to line, tone and rhythm. The style is based upon silhouettes, with some modeling to suggest the third dimension. Notice too the overlapping legs of the animal in the upper right. This style has been used throughout history as a basic part of the visual vocabulary.

Fig. 252

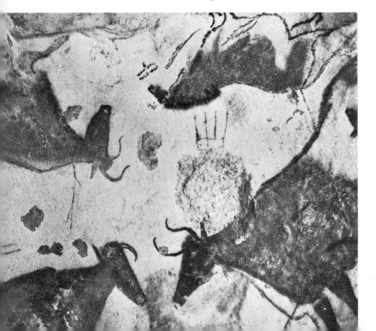

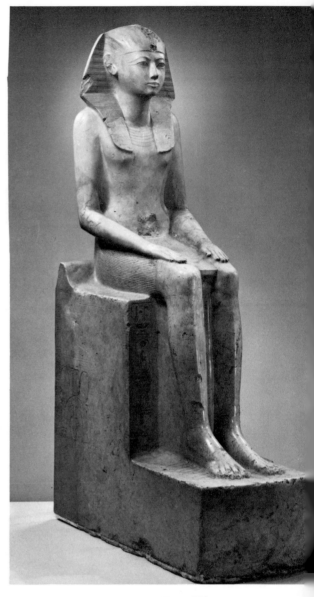

Fig. 253

UNKNOWN ARTIST(S) (ca. 1485 B.C.). Statue of Queen Hatshepsut. Metropolitan Museum of Art, New York (Rogers Fund and Contributions from Edward S. Harkness)

The rigidity of this pose (compare it to the graceful Greek statuette, Fig. 257) cannot be attributed to a lack of skill; the sophisticated modeling of the head is sufficient proof of the artist's mastery of technique. The rigidity was a result of the artist's obligation to portray royal personages as gods. To accomplish this, figures were drawn and carved in formal rather than natural or relaxed poses. This style evokes austere and awe-inspiring feelings; it is another stylistic device artists have used throughout history (compare also Fig. 258 and Color Plate XI, follows page 160).

Developing Artistic Skills

Early artists sought to master skills with which they could depict reality. But the styles and conceptions of reality have varied throughout history. Figure 253 is stiff and unnatural, but because of the draftsmanship evident in the details, we can assume that the artists who carved such statues were skillful and could have presented a more natural likeness. The function of their art, however, was to portray the ancient Egyptian kings and queens, who were considered gods, as austere, majestic, and awe-inspiring personages. Consequently, the essence of Egyptian "Realism" was formality and dignity.

Ancient artists also portrayed the reality of space in a manner that looks unnatural but that may in fact be truer to reality than the ways of drawing space developed by artists centuries later.

For instance, in Figure 254 sketch A is

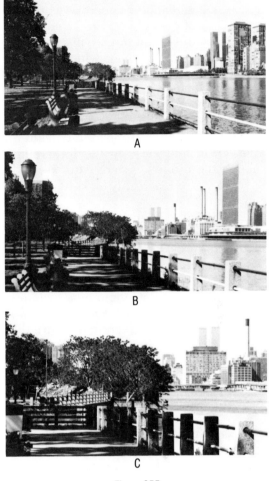

A

B

C

Fig. 255

A

B

Fig. 254

drawn in perspective, a technique developed by Renaissance artists, in which objects and space are drawn as they *appear* to the eye; the further people and trees are from us, the smaller they appear to be. In A the sides of the pool seem to converge as they recede into the distance.

Earlier artists had preferred to draw objects and space as their experience (not solely visual) made them know objects and space to be; a round object may appear elliptical, but they *knew* it was round. Sketch B shows that approach; it is schematic, like a blueprint. Both styles present "realistic" information but they look different.

The perception of reality also varies with the differences in our individual eyesight (not to mention the differences in the vision of animals, insects, birds, fish, and humans). The photographs in Figure 255

show the same scene, from the same position, as it would appear to people who have three types of eyesight (exaggerated in our example by the use of three types of photographic lenses). A has vision which takes in a very wide area. B represents *normal* vision: the spatial relationships correspond to what some people usually experience. In C, the vision is telescopic; only the center of the image is seen, and the background looms up large, clear, and close to the foreground. Though the differences are extreme, each person believes that reality looks like her/his own perception.

Reality appears differently to people whose color perception is normal and to people who are color blind. In addition, our perception often depends upon information we have about the thing or picture we are looking at. Figure 256 might be a technical diagram or just some abstract shapes. But if we are told that it is a picture of a dirigible flying over a football which is floating on a pond, it suddenly takes on a certain amount of realism.

Even from these few examples, it becomes obvious that perception of reality varies and is subject to many interpretations.

The Conquest of Realism

Though the mastery of portraying one style of Realism or another does not, in itself, insure artistic quality, early artists strove to portray the style most people consider real: Naturalism.

Fig. 256

Greek artists were the first to succeed, partly because of the democratic humanism that pervaded their society. It changed the function of art. Greek artists could portray their gods and rulers as people, whereas Egyptian artists portrayed people as gods.

A new function of art evolved during this period. Greek painters and sculptors still produced works for public use—military memorials, portraits of rulers, and religious pieces—but they also created works to be enjoyed for their own sake. Some artists even began to sign their work.

Figure 257 is an example that marks a point in history when people other than kings or rulers could participate in the aesthetic experience by buying art made for the beauty it would bring to their lives and homes.

Religious Art

The secular art that developed in Greece grew in importance and continued throughout the Roman civilization that followed. It marked a change in the basic functions that art had filled during the preceding centuries, art that had been used for religious, military, and political propaganda purposes.

It may be argued that all good art is spiritual, thus all art is religious. However, sacred art is usually defined as that which reflects a specific religious period or culture. The founding and growth of Christianity made religious expression a primary and public form of art once again.

Holy images helped the spread of Christianity from about 300 A.D. until the mid-seventeenth century. As the Christian religion grew, one of the greatest eras of church building the world has ever known flourished. These places of worship were decorated inside and out with paintings and sculpture—later with stained-glass and mosaics—and production of illustrated religious texts proliferated. Large numbers of artists were employed to produce images that were central to the beliefs of their cultures. Medieval art served, in fact, to convey the message of the Church to a population that was largely illiterate and in any case

(before printing was invented) had little access to the written word.

Interestingly, some early Christian art retreated from the Greek style of portraying people naturalistically. It returned to the austere conceptions of Egyptian art. The images that decorated large church walls were meant to indoctrinate masses of new converts and designed to show the church hierarchy and the political leaders who supported them as earthly deputies of Christ.

The effect was achieved by a style that expressed solemnity and inspired respect; a style that precluded the sensuousness of Greek realism. The aim was to create an other-worldly reality, one to be feared and obeyed (Fig. 258).

UNKNOWN ARTIST(S) (536-547 A.D.). Panel showing Empress Theodora and members of her court. (Copy of original mosaic in the Church of San Vitale, Ravenna). Metropolitan Museum of Art, New York, (Fletcher Fund)

In the sixth century, artists, who were once again in the service of the church and royalty, returned to the use of styles which portray rulers as super humans. In this instance, a Byzantine Empress is portrayed as an earthly deputy of god. The very formal pose works to produce an effect that is meant to command respect and obedience (compare also Fig. 253 and Color Plate XI, follows page 160).

Fig. 258

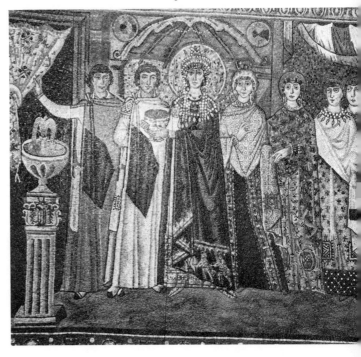

Fig. 257

UNKNOWN ARTIST (ca. 4th or 3d cent. B.C.). Statuette: Woman standing. Metropolitan Museum of Art, New York (Rogers Fund)

Works like this are interesting historically as well as stylistically. It marks a period when art was created for private pleasure and ownership, rather than solely for religious or political functions. It shows a complete mastery of naturalism and a delight in the beauty of simple, human gestures. The artist's ability to organize the lines, shapes, forms, and rhythms organically, gives the figure a feeling of monumentality—the power of something larger than life. This is quite remarkable when we realize that the statuette is only 7 ⅞ inches high.

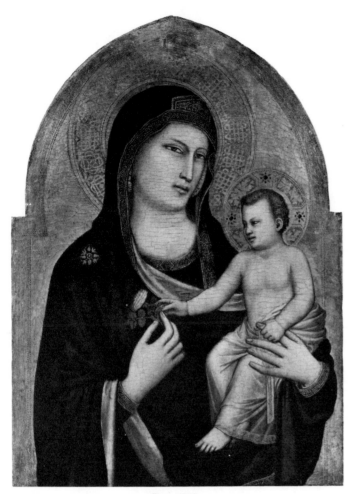

Fig. 259

GIOTTO (ca. 1266-1337). "Madonna and Child." National Gallery of Art, Washington, D.C. (Samuel H. Kress Collection)

Some artists create an interesting style despite technical short-comings. The crudity of Giotto's drawing is transcended by the grace and passionate expression he produces in his images. Anatomical inaccuracies—the Madonna's eyes, the placement of the child's ears and the general disproportions of the figures—are easily overlooked because of the exquisite harmonies. Notice how almost all the forms and shapes are composed to make gentle curving rhythmic patterns, which are so well suited to express the mood.

It is also interesting to note that during the first 1000 years of Christianity, the crucifixion image was rarely used. Christ was almost always portrayed majestically, alive and well, ruler of the universe. In time, the style of portraying Christ would revert to a humanistic one. He would be shown as a mortal, undergoing human suffering (Color Plate XIII).

As Christianity spread over vast geographical areas, art styles were carried with it from country to country. resulting in numerous cross-influences. The reason for this is that styles develop in two primary ways: through artists' direct interpretation of the world they perceive; and by artists who are more influenced by other artists' work than by their own direct perception of nature. Both methods appear again and again throughout history.

Many of the paintings, sculptures, and prints produced in the early centuries of Christianity, including those which were heavily influenced by other art, are of superior quality because the basic techniques of art—composition, perspective, and the use of color, light, and shade—had been studied like exact sciences.

Another contributing factor was the professional status that artists had gained. Renaissance sculptors and painters were seen as geniuses (in the Platonic sense, divinely inspired); the wealth of the Church could employ the most talented creators.

But perhaps the most important reason was that many artists believed in what they were doing. Giotto (1266?-1337), was typical. Not only do his paintings demonstrate consummate skill, beauty, and powerful drama; they also express his own devout inner feelings (Fig. 259).

There were of course exceptions. One of the religious paintings of Veronese (1528-1588), similar in style to "Rebecca at the Well" (Fig. 260), was considered slightly impious, and he was therefore rebuked by the Inquisition. He exemplified an artistic trend that placed aesthetic concerns above the demands of authorities.

The Growth of Printmaking

Prints, unlike simple forms of sculpture and painting that originated in prehistoric times, required sophisticated tools—paper, special inks, a surface that could retain and transfer an image, and in some media, a mechanical press. In the fifteenth century, these tools became available to artists who

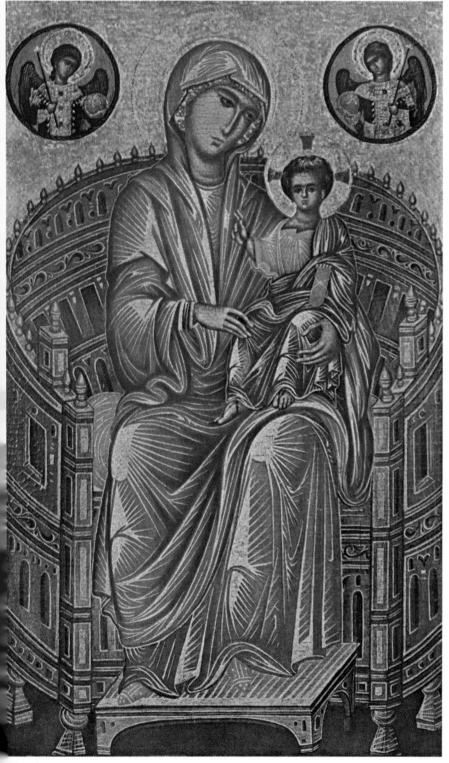

This early painting includes many stylistic devices that are a standard part of the artistic visual vocabulary: the forms are designed as flat shapes and modeled slightly with a few simple tones; anatomy and sizes are freely distorted for expressive purposes; space and perspective are also altered for psychological reasons, instead of being realistically rendered.

These techniques were often used for religious art intended to impart an other-worldly quality to the image and evoke feelings of awe and reverance (compare Figs. 253 and 258).

Artists in different periods and other cultures have used similar techniques—for example, the Japanese artist, Hokusai (Fig. 273) and the American, Shahn (Fig. 287). The technique's emphasis upon two-dimensional rhythmic patterns creates a direct, poster-like image with immediate impact.

BYZANTINE SCHOOL (XIII Century). "Enthroned Madonna and Child." National Gallery of Art, Washington, D.C. (Andrew Mellon Collection)

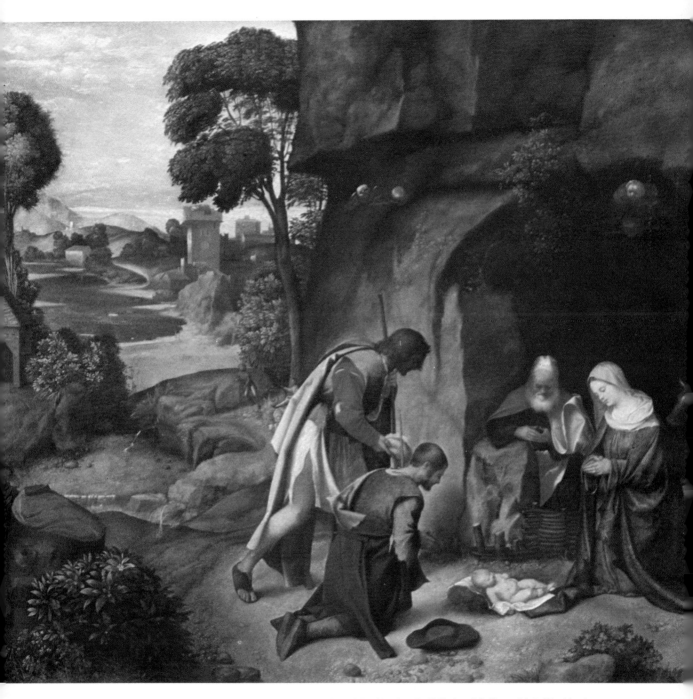

GIORGIONE (ca. 1478-1510). ''The Adoration of the Shepherds.'' National Gallery of Art, Washington, D.C. (Samuel H. Kress Collection)

The visual elements—line, shape, form, light and dark, color and texture—are controlled with great mastery in this exquisite work. Each is treated rhythmically and in well-proportioned sequences (see Chapter I). Turn the picture upside down and notice how the superb arrangement of the elements also functions as an abstract design which reinforces the content.

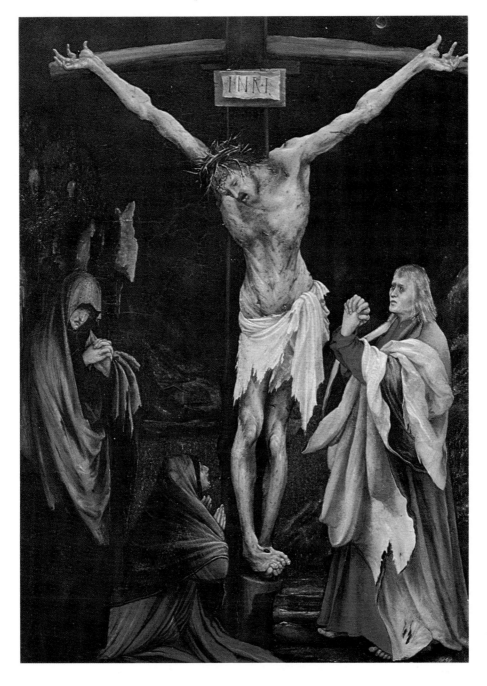

MATTHIAS GRUNEWALD (ca. 1465-1528). "The Small Crucifixion." National Gallery of Art, Washington, D.C. (Samuel H. Kress Collection)

In Grünewald's version of the Crucifixion, a new stylistic device is apparent—violent distortion for emotional effects. Limbs are twisted beyond anatomical plausibility; diagonal movements, jagged and swirling forms, reinforce the mood, as do the strong contrasts of light and dark. Three centuries later artists would make these techniques the central focus of their style, called Expressionism.

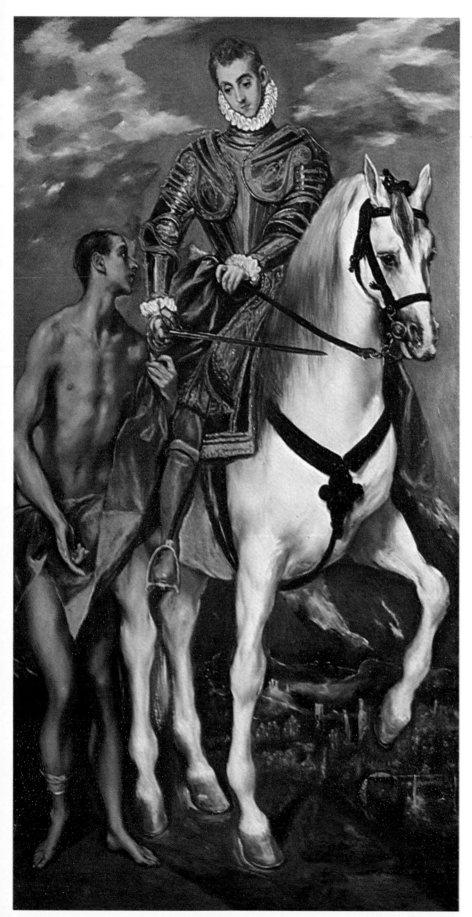

EL GRECO (ca. 1542-1614). "Saint Martin and the Beggar." National Gallery of Art, Washington, D.C. (Widener Collection)

Artists have the ability to transform seemingly prosaic subject matter into dynamic aesthetic experiences. They accomplish this by manipulating the visual language elements on an abstract level (see Chapter I).

Here, within the boundaries of a "realistic" scene, El Greco freely distorts natural appearances: the figure of the beggar is elongated to an unreal height of almost eleven heads! The edges of shapes and forms undulate and pulsate with a rhythm that has little to do with realistic anatomy. Notice too the free invention of shape and form and the expressive play of light in the handling of the clouds.

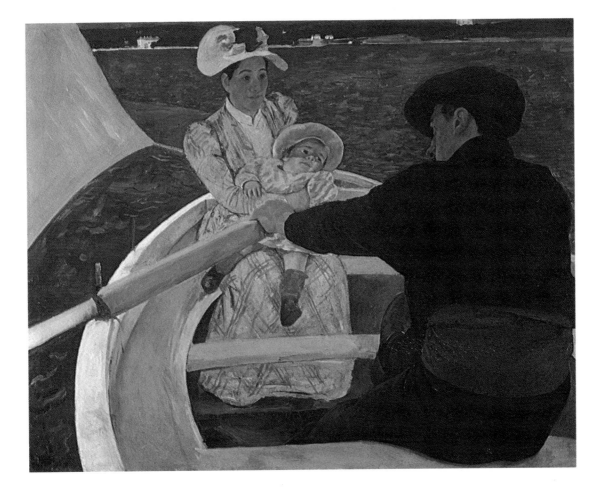

MARY CASSATT (1844-1926). "The Boating Party." National Gallery of Art, Washington, D.C. (Chester Dale Collection)

In analysis of style, particular developments are often associated with specific groups, e.g., *French* Impressionism. But artistic style and creativity are universal and transcend the boundaries of nationality, race, and sex. We have seen in the work of Turner, an Englishman (Fig. 271), a use of color and brushwork that anticipated that of the Impressionists. The pictures of Whistler (Fig. 153), an American who painted in England, were very influential upon the work of Degas (Fig. 275). In addition, a successful school of *American* Impressionists developed. Foremost among them was Cassatt, who painted in France for many years. In this late work, she combined her exceptional drawing ability with several Impressionist techniques. Notice the unusual compositional cropping, which creates dynamic, abstract looking shapes; the wide range of vibrant colors; and the vigorous brush strokes that animate the entire canvas.

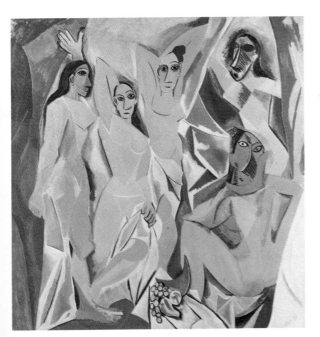

PABLO PICASSO (1881-1973). "Les Demoiselles d'Avignon." Collection, Museum of Modern Art, New York (Lillie P. Bliss Bequest)

In this landmark work, Picasso fused several earlier historical styles: violent emotional distortion (Color Plate XIII); combining multiple views (Fig. 282); and bold geometricizing of the human form (Fig. 283). The historical importance of this work was not its seeming originality, but rather its daring assertion that such stylistic devices could be made the focus of a work of art.

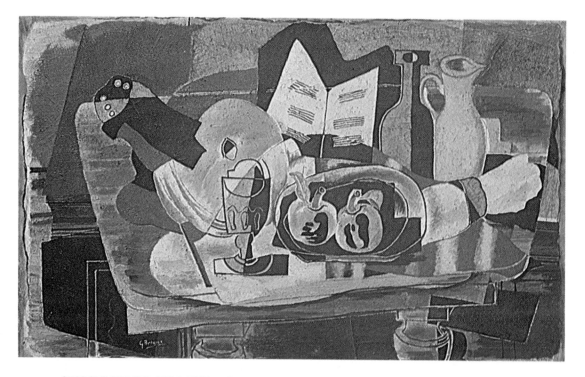

GEORGES BRAQUE (1882-1963). "Still Life: The Table." National Gallery of Art, Washington, D.C. (Chester Dale Collection)

Cubism (see page 173) evolved in different stylistic phases. In the earliest, artists like Picasso (Color Plate XV) and Braque looked at objects from the front, sides, top, and bottom. Then they interpreted those different views geometrically and reassembled them in shallow pictorial space, using limited color, tone, and texture.

The later style, as in this example, retained the geometric patterning, but expanded the movement into pictorial space. Color, tone, and texture were used on a broader scale. Braque actually summarizes the two concepts within the picture itself: the bottle is drawn and "modeled" with just a light and a dark shape; the pitcher is rendered in a more traditional, three-dimensional modeling style.

Despite its semi-abstract appearance, the picture has the powerful compositional structure and eloquence noted in the realistic still lifes of Chardin (Fig. 116) and Cézanne (Fig. 129).

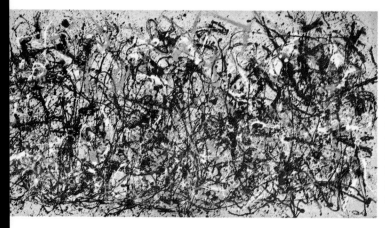

JACKSON POLLOCK (1912-1956). "Autumn Rhythm." Metropolitan Museum of Art, New York. (George A. Heard Fund)

Modern artists' preoccupation with content, concept, and style led to much experimentation. Pollock stretched the boundaries of style by throwing, dripping, and splashing paint on the canvas. While there had been precedent for this technique in the work of the Dadaists, who had kicked cans of paint onto canvases to protest the art of the past, Pollock's use of similar means had a more positive emphasis. He used his technique to express the rich, dynamic, rhythmic energy that is so often the essence of the act of creation; he made that energy both the subject and subject matter of the work.

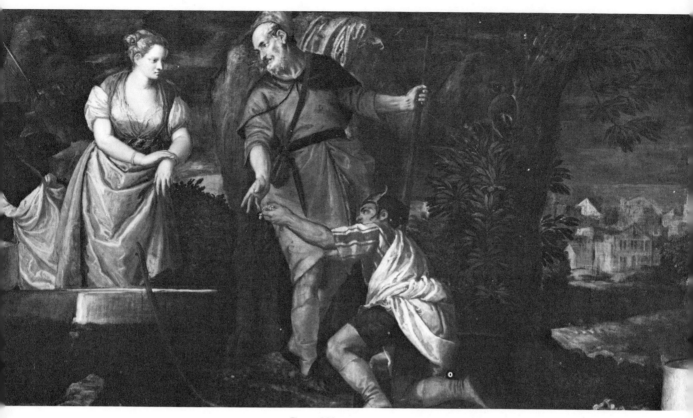

Fig. 260

PAOLO VERONESE (1528-1588). "Rebecca at the Well." National Gallery of Art, Washington, D.C. (Samuel H. Kress Collection)

Veronese represents the trend of "art for art's sake," even though he worked at a time when artists were commissioned by the state or church. He painted in an opulent and colorful style, which was often considered inappropriate to the religious subject matter; notice how concerned he is with rendering the textures of different fabrics. Rebuked by the Inquisition for such practices, he defended himself by saying, "We painters take the same liberties as poets and madmen...if in a picture there remains unfilled space, I adorn it with figures, according to my inventions."

began to produce woodcuts and copper engravings in large quantities.

Early prints were seen as a means to disseminate large numbers of pictures cheaply and quickly; in that sense they served a societal function. In style, they tended to imitate drawings, making use of the elaborate cross-hatching techniques of pen and ink. However, in time, artists became sensitive to the unique qualities of print media; styles began to express the nature of the tools and material of the printmaking process (see Chapter V).

Some artists frequently used prints for personal statements not found in their paintings. Many of the prints of Albrecht Dürer (1471-1528), Rembrandt (1606-1669), and Goya (1746-1828), are examples of pure art, produced independently of official patronage (Fig. 261).

Private Ownership of Art Increases

In the sixteenth and seventeenth centuries, as the need for religious art declined, the demand for secular art—genre scenes, still lifes, landscapes, and portraits—increased. These subjects had formerly been part of the imagery of past art. Now they

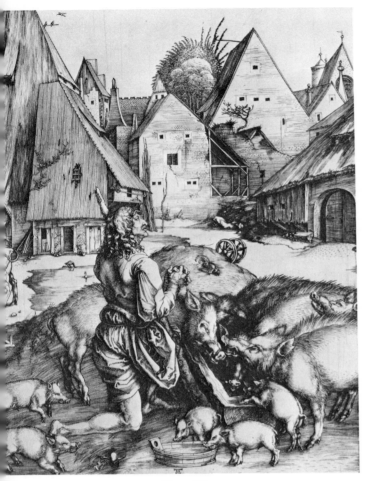

Fig. 261

ALBRECHT DÜRER (1471-1528). "The Prodigal Son."
Metropolitan Museum of Art, New York (Fletcher Fund)

Many artists used prints for their ability to duplicate images, as well as for their unique graphic qualities. Though some prints resemble pen and ink drawings, close examination of this engraving, for example, reveals that the rich black-and-white tonal "color" results from the artist's skillful exploitation of the engraving tool, metal plate, and the intaglio (see Chapter V) printing process. Notice the variety of cross-hatch tones and texture Dürer creates.

became themes that were attractive in themselves to a growing middle class which purchased art objects for their enjoyment (Fig. 262).

The self-portrait also became an intimate form of personal expression for artists at this time. It enabled them to explore, over an extended period of time, the human personality mirrored in their own physiognomy.

Rembrandt, throughout his life, created numerous self-portraits in the forms of drawings, etchings, and paintings. They are a magnificent visual documentation of a human being's struggles and growth (Fig. 263). The Rembrandt is also very instructive to our exploration of style, when it is compared with the portrait by Jean Auguste Dominique Ingres (1780-1867), Figure 264.

JAN VERMEER (1632-1675). "Officer and Laughing Girl."
Copyright the Frick Collection, New York

Vermeer's use of the visual language elements as *subject* surpasses his concern with *subject matter* (see Chapter I). He takes a modest scene as raw material and transforms it into a delight for the eyes by composing the lines, forms, textures, tones, and colors almost as an abstraction. Turn the page sideways or upside down and see with what care each element is arranged. Vermeer also takes great joy in creating the illusion of space and in rendering the play of light on forms; notice the variety of contrasting edges—from hard to soft—and the full range of values, from light to dark.

Fig. 262

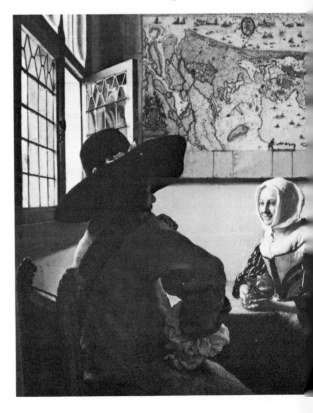

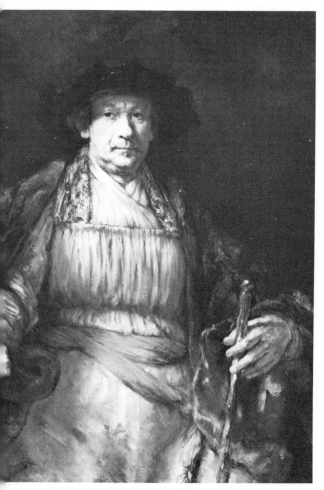

Fig. 263

REMBRANT VAN RIJN (1606-1669). "Self-Portrait."
Copyright the Frick Collection, New York

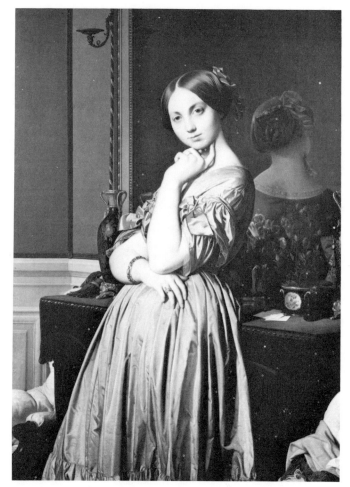

Fig. 264

JEAN AUGUSTE DOMINIQUE INGRES (1780-1867).
"Comtesse d'Haussonville." Copyright the Frick Collection, New York

When large-scale church building declined in the sixteenth and seventeenth centuries, the demand for secular art—genre scenes (like the Vermeer, Fig. 262), still lifes, landscapes and portraits—increased. In addition, the self portrait became an important form of expression for artists. Previously they had occasionally included their own likenesses among groups of figures in a background, but now they used themselves as both subject and subject matter. Rembrandt drew, etched, and painted himself throughout his life, leaving a marvelous series of images that document the effects of life upon human features, as in this powerful and majestic canvas.

It is instructive to compare it with the Ingres, because the two works represent opposite styles of composing space, form, tonality, and color. The concept Ingres uses actually originated centuries before (see Giotto, Fig. 259, and Gérard David, Fig. 37). In this style, each shape and form is isolated by color and tone, and is self-contained. Unity of composition is achieved by balancing these separate and distinct shapes and forms. In the Rembrandt, colors and tones are interwoven between shapes and forms; notice how the edges of the hat and left arm are softened and fused into the background. This mosaic-like interweaving is used as a unifying compositional device. Ingres treats every object in the picture with equal importance; he paints the vase or molding, etc., with as much detail as the face. Rembrandt subdues details by using broad suggestive strokes throughout most of the picture and saves more detailed articulation for the face and hands; notice how he also uses the strongest value-contrast—dark and light—around the face. Study these differences by also comparing the works by Rembrandt (Fig. 27) and Gérard David (Fig. 37) in Chapter I.

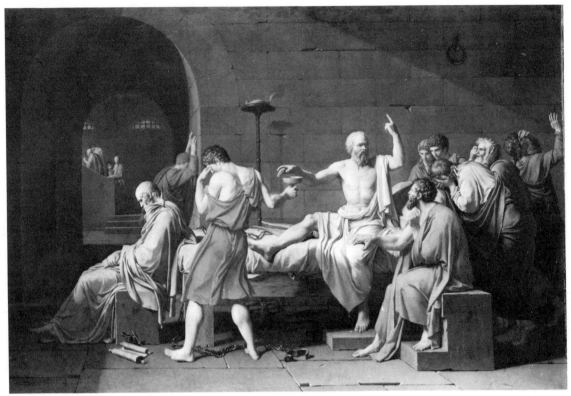

Fig. 265

JACQUES LOUIS DAVID (1748-1825). ''The Death of Socrates.'' Metropolitan Museum of Art, New York (Wolfe Fund)

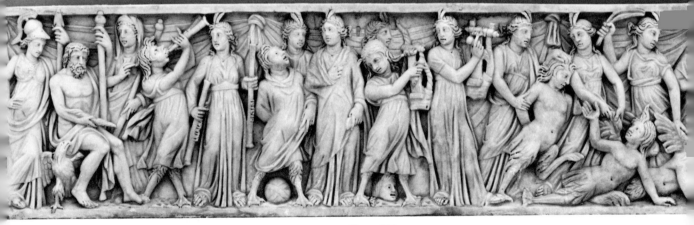

Fig. 266

UNKNOWN ROMAN ARTIST(S) (11th century). Sarcophagus front, relief depicting musical contest between the Muses and the Sirens. Metropolitan Museum of New York (Rogers Fund)

Neo-classicism was an art movement that sought a return to noble themes, painted in a classic style. In this canvas, David, a leading exponent of the school, composes his figures in a manner similar to a medieval Roman bas-relief, itself reminiscent of earlier Greek sculpture. David creates idealized physical types, poses them theatrically, and renders everything in the picture meticulously.

The Origins of Modern Art

In the seventeenth and eighteenth centuries art styles took two major directions: Neo-classicism, which sought a return to Classical styles and themes; and Romanticism, which asserted that subjective feelings and content were the most important ingredients of art.

Neo-classicism may be seen as a yearning for the past, a desire, in a period when industrial and political revolutions began to break up the old foundations of society, for the return of a religious or ruling-class authority.

Jacques Louis David (1748-1825) personifies the Neo-classic impulse in painting. In "The Death of Socrates" (Fig. 265), he chooses an ancient and noble subject, rendering it in a Classical style. The picture is composed like a bas-relief sculpture, recalling Greek and Roman models (compare Fig. 266).

Francisco José de Goya's life span is almost identical to David's, but his styles do not fit neatly into categories such as Neo-classicism. He earned his living by painting portraits of royal and aristocratic personages. Yet even in those works, which other court artists painted in a flattering style, Goya often injected critical, personal statements about his subjects. Later in life this tendency to deep insight became a preoccupation, which he explored in several series of etchings and drawings reflecting his brooding, private, nightmare world. The content and style of these pictures can be seen as a transition to Romanticism—a moving away from what is publicly acceptable to what satisfies the artist's desire to create from an inner need (Fig. 267).

William Blake (1757-1827) also lived at the time of David and Goya. Unlike them, however, he was an avowed Romantic and a forerunner of modern artists. His pictures were conceived as private images that came from inner visions inspired by poetry and the Bible, religious work motivated from within rather than dictated by a church hierarchy. He published hand-made books of his own poetry and illustrations (Fig. 268).

Thus, Romanticism can be seen as a step toward the modern movement when artists

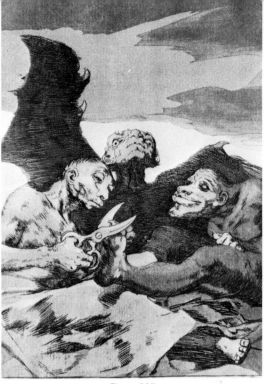

Fig. 267

FRANCISCO JOSE DE GOYA (1746-1828). Plate 51 from "The Caprices." Metropolitan Museum of Art, New York (Rogers Fund)

During the Neo-classical revival, an opposing movement—Romanticism—gained force. Its philosophy was that subjective feelings and content were the most important part of art. Some of the works of Goya and Blake, who lived during the same period as David, demonstrate that trend. Their choice of subject matter was often directed by an inner vision and was rendered in a personal style rather than a formalized one like that of the Neo-classicists. This self-defined approach to image-making was to become the primary focus of artists who followed. It led directly to the development of "modern" art styles.

WILLIAM BLAKE (1757-1827). Plate from a series based on the Book of Job. Metropolitan Museum of Art, New York (Gift of Edward Bement)

Fig. 268

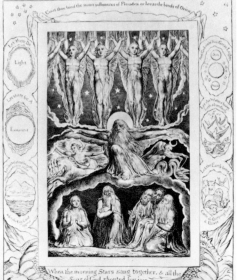

Fig. 269

GUSTAVE COURBET (1819-1877). "La Grotte de la Loue." National Gallery of Art, Washington, D.C. (Gift of Charles L. Lindemann)

The roots of modern styles can be traced to elements found in Romantic art—personal ways of portraying personal choices of subject matter (see Goya, Fig. 267, and Blake, Fig. 268). The artists who followed made the use of these elements a deliberate trend, in opposition to Neo-classicism. Courbet and Manet selected subject matter from everyday life. In style, notice Courbet's emphasis upon rugged brush strokes and the pure visual elements: line, shape, form, and textures. He used them much as modern abstract painters do.

EDOUARD MANET (1832-1883). "The Old Musician." National Gallery of Art, Washington, D.C. (Chester Dale Collection)

Fig. 270

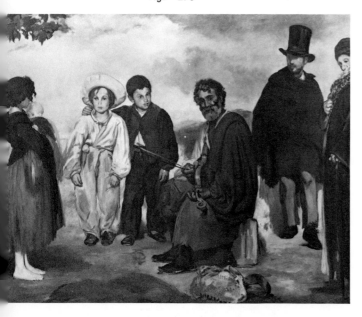

would finally break with the demands of religious leaders, political rulers, the aristocracy, and bureaucratic art establishments.

The Assertion of Artistic Autonomy

In 1846 the French poet Charles Baudelaire, who was also an art critic, demanded that paintings be free to express "the heroism of modern life." His friend, Gustave Courbet (1819-1877), met the challenge with canvases that presented humble subject matter painted in a bold style. Conservative critics and the art public, accustomed to the noble themes of Neo-classicism, were shocked by Courbet's work. They considered it vulgar and lacking in spirituality (Fig. 269).

The new trend was carried further by Edouard Manet (1832-1883), who continued the use of commonplace motifs and in addition made the new assertion that a work of art was itself an object of worth and beauty rather than a mere illusion that attempted to portray other worthy objects or scenes (Fig. 270).

Previously, as artists sought ways to paint realistically, the imitation of nature had become an end in itself and for some people the definition of art. They saw the picture frame as an imaginary window through which the viewer saw a real scene, object, or person. To that end, artists perfected the use of linear perspective, which "led" the viewer deep into the picture.

The new artists saw this as a device that destroyed the two-dimensional integrity of the picture surface, something which made "holes" in it—a deception.

The older artists had also denied their basic material, paint. They applied it thinly and were careful to keep brush marks unobtrusive; they tried to make pigment imitate flesh, wood, grass, or clouds.

Manet rebelled against these precepts with a style that emphasized the two-dimensional character of the picture surface. He related background elements and even "empty" space (see *negative space*, page 28) to the foreground, holding it sharply to

the picture plane. In addition he applied paint heavily, permitting the brush strokes to function as rich textures. This style emphasized that a picture was an object in and of itself, not solely a representation of another thing.

Prior to Courbet and Manet, there had already been artists whose styles were not completely bound by dogmatic ways of painting space and reality. Joseph Turner (1775-1851) (Fig. 271), Frans Hals (1580-1666) (Fig. 272), Velázquez (1599-1660), Goya, and Rembrandt are but a few who had used pigment and space unconventionally. But Manet's rejection of conventional style was a primary concept of his art and a public issue.

Soon other artists, who became known as Impressionists, took up the new ideas, which had been reinforced by the influence of Japanese woodcuts that had just been seen for the first time in Europe. They employed stylistic devices bordering on abstraction. Forms were designed as flat color-shapes, with much attention given to two-dimensional composition (Fig. 273).

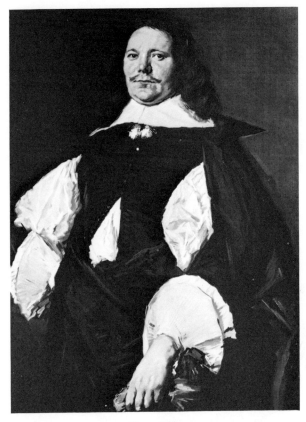

Fig. 272

JOSEPH MALLORD WILLIAM TURNER (1775-1851). "The Junction of the Thames and the Medway." National Gallery of Art, Washington, D.C. (Widener Collection)

Fig. 271

FRANS HALS (1580-1666). "Portrait of a Man." Copyright the Frick Collection, New York.

New styles or art movements are seldom without precedents. We have seen sixth-century Byzantine artists return to a formal style of the past (Fig. 258); the desire of artists to define their own goals was noted in the work of Veronese (Fig. 260); and the genre scenes of such artists as Vermeer (Fig. 262) demonstrate that the use of everyday subject matter was not an innovation of the Romantics or the Moderns.

Hals and Turner were two other older artists, who foreshadowed modern trends. The former, often using common people for subjects, painted them with a grandeur previously reserved for kings and aristocrats. Hals was obviously aware of the expressive qualities of the visual language elements. Notice his use of energetic rhythmic brush strokes—subjects in themselves—and his emphasis of pattern, which he accomplishes by strong contrasts of black and white and of textures. These patterns go beyond the description of clothing, to become independent expressive elements in the painting.

Turner was a great interpreter of the sea, sky, and air. His free and creative use of color anticipated the stylistic devices of the Impressionists.

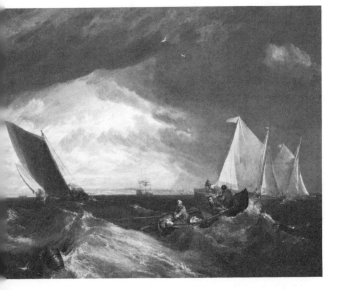

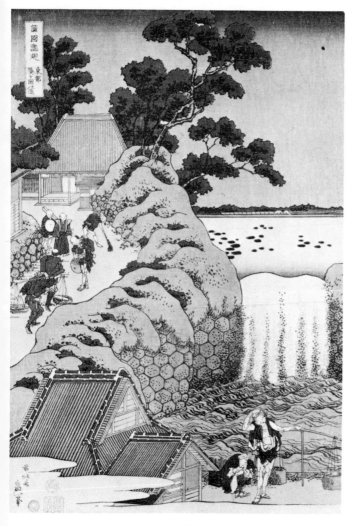

Fig. 273

KATSUSHIKA HOKUSAI (1760-1849). "Waterfall of Aoigaoka." Metropolitan Museum of Art, New York

In their woodcut prints, the Japanese used flowing elegant lines to describe shape and form; they also stylized shapes and forms by arranging values, textures, and colors into striking and dynamic patterns. When these works were shown in Europe, the exciting stylistic elements had an immediate influence upon those artists who were rebelling against traditional styles.

Notice how organically Hokusai composes: lines, textures, shapes, forms, and values are repeated with subtle variations and changes of proportion. Turn the picture upside down and see with what exquisite care the abstract visual language elements (see Chapter I) are arranged.

Claude Monet (1840-1926) created a personal style in the new manner, based upon his preoccupation with the changing effects of light and color (Color Plate III).

Pierre Renoir (1841-1919) used the bright, strong color characteristic of Impressionism and vigorous brushwork to paint subjects that expressed the simple joys of life (Fig. 274). Edgar Degas (1834-1917) also utilized freer color and brushwork to create works that combined strong classical drawing with flat, semi-abstract composition (Fig. 275).

Henri de Toulouse-Lautrec (1864-1901) combined superb spontaneous drawing skill with strong color and the new trends in designing pictorial space (Fig. 276).

Four more artists developed major new styles that were labeled Neo-impressionism and Post-impressionism. Georges Seurat (1859-1891) exemplified a highly scientific and intellectual approach to painting (Fig. 277). Paul Gauguin (1848-1903) sought to create pictures out of his inner visions rather than from nature (Fig. 278). Vincent van Gogh (1853-1890) focused on intense emotional expression, which he achieved through the turbulent use of color and violent application of paint (Fig. 279). Paul Cézanne (1839-1906) devised a style that restructured the three-dimensional forms of nature on the two-dimensional picture surface by geometricizing both forms and space and by controlling the tonality and intensity of colors (Color Plate IV).

Thus, in less than 30 years many disparate and unorthodox styles were developed. Initially they met official and public resistance; some artists even disparaged each other's experiments. But in a relatively short time most gained recognition and became established "masters" in their own lifetimes. The conditioning for change and exploration had been established.

A new era in art had begun. Artists freed themselves from employers and bureaucracies who had dictated style and content. Works of art were seen in a new way.

There was still a public function for art. Some sculpture and murals were commissioned to commemorate royalty, leaders, and wars; book and magazine illustration and advertising grew rapidly as printing and reproduction technology advanced. But in what has come to be known as the ongoing mainstream of fine art, artists made the final break with their traditional roles. They redefined themselves as independent creators,

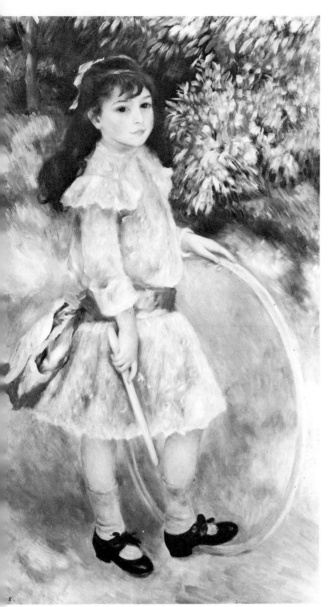

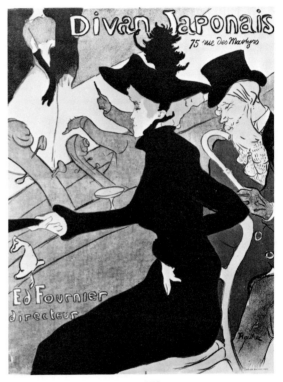

Fig. 275

EDGAR DEGAS (1834-1917). "Before the Ballet." National Gallery of Art, Washington, D.C. (Widener Collection)

Fig. 274

Fig. 276

PIERRE AUGUSTE RENOIR (1841-1919). "Girl with a Hoop." National Gallery of Art, Washington, D.C. (Chester Dale Collection)

HENRI DE TOULOUSE-LAUTREC (1864-1901). "Divan Japonais." Metropolitan Museum of Art, New York (Dick Fund)

Monet (Color Plate III, follows page 96), Renoir, Degas, and Toulouse-Lautrec are grouped together as Impressionists, though they painted in quite different styles. They do have in common the use of vivid color, an approach to composition influenced by Japanese prints, and a personal choice of subject matter.

Monet was intrigued with light itself as a subject. Rouen Cathedral (Color Plate III) is one of many versions he painted to record the changing effects of light and color at different hours. Renoir used Impressionist techniques to express joyful themes. Compare the looseness of his brush strokes with those of Rembrandt (Fig. 263) or Hals (Fig. 272); but note the different use of tonality. The earlier painters worked in lower tonal keys; the Impressionists used a key at the higher end of the value scale. Degas (not unlike Whistler, Fig. 153) created a beautiful and novel style by combining vivid Impressionist color, the stylization of Japanese composition, and his own superb classical draftsmanship.

Toulouse-Lautrec wedded his brilliant, spontaneous drawing skill to the new uses of color and design to produce vital and energetic images.

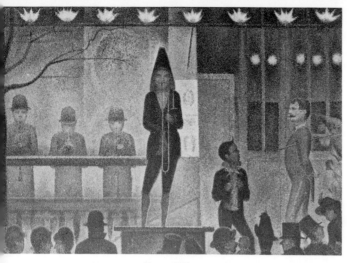

Fig. 277

GEORGES SEURAT (1859-1891). "La Parade." Metropolitan Museum of Art, New York (Bequest of Stephen C. Clark)

Four other artists are usually grouped together as Neo-impressionists and Post-impressionists, though they, like the Impressionists, worked in quite different styles. Seurat paid meticulous attention to two-dimensional design, the careful balancing of tonality, and the optical effects of small dots of pure color placed next to each other which, when viewed from a distance, are "mixed" by the eye. Gauguin took his inspiration from his inner visions, which he expressed by an arbitrary use of color and manipulation of shapes. In this woodcut Gauguin flattens out forms in the manner of Japanese printmakers (see Fig. 273); but unlike those artists, who retained a high degree of realism within their stylized compositions, Gauguin's extreme distortion of shapes gives them an expressive function quite removed from their function of describing trees, mountains, people, etc. (Compare the similar use of distortion by Grünewald, Color Plate XIII, (follows page 160). Van Gogh used visual elements to express his turbulent emotions. He often employed strident color applied with vigorous strokes, which create patterns and textures, that become dynamic expressive elements of the picture. Cézanne's (see Color Plate IV, follows page 96) style evolved from his attempt to translate the visual world into simple geometric forms such as cubes, cones, and spheres. He unified these forms by painting them with small patches of color, whose values, chromas and temperatures he carefully controlled. In his best canvases, this technique creates an organic unity that give the work monumental power and energy.

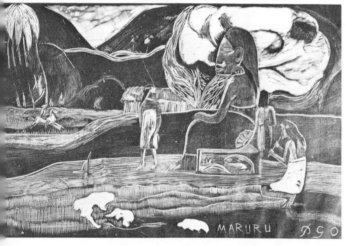

Fig. 278

PAUL GAUGUIN (1848-1903). "Maruru (Thanksgiving)." Metropolitan Museum of Art, New York (Rogers Fund)

VINCENT VAN GOGH (1853-1890). "The Olive Orchard." National Gallery of Art, Washington, D.C. (Chester Dale Collection)

Fig. 279

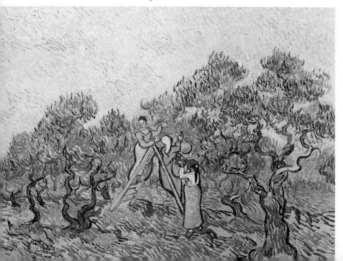

who would stand or fall by the images they made.

The new autonomy assured artistic freedom, but not a livelihood. Artists without independent means would have to struggle with economic as well as aesthetic problems.

The Acceleration of Styles and Movements

Prior to the mid-nineteenth century, styles and movements in art changed slowly. The exchange of ideas and stylistic influences depended upon the limitations of travel and crude forms of pictorial reproduction.

Another important factor was art training. Artists learned their craft through apprenticeships. Students sought to emulate their masters' work; originality and innovation came about slowly. Medieval art, Romanesque art, Gothic art, Renaissance art, Mannerism, Baroque, Neo-classicism, and

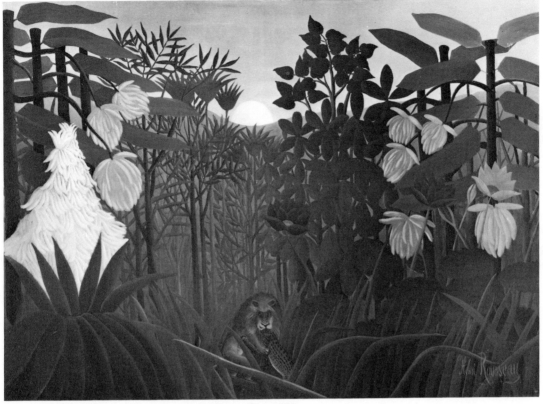

Fig. 280

HENRI JULIEN FELIX ROUSSEAU (1844-1910). "The Repast of the Lion." Metropolitan Museum of Art, New York (Bequest of Samuel A. Lewison)

Rousseau is another example of a primitive (see also Giotto, Fig. 259). Despite a lack of formal training he was able to create a rich, provocative style. Like Giotto, Rousseau had an intuitive sense of design. Notice how well he controls the complex variety of shapes and the broad range of tonalities. All the visual elements are built up organically (see Chapter I) to reinforce his mysterious, imaginative image.

Romanticism spanned a period of approximately 1200 years. As a result of modern communication, and the fact that the new artists defined their own goals, as many changes now occur during one season's exhibitions.

When modern artists proclaimed artistic autonomy, the standards of art entered a period of relative anarchy. People declared themselves to be artists, often in the face of establishment art academies and official art institutions, and went their own ways. An untrained painter such as Henri Rousseau (1844-1910), for example, could achieve great fame as a primitive (Fig. 280). The key to such success depends upon hard work and *verbal* championing of the art.

Mere declaration that one is an artist is not enough. The competition for approval and sale is formidable. It is not easy to face a blank canvas each day and try to create on it something that will be of interest to other people. The artist must produce a sizable body of work and find a way to put it before the public and art experts.

(Art is a subjective human phenomenon in which change and reevaluation are constants. The opinions of experts have varied and often been contradictory. Yet there is expert opinion as opposed to public or uninformed opinion. An expert is a person who devotes a large part of his/her life to looking at, reading, and thinking about art, and who learns to make intellectual or intuitive judgments based upon experienced comparisons.)

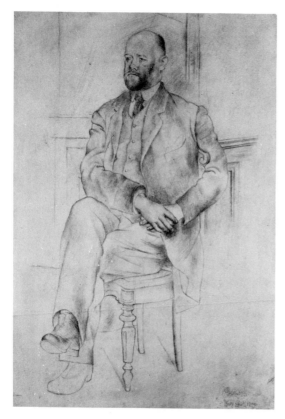

Fig. 281

PABLO PICASSO (1881-1973). "Ambroise Vollard." Metropolitan Museum of Art, New York (Elisha Whittelsey Collection)

UNKNOWN ARTIST(S) (Egyptian VII-VIII Dynasties). Frieze of Mereri. Metropolitan Museum of Art, New York (Gift of Egypt Exploration Fund)

Fig. 282

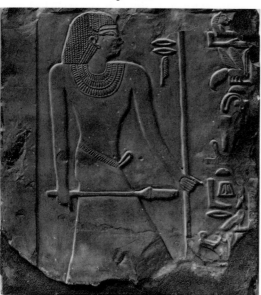

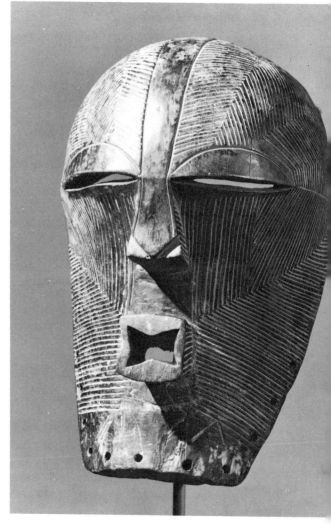

Fig. 283

UNKNOWN ARTIST (date unknown). Wood mask from Zaire. Metropolitan Museum of Art, New York (Rockefeller Memorial Collection of Primitive Art)

Picasso's "Les Demoiselles d'Avignon" (Color Plate XV, follows page 160) is of special interest to this survey of styles, because it fuses several of them. It should be noted that Picasso was a well trained draftsman, as his portrait of Vollard attests; the distortions in "Les Demoiselles d'Avignon" were deliberate, but not without precedents. For example, Grünewald (Plate XIII) and Gauguin (Fig. 278), used distortion to heighten emotional effects; Egyptian artists combined side and front views, when creating images of people (Fig. 282); and African sculptors stylized the human figure by boldly geometricizing its forms (Fig. 283). The importance of Picasso's painting was its assertion that distortions of form and space could be the focus of a work of art and that they should be taken seriously as a primary and vital part of the visual vocabulary.

Today, anyone with the trappings of authority can step forward as a passionate advocate of a new artist or art movement. Because the styles and content are often so difficult to understand, the *talk* about art has become as important as the art itself. This phenomenon can be traced to early controversial works, which baffled both the public and professionals, but which nonetheless became landmarks in art history as a result of verbal advocacy. An outstanding example is Pablo Picasso's (1881-1973) "Les Demoiselles d'Avignon" (Color Plate XV, follows page 160) which he painted in 1907, when modern art was still in its infancy. (Degas, Monet, Renoir were still alive in that year; Manet, Cézanne, Gauguin, Van Gogh, and Seurat had only recently died.)

Picasso's radical work was not immediately accepted; it lay rolled up on the floor of his studio for 13 years. Even some of his friends (modern artists themselves) thought it a hoax that would damage the new and precarious reputation of modern art. Finally some of Picasso's friends and a few daring critics *explained* the difficult work into acceptance.

Its quality as an individual masterpiece by a talented and versatile artist may, of course, be debated; but as an assertion of artistic freedom, 44 years after Manet, it is of unquestioned importance.

It often surprises students or lay people to learn that not all works in a museum or prestigious gallery are "great art." Many works merely document noteworthy stylistic or conceptual changes in the history of art.

The crudities and distortions in "Les Demoiselles d'Avignon" were very deliberate, Picasso was a very skillful draftsman (Fig. 281), but in this controversial canvas he explored several "unrealistic" concepts and styles. However, they were not without precedent. Matthias Grünewald (1485-1530) (Color Plate XIII, follows page 160) had used violent, contorted distortions of the human figure for expressive purposes. The ancient Egyptians had combined several optical viewpoints in one image (Fig. 282). The sculptors of Africa had translated the human body into bold, geometric forms (Fig. 283).

The importance of Picasso's use of these styles and influences was that he made them a primary assertion of a new point of view. Art had always been concerned with the perception and portrayal of reality; Picasso's picture dealt with reality in still another way. It is considered the first Cubist painting. One of the aims of Cubism was to incorporate *time*, the "fourth dimension," into still art and thus make that art more real. In this work Picasso looked at or conceived of the figures, and the space around them, from all sides; then he "reassembled" and restructured his remembrance of those three-dimensional views into one image on the two-dimensional surface of the picture.

The momentum of these ideas inspired even more radical concepts. Three years later, in 1910, Wassily Kandinsky (1866-1944) began painting in a completely abstract style—that is, without literal subject matter (Fig. 284). He declared that painting should be as free from subject matter as was music, and that its power and expression should come directly from the relationships of its inherent elements: line, shape, form, texture, color, and space. Subsequently, nothing was too sacred in reality, philosophy, or illusion for artists to dissect and restyle.

These final declarations of artistic freedom, which could spread their influence rapidly throughout the world because of modern communication, spawned numerous art movements in a very short time: Constructivism, Neo-plasticism, Metaphysics, Fantasy, Dadaism, the New Objectivity, Expressionism, Surrealism, Assemblage, Social Realism, Abstract Expressionism, Action Painting, Abstract Imagism, Art Concrete, Junk Art, Found Art, Happenings, Pop Art, Photo Realism, Primary Structures, Minimal Art, Neon Art, Optical Art, Color Field Painting, Shaped Canvases, and Psychedelic Art, to cite just a few. Thus, an examination of the world of art today—even one year's exhibitions in New York City—can be very confusing to students seeking to understand the styles and functions of art.

Newness and novelty have become marketing tools that have engendered many fleeting "movements," but few of lasting substance. Adding to the confusion is the phenomenon of recent paintings executed in

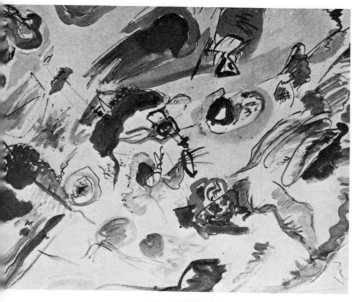

Fig. 284

WASSILY KANDINSKY (1866-1944). "First Abstract Watercolor." Collection: Mme. Nina Kandinsky, France.

The experiments of artists in the late nineteenth century and the first decade of the twentieth led to the style of complete abstraction—the use of visual elements without regard to recognizable subject matter. Kandinsky declared that the visual arts should have the same freedom as music and achieve expression solely through the viewer's response to the artist's manipulation of line, shape, form, tone, texture, and color, just as composers achieved musical expression solely by organizing sequences of pitch, harmony, timbre, and rhythm.

conservative styles, some of which look as if they might have been painted 500 years ago, hanging side by side with extreme avant-garde works. There is profound disagreement about the quality of contemporary works among critics and experts. Moreover, economics is now a powerful determining factor in the functions and styles of art.

The Economics of Modern Art

Despite the fact that modern art has no public function, it is a marketable commodity. One irrefutable measure of artistic acceptance, when there is no function, is the amount of money someone will spend for its aesthetic and/or historical prestige value. Jackson Pollock's (1912-1956) "Blue Poles," similar in style to "Autumn Rhythm" (Color

Plate XVI, follows page 160), was purchased by the Australian National Gallery in 1973 for $2,000,000. Its original selling price was $6,000.*

Since antiquity, art objects have been considered treasures. In addition to their monetary value, they have the unique value of being a tangible piece of history. Masterpieces in other fields of expression—the works of Shakespeare or Beethoven, for instance—belong to everyone. But with the exception of prints and cast sculpture, the works of visual artists are unique. Only one individual or institution can own each of them. It must also be noted, that in some countries, in addition to that status factor, works of art can yield the owner substantial tax benefits. And some art buyers are more interested in the investment potential of art works than they are in their aesthetic value.

Whether or not money should be a determining factor in the evaluation of artistic quality, it is a fact of life in modern art. In some ways, the relationship of money to art is no different now than it was in the past—remuneration for quality. In the past, however, quality was simpler to define and agree upon. And most important, past art was not as susceptible to corruption and manipulation as is some modern art.

In the past, quality in art was defined by the hierarchy of guild systems and academies, and the agreement of professionals—historians, critics, and peers of the artists. Of course, those opinions were not always unanimous or free from bias; few artists regardless of success have escaped attack by either colleagues or critics.

Thus, the subject of styles and the functions of art in the modern era raises serious paradoxical questions. It should be noted that artists in the Soviet Union and China function for the state; subject matter and styles are dictated by political ideology (though in recent times some Soviet artists began to rebel and are now openly painting and exhibiting works influenced by modern art of the West).

In the West itself, many of the most financially successful artists produce work

Newsweek, Oct. 8, 1973, p.45.

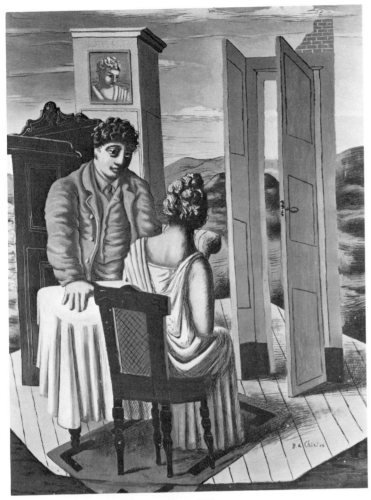

Fig. 285

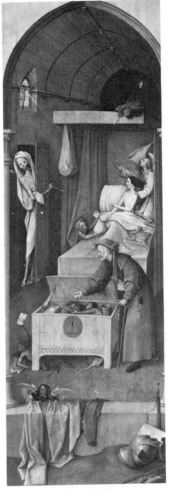

Fig. 286

GIORGIO DE CHIRICO (1888-). "Conversation Among the Ruins." National Gallery of Art, Washington, D.C. (Chester Dale Collection)

HIERONYMUS BOSCH (ca. 1450-1516). "Death and the Miser." National Gallery of Art, Washington, D.C. (Samuel H. Kress Collection)

Since 1900, the variety of modern styles has proliferated rapidly, but as we have seen they are seldom completely unrelated to the past. De Chirico, an exponent of the modern Metaphysical school of painting—an art concerned with alienation—used rather traditional methods to express his dreamlike images; notice that he models form with light and shade in a classic manner. He also uses a modified form of traditional perspective. It is interesting to compare the stylistic similarities to a work created 400 years earlier by the great phantasy painter Bosch.

that is neither materially functional nor even decorative, but in a sense they have regained an ancient function, that of tribal witch doctor—a professional who stands somewhat outside the society which supports her/him for a variety of insights and visionary powers.

It should also be noted that large num-

bers of people with artistic talent do function for society in the vast field of commercial art, perhaps the largest and most public art in history. An interesting sidelight to this is that "fine artists" have often come from the ranks of commercial art (Honoré Daumier (1808-1879) (Fig. 54) and Andy Warhol (1927-)

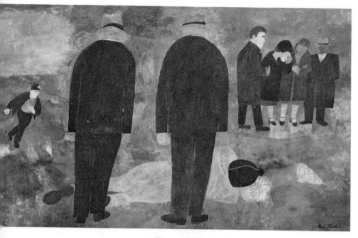

Fig. 287

BEN SHAHN (1898-1969). "Death of a Miner." Metropolitan Museum of Art, New York (Hearn Fund)

Some recent artists use modern stylistic devices to express humanistic subject matter. Shahn, a well-trained draftsman, often presented his politically motivated images in a style resembling that of a primitive. The flat, direct treatment of form and space gives the picture the immediate impact we get from a poster.

Bearden combines collage techniques (the pasting of objects, materials, or parts of other pictures, to a painting). The combination evokes shifting emotional tensions and moods, as we try to resolve the provocative juxtapositions.

ROMARE BEARDEN (1914-). "The Woodshed." Metropolitan Museum of art, New York (Hearn Fund)

Fig. 288

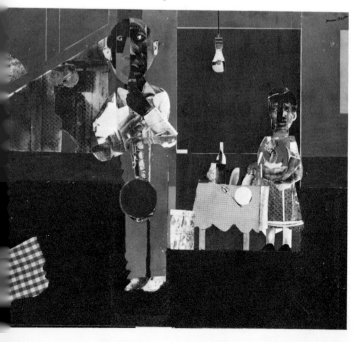

for example, and some of the work they do overlaps both fields. In recent years, museums and galleries have honored commercial art on their walls.*

Thus the line between contemporary fine art and commercial art sometimes blurs. Advertising techniques are used to promote some fine art in the crudest commercial form. Galleries will often insist that a fine artist "produce" work in a particular style because it sold well in a previous exhibit.

However, one paramount difference should not be lost sight of: Fine art grows from the inner inspiration of the artist; which is its reason for existence. Commercial art is commissioned; it would not come into being were it not assigned. It is true that some great fine art of the past was done by contract (most religious art), but it was usually done by artists with a deep conviction for what they did.

Despite the proliferation of "modern" styles, some recent artists continue to create images inspired by humanistic concerns. Giorgio De Chirico (1888-) (Fig. 285) explores the world of the subconscious in phantasies not unlike those of the earlier master, Hieronymus Bosch (ca. 1450-1516) (Fig. 286. Ben Shahn (1898-1969) (Fig. 287) and Romare Bearden (1914-) (Fig. 288), apply contemporary styles to social themes.

While these paradoxes in the world of art may seem confusing to a new student, they also offer an enormously expanded visual vocabulary for artistic self-expression. The magic of the still image created by human hands, in a painting, drawing, print, or sculpture, is often the quality that first attracts students to begin their studies. Coupled with a reasonable definition of art (see Chapter I), it can inspire them to search out significant creative styles of their own, as it has for others throughout the long and fascinating history of art.

* Push Pin Studios of New York City were given an exhibition at the Louvre Museum, Paris, in March 1970.

CAREERS IN ART

MORTON GARCHIK. Illustration, layout, photography

Chapter VII

CAREERS IN ART

I S A CAREER IN FINE ART FOR YOU? The study and practice of fine art is one of the most challenging and enriching activities in life. One of the many joys of art is that the very process of attaining skill in it increases one's ability to perceive profounder levels of beauty. But it is also one of the most difficult careers. Those dedicated to pursuing it often face discouragement, lack of acceptance, and financial hardships. Fine artists often have to supplement their income by taking part-time employment in other fields or in one of the professions described below.

Many people with artistic skills do not wish to pursue a career in fine art at all, but they would like to use those skills in some creative work. The following survey describes a variety of professions, which might be considered.

The decision to pursue one of these careers should be preceded by counseling, by sessions in art schools or colleges, and, if possible, by interviews with people working at the chosen occupation.

Salaries in these professions vary greatly—minimum wage for novices and as high as the best professional remuneration in other fields. Most positions are nonunion but some offer corporate or civil service security. It is possible to free-lance in many of these fields; some artists run their own business.

Temperament

The practice of fine art requires the ability to work alone, and many fine artists are indeed people who prefer working in solitude. They are also people who are self-motivated and self-disciplined.

Most of the professions described below, while also requiring discipline, demand different personality traits. Two of the most important are a business-like reliability and the ability to interact and communicate well with people.

Reliability means, quite simply, doing and delivering a job in a thorough manner and on time. Good interaction means being able to discuss jobs intelligently and articulately, and being able to accept criticism.

Other Art Careers
Illustration (Book and Magazine)

These fields are closely related to fine art picture-making; in fact, many fine artists have made illustrations specifically for publications (Daumier, Degas, Toulouse-Lautrec, Maillol, Picasso, Rouault, Baskin). *Skills needed*

Solid training in drawing, composition, and color.

The ability to work in many techniques (pen and ink, painting, etc.).

An active interest in other areas of image-making (photography, theater, film, etc.).

Preparation

An illustration major in a commercial art school or college and apprenticeship with a practicing professional or in an art studio.

Illustration (Fashion)

This specialty requires a great interest in the decorative and expressive aspects of clothing, and the ability to draw the figure well.

Skills needed

The ability to draw the figure from models and from one's imagination if necessary.

The ability to interpret the fit, style, detail, and texture of clothing.

The ability to work in many media (pen and ink, charcoal, paints, etc.).

Preparation

Courses in fashion illustration at a commercial art school or college and an apprenticeship in the field.

Illustration (Advertising)

This is not a separate specialty, because advertisers require too many styles of illustration for any one artist to encompass. Thus assignments are given to specific illustrators whose style suits a particular need.

Skills needed

The ability to develop a unique style.

The flexibility to illustrate many subjects in your style.

Preparation

An illustration major in a commercial art school or college and an apprenticeship in the field.

Illustration (Technical)

This branch of illustration is particularly well suited for people who like to draw charts, diagrams, or mechanical objects (cars, ships, machinery, etc.) rather than pictures of people or landscapes.

Skills needed

The ability to do mechanical drawing with precision.

Preparation

Courses in vocational or commercial art

school and an apprenticeship in an art studio or firm doing this type of work.

Illustration (Medical)

This is a highly specialized area of illustration. One would work in a hospital; with firms that manufacture medical products or advertise them; or on medical textbooks.

Skills needed

The ability to draw and paint very realistically.

Preparation

Undergraduate and graduate degrees are required.

Illustration (Cartooning)

Cartooning has several branches: humor, comic strip, political, and advertising. The first three are difficult fields to break into. Humor cartoonists and comic strip artists must first create their product and then sell it. The work of political cartoonists is syndicated to newspapers across the country, and therefore opportunities for newcomers are infrequent.

The best opportunities are in advertising, particularly in TV commercials.

Skills needed

For cartoonists generally: The ability to draw well. (Despite their simple look, cartoons require considerable drawing skill.)

For humor cartoonists: Verbal and literary ability. (Some humor cartoons depend as much upon a clever line as they do upon drawing.)

For political cartoonists: The ability to draw good likenesses or caricatures; the ability to look at society, people, or politics critically and creatively.

Preparation

Drawing and composition in a fine art or commercial art school.

An apprenticeship with a practicing cartoonist or in an art studio.

Illustration (Reportage)

This is a form of illustration used where cameras are forbidden—in courtrooms, for example; thus it is highly specialized. In view of pending legislation to legalize the use of cameras and TV in courts, it could become an obsolete field for artists.

Skills needed

The ability to draw rapidly and accurately from life.

The ability to produce good likenesses.

Preparation

Drawing and composition in a fine art or commercial art school.

Graphic Design (Layout and Art Direction)

This is one of the broadest fields of commercial art. The graphic artist, layout artist, or art director is a person who organizes and composes all the elements of a piece of commercial art: a page in a book or magazine, the whole book or magazine, a menu, the titles of a film or TV production, even the planning of a film or TV show.

An art director may be called upon to design everything visual in a large corporation—from the lettering on its trucks and buildings to the planning of multi-media advertising campaigns and the company's business forms.

Skills needed

The ability to draw and compose.

Knowledge of typography (styles of lettering).

The ability to conceptualize and think creatively.

The ability to conduct business with suppliers (printers, paper salespeople, freelance photographers and illustrators, etc.).

The ability to supervise work and assistants.

The ability to hire and fire assistants.

The ability to interact with editors, publishers, copywriters, clients, and business executives, and to establish good verbal communication with them.

Preparation

A good general graphic art course in a commercial art school or college and an apprenticeship in the field.

Book and Magazine Design

Though this work is sometimes done by art directors as part of a larger job, it is also a specialization.

Skills needed

The ability to transform a typewritten manuscript into a finished book or magazine story by making layouts, specifying the typography, and following through on all the details.

The ability to work well with others and conduct business with suppliers.

Preparation

Courses in layout, typography, and book design at a commercial art school or college.

Lettering

This category can be subdivided into sign-painting, calligraphy, hand-lettering, and the designing of type faces.

Skills needed

The ability to do precise, technical-style drawing; and a thorough understanding of letter forms.

Preparation

A specialized course in a vocational or commercial art school and an apprenticeship with a practicing professional or in an art studio.

Paste-ups and Mechanicals

Sometimes called *boardwork*, these terms refer to the physical work done on a piece of commercial art work before it goes to the printer. It consists of assembling, preparing, and pasting together many elements—type, illustrations, photographs, etc.

This job is the one through which most people gain entry to the commercial art field as apprentices or assistants and is an excellent way to learn many aspects of the business.

Skills needed

The ability to draw, letter, do layout, work neatly, have a knowledge of typography, and some creative ability.

The beginner will not be expected to be a master of all these skills but will be expected to have a rudimentary knowledge of them, gained either in school or on a previous job. The important thing is a willingness to learn.

Preparation

A general course in commercial art, supplemented by courses in paste-ups and mechanicals. (A student who is able to get a part-time paste-up job while in school will be far ahead of the competition.)

Textile Design, Interior Design, Fashion Design

These specialties are well suited to people who have a good sense of color and decoration and who like to improve the appearance of the environment.

Skills needed

The ability to draw and design with an emphasis on pattern.

The ability to design with color.

For interior design: The ability to do technical drawing and perspective.

Preparation

Specialized training in college or commercial art school, followed by an apprenticeship in the field.

Architecture

People who respond to the aesthetic qualities of structures and who would like to apply their artistic skills on a grand scale may find this a rewarding career.

Skills needed

The ability to do technical drawing.

The ability to design in three dimensions.

Some business and administrative ability. (Budgets often directly affect the aesthetic possibilities of a project.)

Preparation

College and university training in the fundamentals of the discipline.

Theatrical Set Design

Like architecture, this profession appeals to artists with a feeling for sculpture, who have a flair for designing real space.

Skills needed

The ability to do technical, architectural-style drawings.

The ability to understand and plan real structures and lighting systems.

The ability to compose dramatically with real light and dark, and colors.

The ability to design costumes.

Preparation

College and/or special courses in commercial art school and an apprenticeship in the field.

Industrial Design

People who work in this field design all manner of products—anything from a computer circuit to a water faucet. They apply their artistic talent towards making utilitarian objects attractive as well as functional.

Skills needed

The ability to do technical drawing.

The ability to conceptualize in three dimensions.

Some business and administrative ability.

Preparation

College and university training and apprenticeship in the field.

Applied Sculpture

Applied sculpture, or model making, is a highly specialized field that attracts people with talent for sculpture or with the ability to build and construct objects in a variety of materials: mock-ups of automobiles, toys, industrial products, etc.

Skills needed

The ability to read and interpret plans.

The ability to work with a variety of tools and materials.

The ability to carry through jobs with craftsmanship.

Preparation

Vocational school training emphasizing work with clay, wood, plaster, metal, plastics etc., and an apprenticeship in the field.

Photography

In commercial art, photography is used as another tool for illustration and is an excellent area for people who may have a good picture-making sense but who may not be able to draw well.

Skills needed

The ability to learn the mechanics of cameras and darkroom work.

The talent to see in a unique pictorial way.

Preparation

A major in photography in college or art school or a school of photography (extra courses in drawing, composition, and painting can be very beneficial) and an apprenticeship in the field.

Photography Assistants

There are positions for camera and dark-

room assistants, and for stylists. The latter work as administrators and coordinators—hiring models and renting sets, costumes, and props. The stylist may also assist with the costuming and sets during photography sessions.

Skills needed

The ability to arrange and coordinate details.

The ability to work well with people.

Reliability.

Preparation

Camera or darkroom assistants: schooling in photography (see above).

Stylists: schooling or equivalent practical experience in fashion (with an eye for design, composition, color, etc.), business administration, and public relations.

Photo-retouching

This is an important phase of commercial photography usually done by specialists, not by the photographers themselves. A retoucher works with brushes and paints and an *airbrush* (similar to a spray gun), which the retoucher uses for precise and delicate effects, correcting flaws in pictures, eliminating parts of a photo, or even drawing in something which was not there to begin with.

Skills needed

A very steady hand and sharp eyes.

The ability to interpret black-and-white values, colors, and color tones, and to mix them with paints.

Preparation

Vocational or commercial photography school and an apprenticeship.

Film and TV

In film and TV, artists are employed as designers of sets, of titles, of costumes, and—in one highly specialized area—the sketching of storyboards.

Storyboards are a quick, inexpensive way of getting a visual sense of what the film may look like. The artist, working with the script and possibly with the writer and director, makes a series of roughly sketched pictures, indicating the settings, lighting effects, positions of the actors and the camera angles. The storyboards are then used by the director, producer, and camera operator as a guide for coordinating the complicated procedures of producing a movie, TV show, or commercial.

Skills needed

The ability to sketch rapidly, and to some degree from memory, a large repertoire of subjects: people, places, and things.

The ability to collaborate well with others.

Preparation

Extensive training in drawing and composition.

Film and TV Animation

In animation work, artists create storyboards (see above: "Film and TV"); draw detailed prototypes of characters and backgrounds; and draw the actual frame-by-frame animation. In small companies, one or two artists may work on all phases; in larger operations, each phase is apt to be done by specialists.

Skills needed

For storyboard and prototype artists: The ability to draw well creatively and collaborate with others.

For frame animators: The ability to draw well technically rather than creatively.

Preparation

Courses in film animation at college or commercial art school and an apprenticeship in the field.

Crafts: Pottery, Jewelry, Leatherworking

These fields have in common with fine art the fact that the artist must first invest time, money, and effort to create the objects, and then try to sell them.

Skills needed

The ability to design well, both two- and three-dimensionally.

The ability to work well with one's hands.

A feeling for sculptural beauty.

If self-employed: Some sales ability and business administration experience.

Preparation

Courses in a vocational school or college and an apprenticeship in the field.

Teaching and Scholarship

For many practicing artists and art-oriented persons, teaching offers a stimulating and satisfying career. Opportunities in this field exist on many levels, ranging from part-time lecturing and art instruction in community centers all the way to art scholarship and teaching on the university level. Many artists find teaching a stimulating way to supplement their incomes.

Skills needed

For academic instructors, researchers, and scholars: The ability to do good academic work in the areas of research, writing, languages, history, philosophy, etc.; an interest in travel; and a desire to communicate about art with other people.

For instructors in techniques (painting, drawing, sculpture, printmaking): The ability to impart knowledge and offer constructive criticism.

Preparation

For academic careers: Undergraduate and graduate degrees.

For instructors in techniques: Some institutions require their instructors to have academic degrees; others will accept high professional standing (work in the collec- tions of museums, one-person exhibitions, prizes, etc.) as credentials.

Museums and Galleries

These fields offer people who love art an opportunity to build gratifying careers. Galleries and auction houses are concerned chiefly with buying and selling art; museums have numerous functions: displays, sales of reproductions and gifts, publications, and educational programs. There are also curatorial, administrative, and repair positions.

Skills needed

In galleries and auction houses: The ability to mount exhibitions including the administrative details of working with artists, framers, and the public. Larger auction houses may require academic degrees, expertise in specific periods of art, and a knowledge of foreign languages.

In museums: Academic degrees with art history majors.

The ability to deal with the public.

Preparation

Undergraduate and graduate work in a variety of art subjects.

APPENDIX

Alphabetical List of Artists

(Figures indicate page numbers of the artist's illustrations.)

INDEX